Cartooning
THE HEAD & FIGURE

PARTIAL CONTENTS OF "CARTOONING THE HEAD AND FIGURE":

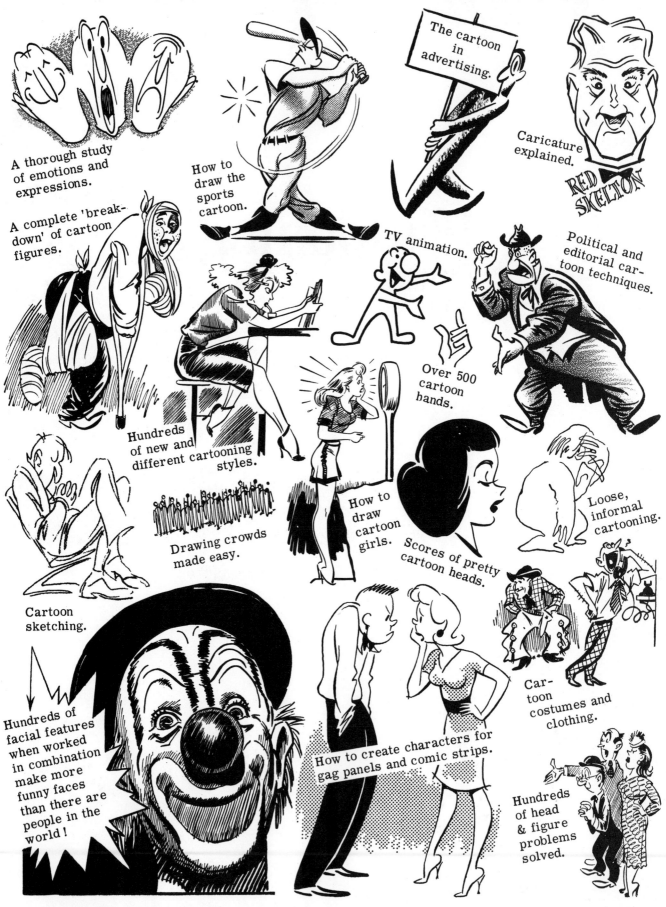

A thorough study of emotions and expressions.

A complete 'break-down' of cartoon figures.

How to draw the sports cartoon.

The cartoon in advertising.

Caricature explained.

RED SKELTON

TV animation.

Political and editorial cartoon techniques.

Hundreds of new and different cartooning styles.

Over 500 cartoon hands.

Drawing crowds made easy.

How to draw cartoon girls.

Scores of pretty cartoon heads.

Loose, informal cartooning.

Cartoon sketching.

Hundreds of facial features when worked in combination make more funny faces than there are people in the world!

How to create characters for gag panels and comic strips.

Cartoon costumes and clothing.

Hundreds of head & figure problems solved.

Cartooning
THE HEAD & FIGURE

by JACK HAMM

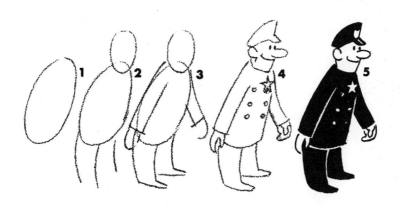

A GD/PERIGEE BOOK

Dedicated

to

The Four Walking Cartoons:
Dawna, Charlotte, Monty and Jerry

PERIGEE BOOKS

ARE PUBLISHED BY

THE PUTNAM PUBLISHING GROUP

200 MADISON AVENUE

NEW YORK, NEW YORK 10016

PUBLISHED SIMULTANEOUSLY IN CANADA BY GENERAL PUBLISHING

CO. LIMITED, TORONTO.

LIBRARY OF CONGRESS CATALOG CARD NUMBER: 67-14755

ISBN 0-399-50803-1

FIRST PERIGEE PRINTING, 1982

SEVEN PREVIOUS GROSSET & DUNLAP PRINTINGS

PRINTED IN THE UNITED STATES OF AMERICA

19 18 17 16 15 14 13 12

CONTENTS

PREFACE

Who can imagine a newspaper without a comic section, an editorial page without a central cartoon, television without animated cartoons, the theater without lively cartoon comedies, magazines and trade publications without amusing gag panels or advertising in its endless forms without cartoons? Cartoons are playing an ever-larger part in today's world. Within the last few years multi-million dollar advertising campaigns have been built around a few simple commercial cartoons. The cartoon has become the king in many quarters, showing no signs at all of abdication.

The most natural "cartooners" on the earth are children. They draw cartoons without half trying. Occasionally a seasoned cartoonist, for a refreshing change, will return to this natural flare possessed by nearly every child. When even a small child is encouraged to take the workable step-at-a-time procedures, he, along with adults, can make tremendous strides in cartooning know-how.

There is a universal something in human nature which loves the light touch in most any given situation. Of all people, the cartoonist develops an affinity for this. Of course, eventually it's not enough just to cartoon a character in the middle of peculiar circumstances or in an outlandish pre-

dicament. But being able to do it, and do it well, opens up doors in many rewarding fields and markets.

Mankind has passed through many ages and stages, and these changes have made some professions and lines of work obsolete. However, it is fairly safe to say we will remain forever in the "Picture Age." Our accelerated pace of living finds us seizing on pictures which can be grasped in a flash. And, in a world overrun by peril and tragedy, humorous pictures are wanted. The relief-bringing cartoon gives us all a much needed lift.

Because cartoons are used in so many places for so many purposes, learning one phase or application helps in all the rest. It is possible to diversify one's abilities, as he goes along, so that one's talents are in greater demand. This book seeks to familiarize the learner not in just one phase of cartooning nor in just one way of doing it, but in multiple ways and means, styles and techniques.

Another advantage in presenting so many different preliminary steps in all the related cartoon fields, is that the student is less likely to become a copyist of somebody in particular who already has laid claim to a single style. Every student has within himself the potential to draw like

no one else. Such individuality can best be promoted by stretching the "drawing muscles" and expanding the cartoon concepts. The reason for combining the simplest kind of *head and figure* cartooning with the most complex and advanced is to give the individual cartoonist, regardless of his stage of development, that which will be of personal value to him in a one-volume package.

It should be noted that some modes of expression set forth in a specific section of this book are applicable in related fields of cartooning, presented on still other pages. There is no absolute, set, prescribed way of doing any kind of cartooning. There are, however, new lines of approach which will in no way deter artistic development, but rather will serve to channel practice efforts into an enjoyably wide area of creativeness.

This book was not meant to entertain with gag lines, jokes and stories. Such entertainment detracts from the elected purpose which is to teach the many ramifications of *head and figure* cartooning. Actually, there can be more *fun* in cartoon *work* than in most anything a person can do. Help yourself to many interesting periods of *enjoyable exertion*. Welcome to the fantastic land of the cartoon!

JACK HAMM

CARTOON FACES — IN FOUR EASY STEPS

Let's pull back the curtain from your own latent creative abilities, provided you are new at this funny business of cartooning, and introduce you to some whimsical people who perhaps you didn't know could come from your own pencil.

A

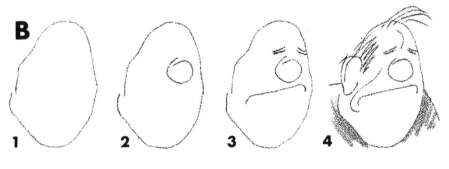

First, draw <u>any kind</u> of a semi-round enclosure. Whether it is lop-sided or crooked makes little difference.

Next, as a starter, draw a bulb-like nose somewhere in the central area where we're accustomed to "wearing" this rather vital breathing feature.

Above the nose draw spots or slits for eyes such as has been done in the stages numbered "3" on this page.

Beneath the nose draw a mouth either smiling (A), indifferent (B), mad (C) or laughing (D).

Letting it go at that, already you have some funny faces. If you wish to add some "extras" like ears, wrinkles in forehead or around mouth, hair, hat or collar and tie, this may be done. See figures in the "4" column.

There are many people in this world who have doodled miles of 'nothing' while talking on the phone or killing time with restless fingers. Why not turn your markings into pleasurable and even profitable cartooning? It can be done!

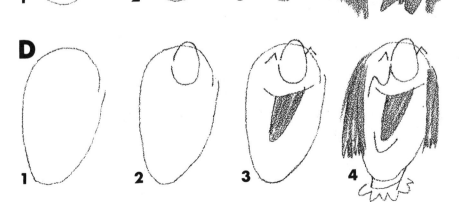

SIMPLE YET 'PROFOUND' FACTS ABOUT CARTOONING

At the outset there are several important factors at work on the side of the cartoon student. One is the very positioning of the facial features. To illustrate:

Set down four dots
four dashes _ _ _ _
and four checks ✓ ✓ ✓ ✓

Anyone can line them up that way. Now, start again with each set; but, instead of making the third in a row, drop this one below center of the first two. Then make the fourth one below the third so that they appear in this arrangement:

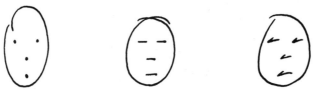

It is easy to see that the marks which, only a moment before, were simply cold dots, dashes and checks have come to life. Each set has an expression all its own. When these 'faces' are placed inside simple circular shapes, we find we've created several cartoon heads:

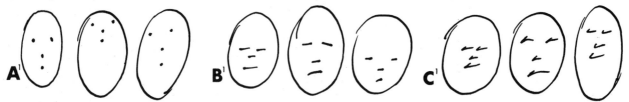

If a series of the dot, dash or check men were done at random side by side, the viewer would readily notice that the individuals would not look exactly alike but would possess certain 'personality differences':

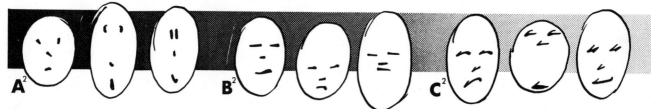

Next, when slight pressures are exerted on the pen, and the act of placing the markings is off-hand within the head, pronounced individuality shows up in the 'people':

The foregoing serves to emphasize the fact that shades of expression creep into the simplest of facial features. This is another factor that is a tremendous assist to the cartoonist. Brows and facial lines about these four features can do much, but some of the greatest cartoons ever drawn have been without them. The ease with which such heads as these can be done should be an encouragement to the beginner. On the following pages the separate facial features are discussed and illustrated. It is interesting to 'create' totally new faces by working these and their variations in combination. In connection with this study, investigate the various emotions (which follow) that are felt and experienced by man, and learn to incorporate them into the cartoon face. The body may react to the emotion — that is why some bodies are included in the section on emotions — but the emotion in cartoon never escapes the face. Most humor is utterly dependent upon what transpires in the face. If each head and facial feature on the next six pages were tried with all the other possible combinations of features presented, mathematically the heads would outnumber the population of the world.

SIDE VIEW CARTOON NOSES

ROUND → A 1 2 3 4 5 6 7 8 9 10 11 12 13 14 15 16 17 18 19
20 21 22 23 24 25 26 27 28 29 30 31 32 33 34 35 36 37 38 39

SQUARE → B POINTED → C
40 41 42 43 44 45 46 47 48 49 50 51 52 53 STRAIGHT → D 54 55 56 57 58 59

HUMPED → E 60 61 62 63 64 65 66 67 68 CONCAVE → F 69 70 71 72 73 74 75 76

77 78 79 80 81 82 83 84 CONVEX → G 85 86 87 88 89 BROKEN → H 90 91 92

93 94 95 96 97 ENCLOSED → I 98 99 100 101 102 103 104 105 106 MISC. → J 107 108 109 110

111 112 113 114 115 116 117 118 119 SHADOWS → (UNDER ANY NOSE) K 120 121 122 123 124 125 126 127

As a rule the first thing a cartoonist puts on the face is the nose. It has little to do with expression as such, but usually does more in establishing the identity of a character than any other feature. In this respect its sameness is as important as the mobility of the eyes and mouth. Variety in sizes is suggested (above) in repeating in sequence several of the same types. These are not the only shapes by far, but most types are represented. Joining points of different foreheads and upper lips open up even further possibilities in creating brand new faces.

← JOINING POINTS
SIDE VIEW
FRONT VIEW
← JOINING POINT

FRONT VIEW CARTOON NOSES

Inasmuch as nearly any <u>side</u> view cartoon nose may be used on a full <u>front</u> view face, it is not necessary to show as many front view noses. In fact, many cartoonists use <u>nothing but side view noses</u> on their front (or semi-front) view faces. A given side view nose may have its front view counterpart however. In this listing (below) one may 'cross' a couple of noses obtaining thereby a still different nose. Real-life noses (at left) furnish us our cues.

1 2 3 4 5 6 7 8 9 10 11 12 13 14 15 16 17 18 19 20 21 22 23

24 25 26 27 28 29 30 31 32 33 34 35 36 37 38 39 40 41 42 43 44 45 46 47 48 49 50 51

52 53 54 55 56 57 58 59 60 61 62 63 64 65 66 67 68 69 70 71 72 73

CARTOON EYEGLASSES

Eyeglasses are shown here because they invariably rest on the nose. Following are a few styles:

1 2 3 4 5 6 7 8 9 10 11 12 13 14 15 16 17

18 19 20 21 22 23 24 25 26 27 28 29 30 31 32

3

CARTOON EYES

From the eyes thoughts behind expressions emerge — even in cartoon.

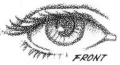

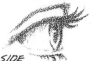

FRONT SIDE

After establishing the nose on the face, some cartoonists prefer to put in the eyes next, others the mouth. At the upper right the real life eye is pictured from which something about every cartoon eye must come — if only the center pupil. A good cartoon eye does not necessarily depend on intricacy. Some of the best cartoons ever drawn are amazingly simple. However, to always insist on the simplest is to ever confine oneself to it, and ingenious experimentation may be sadly curtailed. A head and face may be quite involved, yet the eye may be one of the first few dots at the beginning of the list below. Combinations of these parts, or lines about the eyes, or brows above, or placement on the head — effects unlimited!

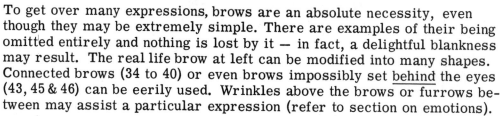

Though any eye may be male or female in cartoon, eyes from 112 to 135 might be considered 'more female' than the preceding ones.

(see addendum to eyes bottom of page 6)

CARTOON BROWS

To get over many expressions, brows are an absolute necessity, even though they may be extremely simple. There are examples of their being omitted entirely and nothing is lost by it — in fact, a delightful blankness may result. The real life brow at left can be modified into many shapes. Connected brows (34 to 40) or even brows impossibly set behind the eyes (43, 45 & 46) can be eerily used. Wrinkles above the brows or furrows between may assist a particular expression (refer to section on emotions).

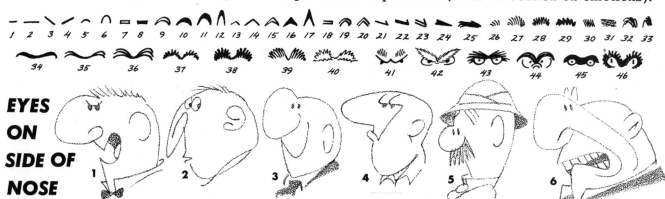

EYES ON SIDE OF NOSE

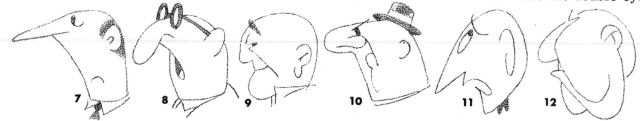

A word should be included about both eyes being drawn on this side of the nose (see heads 1 to 6). This is a comparatively recent innovation in cartooning. It can be very funny. Relatively simple eyes must be used in this manner. Such eye placement usually is teamed with a large nose coming off the top of the head (though not always — see 5). Profiles 7 to 12 could take the double eye.

CARTOON MOUTHS

FRONT SIDE

In the section on emotions the smile and the laugh are dealt with specifically as are other basic mouth patterns. However, for purposes of general comparison and study, the following mouth possibilities are given below. In cartoon the mouth can 'bring on' an expression quicker than any other feature. A score of heads may have only dots for eyes, but each may possess a different expression — the mouth does the trick. It is a good exercise to draw a half-dozen ovals with only dots for eyes; then insert a variety of mouths and watch what happens. True, a 'lift' or a 'frown' line over the dot eyes adds a great deal. The mouth is more independent. It should be mentioned that some cartoonists omit the mouth on occasion. This can assist in conveying a certain 'blank look.' Likewise, the dot mouth (No. 1 below) or the flat dashes (2 to 5) can help in this coveted blankness, a prime look which causes us to chuckle — but leave the eyes wide open; don't draw down the brows (for the blank look, that is).

The first shadowed lip is No. 39. Any may be shadowed. Mouths 43, 44 & 155, or variations thereof, go with the 'unhinged' character who is beside himself. Remember, a full front view mouth can go under a nose in a profile face. Also, a side view mouth can go under a nose in a full front view face (this is sometimes helped by a line from the nose corner to a mouth corner). One may wish to cut some front view mouths in two for a profile. Keep in mind that the following mouths can be changed in size and given twists that are deemed necessary to promote the desired expression. Tongues and teeth in the mouth with lips apart are not stressed here; sometimes they are drawn (see page on the laugh), but many cartoonists never show them (observe wide-open mouths 138 to 156 below). Mouths 106 to 137 are 'female' mouths, though in 'crazy' cartooning any mouth may do for a woman.

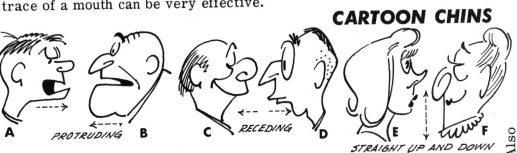

THE 'CONDENSED' MOUTH

Mention should be made of the 'minimal' mouth in profile. It can barely show in the several ways at the right, yet this mere trace of a mouth can be very effective.

CARTOON CHINS

A

PROTRUDING B

C

RECEDING D

E

F

STRAIGHT UP AND DOWN

Also try less severe modifications

Chins can go out (A&B), in (C&D) or centered (E&F).
They may be:

L = Squared,
C = Rounded,
∠ = Pointed,
 = Flat with the neck
ϟ =Multiplied

CARTOON MUSTACHES AND BEARDS

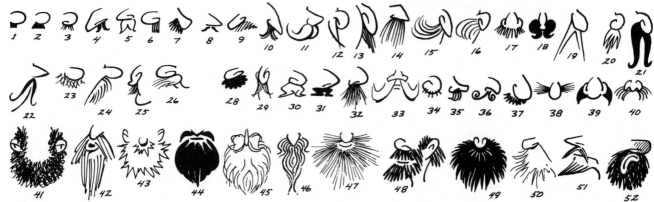

In connection with the mouth and chin, a few drawings and remarks should be made on mustaches and whiskers. Solid blacks (Nos. 1, 2, etc.), patches of white (5, 11, etc.) or line groups (3, 6, etc.) serve well under the nose. Whiskers, like mustaches, may have a closed outline (43) or open edging (42, 47, 50, etc.). In any event, both should look like hair whether clumped (18, 21, 28, 33, 44, etc.), bristled (17, 23, 34, 47, 48, etc.), arranged in strands (19, 22, 29, etc.) or tangled (41 & 52). One should be able to look at a mustache and draw a beard in keeping with it, but be careful of type; is it for an aristocrat or a tramp?

CARTOON EARS

SIDE VIEW → C C ((C < (((E E (0 6 (@ C E ((c 0 (C @ € 6
1 2 3 4 5 6 7 8 9 10 11 12 13 14 15 16 17 18 19 20 21 22 23 24 25 26 27

€ € € € c c c C C G B G G T ((((E (A G (((0 Q € € € € € €
28 29 30 31 32 33 34 35 36 37 38 39 40 41 42 43 44 45 46 47 48 49 50 51 52 53 54 55 56 57 58

C (((((6 F (((f (((((((C E ((C 6 C FRONT VIEW → ((€ (((
59 60 61 62 63 64 65 66 67 68 69 70 71 72 73 74 75 76 77 78 79 80 81 82 83 84 85 86 87 88 89

((((((8 8 8 ((((C BACK VIEW → C G ((C ((((C C ((
90 91 92 93 94 95 96 97 98 99 100 101 102 103 104 105 106 107 108 109 110 111 112 113 114 115 116 117

介 介 K K K
118 119 120 121 122

Ears have nothing to do with expression as such, but certain types of ears may occasionally give a touch of character one way or the other. To conserve space the above examples are all very nearly the same size. Any ear shown here may be enlarged or reduced as it is intended to appear on the head. Some cartoonists use the same kind of ear on all their characters. The most often used is the open, no-interior-construction kind, 1 through 9. Nos. 10 & 11 are good simple ears. Aristocrats and old people may have long ears, loud mouths may have flamboyant ears, thugs and wrestlers may have cauliflower ears (53 to 58) -- yet, there is no rule; big ears may be on little people and little ears may be on big people.

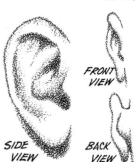

FRONT VIEW

SIDE VIEW

BACK VIEW

ADDITIONAL NOTE ON EYES

A B WRONG C RIGHT

A short addendum to eyes may prove helpful in regard to pinpoint focusing. The real-life gaze in A at left points toward spoon. In B it does not, but in C, because ovals are tilted like the eyeballs of A, the gaze is toward spoon. Further, gaze may be directed by (D) spots at edge of eye frame, (E) spots just outside of broken frame or (F) frames tilted with edges of spots showing.

D E F

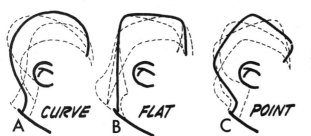

CARTOON HEAD SHAPES
AND HAIR — MALE

Every cartoon head shape has to have segments of the basic contours (A, B, C) at the left. They may be modified to be sure — they may be convex or concave in places, and they may be in combination. Before any hair is added consider the possibilities. The student should sketch several dozen head shapes of his own. Investigate published cartoons with an awareness as to head shape, side, front and back. D, E & F will call for a degree of symmetry for both sides.

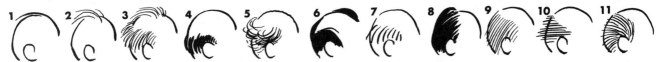

Now begin to add hair. All these suggested 'hair styles' are placed on nearly the same head shape, for the concentration here is on the hair and not on the head.

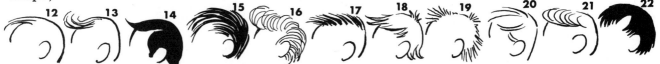

Whereas figs. 1 to 11 have the hair growing <u>away</u> from the forehead, 12 to 22 have it growing <u>toward</u> the forehead (the other side of the head being considered). For every example on this page there are scores of variations. Don't try copying hair for hair.

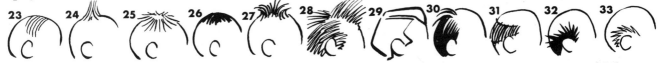

Hair 23 to 27 is at center top. Hair 32 to 35 occurs around the ears. All hair may be thicker or thinner, darker or lighter. In 33 the tuft is connected; in 35 it is open. (See 18 connected; 19 open)

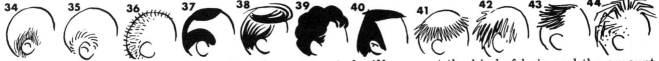

Often the type personality desired or the age wanted will suggest the kind of hair and the amount.

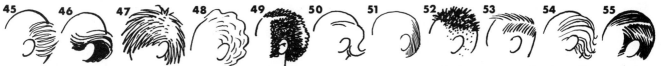

The coarseness of the pen point or the pressure of the brush will determine the 'quality' of the hair. Ears are of no concern in this series — for pointers, see special section on ears.

It is not necessary to show as many front view heads of hair. After the student has studied and drawn both in practice, he will be able to convert any side view to a straight-on or vice-versa.

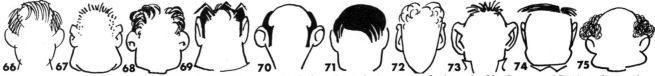

To have a good base for the hair always lightly sketch in pencil the skull shape. Notice how the hair appears to grow <u>around</u> and <u>in back of</u> the skull in some cases (see figs. 66, 70 & 75).

7

CARTOON HAIR—FEMALE

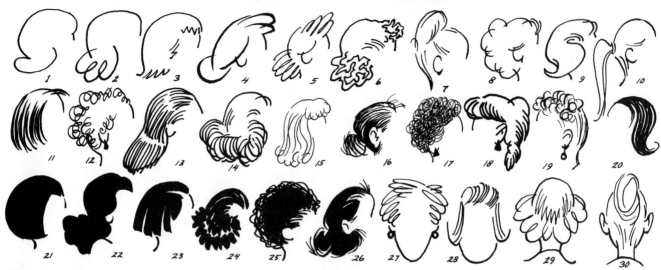

It is not necessary to show as many women's hairdos as men's; for, in a number of cases, the man's hair as shown can become a comic woman's hair by simply spreading it around for more coverage. Some cartooned woman's hair is a mess intentionally. It depends on the type desired. Above are some suggested female coiffures which may be altered to comply with style changes; that is, shortened or lengthened, puffed, frizzed or straightened. Most of the views here are from the same side for comparison. The last four are front and back views; but, as with men's hair, most fronts or semi-fronts can be taken from the side samplings — simply draw less of it as in 27 and 28. As for the back, draw the crown, then spread it clear across or on top with the desired neck width beneath (see 29 and 30).

WOMEN'S CARTOON HATS

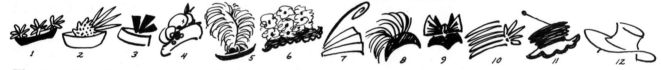

The female hat can take nearly any shape in cartoon. The simplest way is to make some kind of container (see hats 1 to 5), then put something in it or on it: flowers, sponges, bows, fruit, feathers, etc. —or leave it vacant. The cartoon's purpose may dictate the hat's 'sensibility.'

MEN'S CARTOON HATS

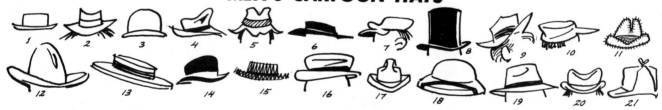

A man's hat or cap in cartoon is often drawn too small or too big purposely. Does the character call for a high fashion or a lowbrow treatment? Let the hat lines 'belong' with the clothes lines — in technique, that is. It's not a bad idea to sketch the hat's 'contact' line around the head, then build the hat's brim on it — unless, of course, the hat is just perched on the very top. Throughout this book there are many comic hats other than the ones pictured here.

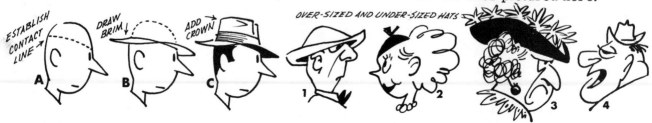

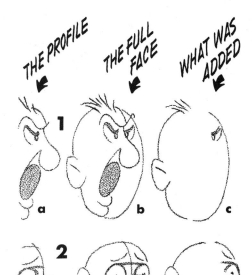

THE PROFILE WITHIN THE FRONT VIEW HEAD

One of the most important discoveries any cartoon student can make is that he can create many unique heads by simply incorporating a profile inside a full face. There are several advantages to this. One is that it opens up new prospects for faces that are totally different. Another is that it makes it easier to repeat the same character in several poses in a strip or advertising sequence. Examine the three columns of drawings at the left. That which is added to the profile is: an opposite cheek and forehead line, the other eye (or partial eye) and brow, and the back of the head. The inside remains the same as in the profile. The same back of the head (c) could be used in a full profile (a) by moving it back slightly and by bringing the ear in a little.

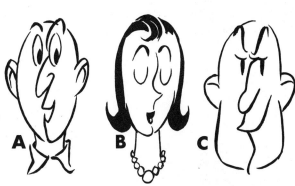

The heads A, B & C (above) may be considered straight front views, and yet observe the profile down the middle.

THE PARTIAL PROFILE IN THE FULL FACE

Down the center of the foreheads in all the 'b' pictures at the left is a line found on the 'a' foreheads. This in 3b is helpful because the fellow is mad. In 1b there is a scowl, so it's all right there. In 2b and 6b it is needless. In many instances a PARTIAL PROFILE such as is found below is better. This information is of <u>great value</u> to the cartoonist and cannot be stressed too much.

1, protruding upper lip. 2, protruding lower jaw. 3, mouth that has both lips protruding. 4, receding mouth. Variations of these are endless!

At right the line from the nose goes on <u>other</u> side of mouth. This is sometimes done and has its place, but lacks the D group's potential.

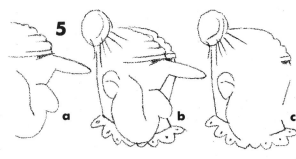

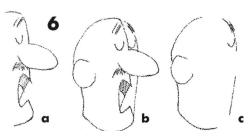

THE EMOTIONS — ANGER

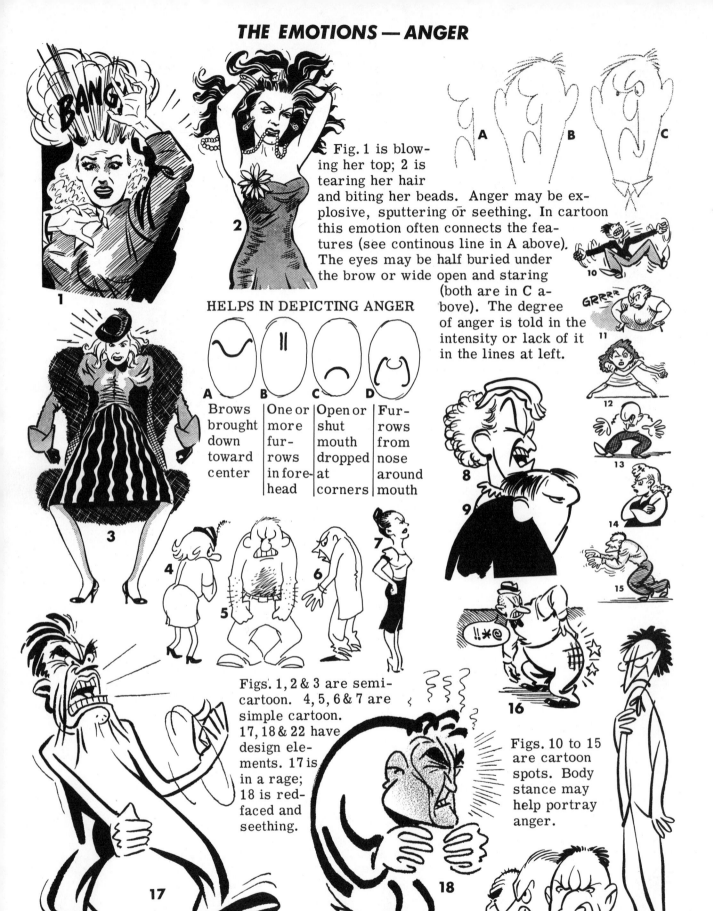

Fig. 1 is blowing her top; 2 is tearing her hair and biting her beads. Anger may be explosive, sputtering or seething. In cartoon this emotion often connects the features (see continous line in A above). The eyes may be half buried under the brow or wide open and staring (both are in C above). The degree of anger is told in the intensity or lack of it in the lines at left.

HELPS IN DEPICTING ANGER

A	B	C	D
Brows brought down toward center	One or more furrows in forehead	Open or shut mouth dropped at corners	Furrows from nose around mouth

Figs. 1, 2 & 3 are semi-cartoon. 4, 5, 6 & 7 are simple cartoon. 17, 18 & 22 have design elements. 17 is in a rage; 18 is red-faced and seething.

Figs. 10 to 15 are cartoon spots. Body stance may help portray anger.

FEER

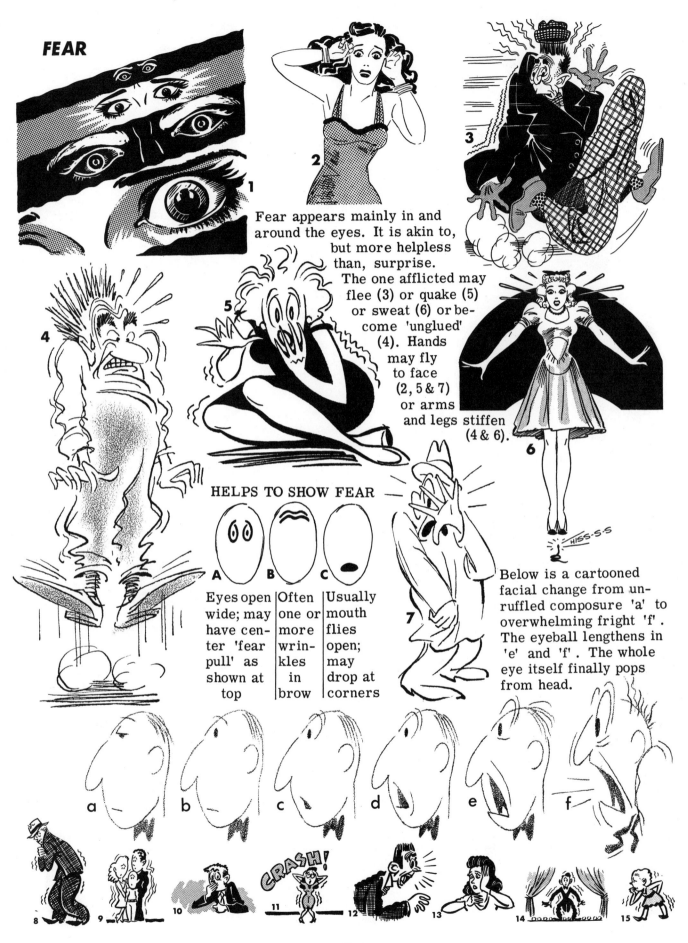

Fear appears mainly in and around the eyes. It is akin to, but more helpless than, surprise.

The one afflicted may flee (3) or quake (5) or sweat (6) or become 'unglued' (4). Hands may fly to face (2, 5 & 7) or arms and legs stiffen (4 & 6).

HELPS TO SHOW FEAR

A	B	C
Eyes open wide; may have center 'fear pull' as shown at top	Often one or more wrinkles in brow	Usually mouth flies open; may drop at corners

Below is a cartooned facial change from unruffled composure 'a' to overwhelming fright 'f'. The eyeball lengthens in 'e' and 'f'. The whole eye itself finally pops from head.

HISS-S-S

CRASH!

11

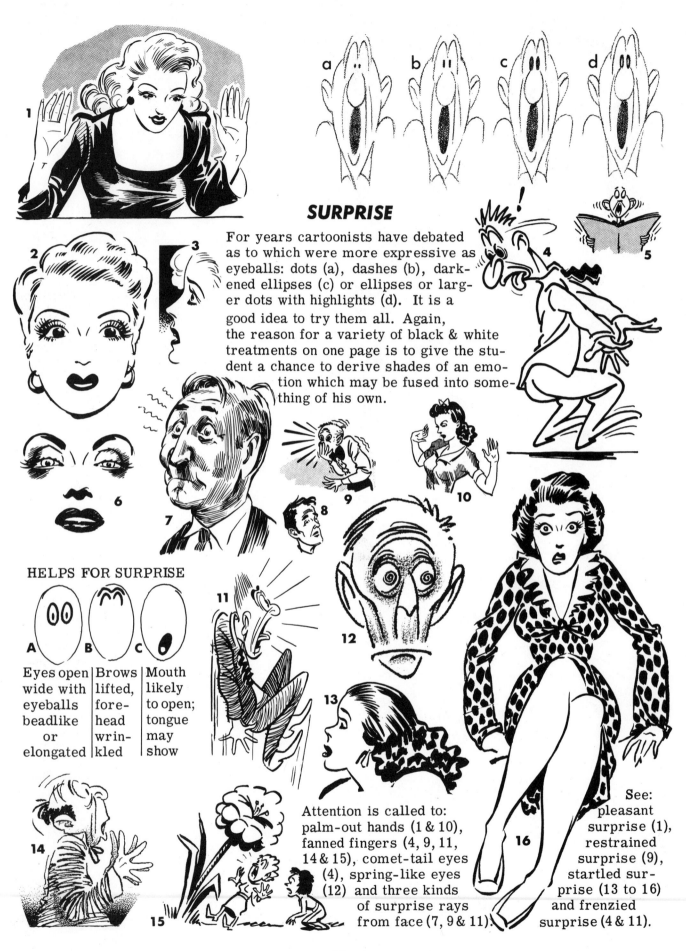

SURPRISE

For years cartoonists have debated as to which were more expressive as eyeballs: dots (a), dashes (b), darkened ellipses (c) or ellipses or larger dots with highlights (d). It is a good idea to try them all. Again, the reason for a variety of black & white treatments on one page is to give the student a chance to derive shades of an emotion which may be fused into something of his own.

HELPS FOR SURPRISE

A	B	C
Eyes open wide with eyeballs beadlike or elongated	Brows lifted, forehead wrinkled	Mouth likely to open; tongue may show

Attention is called to: palm-out hands (1 & 10), fanned fingers (4, 9, 11, 14 & 15), comet-tail eyes (4), spring-like eyes (12) and three kinds of surprise rays from face (7, 9 & 11).

See: pleasant surprise (1), restrained surprise (9), startled surprise (13 to 16) and frenzied surprise (4 & 11).

12

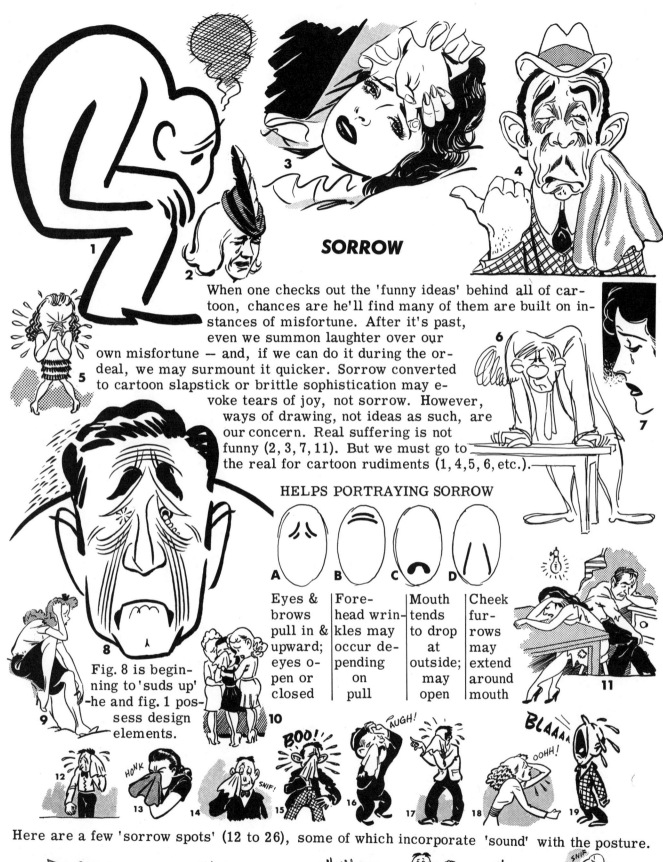

SORROW

When one checks out the 'funny ideas' behind all of cartoon, chances are he'll find many of them are built on instances of misfortune. After it's past, even we summon laughter over our own misfortune — and, if we can do it during the ordeal, we may surmount it quicker. Sorrow converted to cartoon slapstick or brittle sophistication may evoke tears of joy, not sorrow. However, ways of drawing, not ideas as such, are our concern. Real suffering is not funny (2, 3, 7, 11). But we must go to the real for cartoon rudiments (1, 4, 5, 6, etc.).

HELPS PORTRAYING SORROW

A	B	C	D
Eyes & brows pull in & upward; eyes open or closed	Forehead wrinkles may occur depending on pull	Mouth tends to drop at outside; may open	Cheek furrows may extend around mouth

Fig. 8 is beginning to 'suds up' —he and fig. 1 possess design elements.

Here are a few 'sorrow spots' (12 to 26), some of which incorporate 'sound' with the posture.

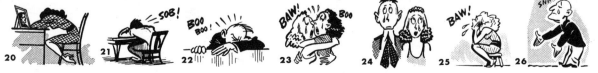

13

YELLING

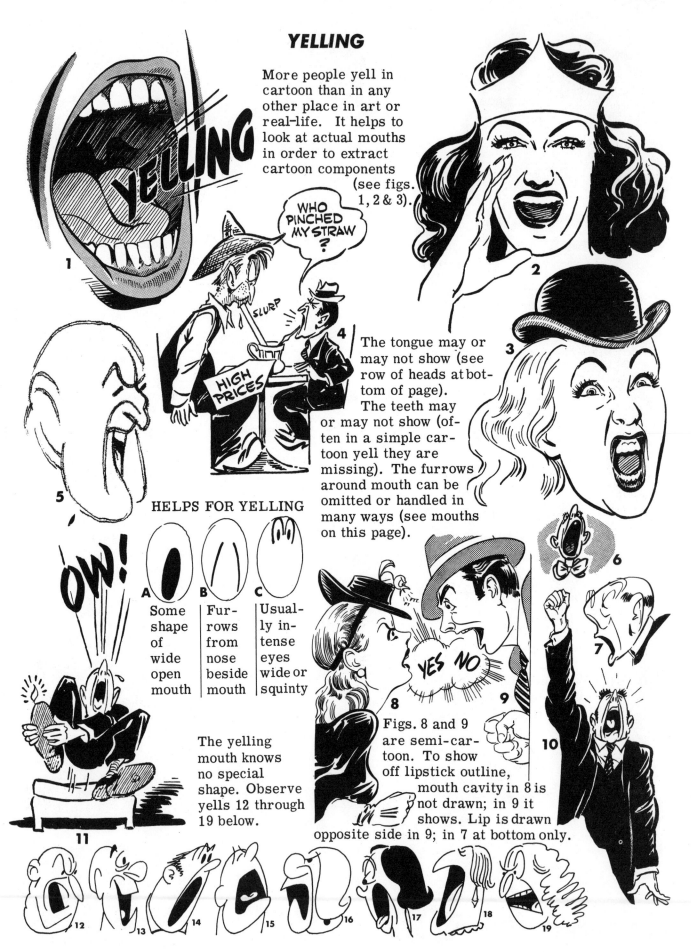

More people yell in cartoon than in any other place in art or real–life. It helps to look at actual mouths in order to extract cartoon components (see figs. 1, 2 & 3).

1

WHO PINCHED MY STRAW ?

SLURP

HIGH PRICES

4

2

5

The tongue may or may not show (see row of heads at bottom of page). The teeth may or may not show (often in a simple cartoon yell they are missing). The furrows around mouth can be omitted or handled in many ways (see mouths on this page).

3

HELPS FOR YELLING

OW!

6

A	B	C
Some shape of wide open mouth	Furrows from nose beside mouth	Usually intense eyes wide or squinty

The yelling mouth knows no special shape. Observe yells 12 through 19 below.

YES NO

8 **9**

7

10

Figs. 8 and 9 are semi-cartoon. To show off lipstick outline, mouth cavity in 8 is not drawn; in 9 it shows. Lip is drawn opposite side in 9; in 7 at bottom only.

11

12 **13** **14** **15** **16** **17** **18** **19**

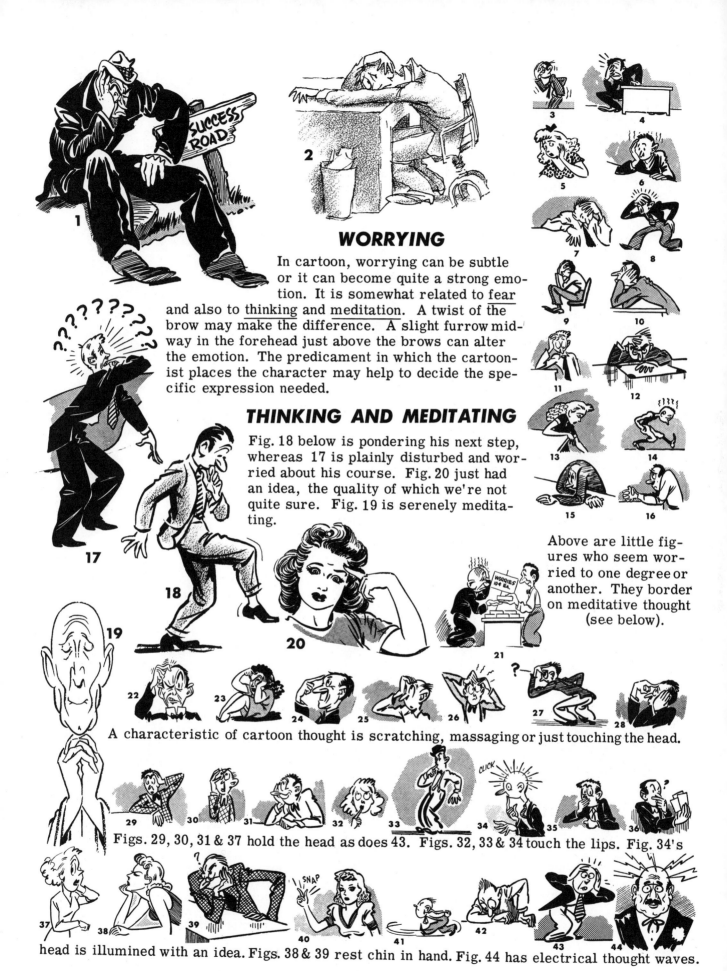

WORRYING

In cartoon, worrying can be subtle or it can become quite a strong emotion. It is somewhat related to fear and also to thinking and meditation. A twist of the brow may make the difference. A slight furrow midway in the forehead just above the brows can alter the emotion. The predicament in which the cartoonist places the character may help to decide the specific expression needed.

THINKING AND MEDITATING

Fig. 18 below is pondering his next step, whereas 17 is plainly disturbed and worried about his course. Fig. 20 just had an idea, the quality of which we're not quite sure. Fig. 19 is serenely meditating.

Above are little figures who seem worried to one degree or another. They border on meditative thought (see below).

A characteristic of cartoon thought is scratching, massaging or just touching the head.

Figs. 29, 30, 31 & 37 hold the head as does 43. Figs. 32, 33 & 34 touch the lips. Fig. 34's

head is illumined with an idea. Figs. 38 & 39 rest chin in hand. Fig. 44 has electrical thought waves.

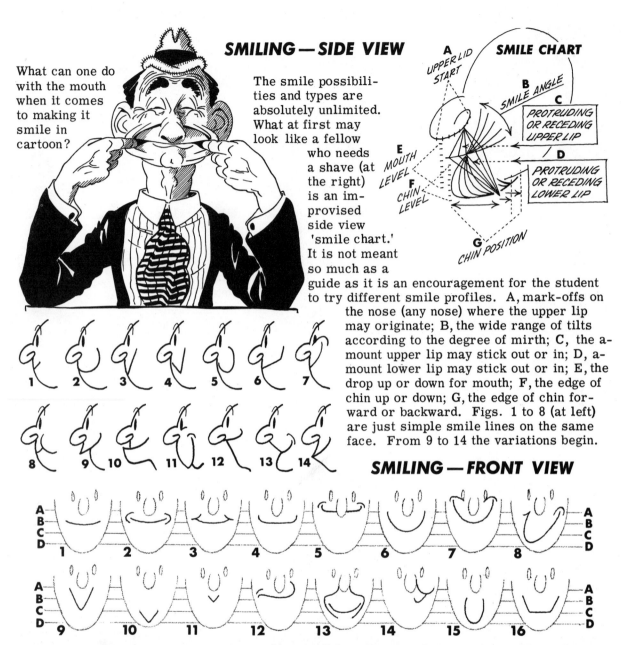

SMILING — SIDE VIEW

What can one do with the mouth when it comes to making it smile in cartoon?

The smile possibilities and types are absolutely unlimited. What at first may look like a fellow who needs a shave (at the right) is an improvised side view 'smile chart.' It is not meant so much as a guide as it is an encouragement for the student to try different smile profiles. A, mark-offs on the nose (any nose) where the upper lip may originate; B, the wide range of tilts according to the degree of mirth; C, the amount upper lip may stick out or in; D, amount lower lip may stick out or in; E, the drop up or down for mouth; F, the edge of chin up or down; G, the edge of chin forward or backward. Figs. 1 to 8 (at left) are just simple smile lines on the same face. From 9 to 14 the variations begin.

SMILE CHART — UPPER LID START — SMILE ANGLE — PROTRUDING OR RECEDING UPPER LIP — PROTRUDING OR RECEDING LOWER LIP — MOUTH LEVEL — CHIN LEVEL — CHIN POSITION

SMILING — FRONT VIEW

This chart stresses two matters: first, the up and down range in locating the mouth on the cartoon face; second, the different kinds of single line smiles (without a shadow below the bottom lip, which can always be expressed with a shorter second line, but which is often omitted in cartoon). No variation is sought with the nose and eyes in this diagram so that concentration may rest upon the mouth. In real life the 'normal' setting is in the B-C area. In cartoon it is frequently there too, but it may vacillate anywhere between A and D. Every time a cartoonist draws a face he must decide on the mouth placement. To cartoon comedy this is important.

Considering the smile shapes: 1, the slight upward bend which may be many widths and placed from A to D. 2, the same smile with parenthesie cheek lines. 3, the same again with cupid or fat cheek lines. 4, a flat smile with corners turned up. 5, the same smile in 'A' position with parentheses (this mouth may be shortened and run from A to D). 6, the big 'half-moon.' 7, the same smile lifted and pushing the cheeks in contact with the eyes or covering the lower part of the eyes. 8, the 'half-moon' twisted. 9, the 'V' smile (very good in cartoon). 10, medium 'V' in D position. 11, small, pinched 'V' in B position. 12, a 'whiplash' or part-smile with one corner turned down. 13, long furrows from nose toward chin. 14, small smile on one side of face. 15, big 'U' rounded to limit — extension would make a complete circle and look like open mouth. 16, flat smile with straight turn-ups (this is good to try out, and, like the others, can be most pleasing). Keep in mind mouth location and smile shape.

16

LAUGHING — TONGUES, TEETH AND PLAIN OPENINGS

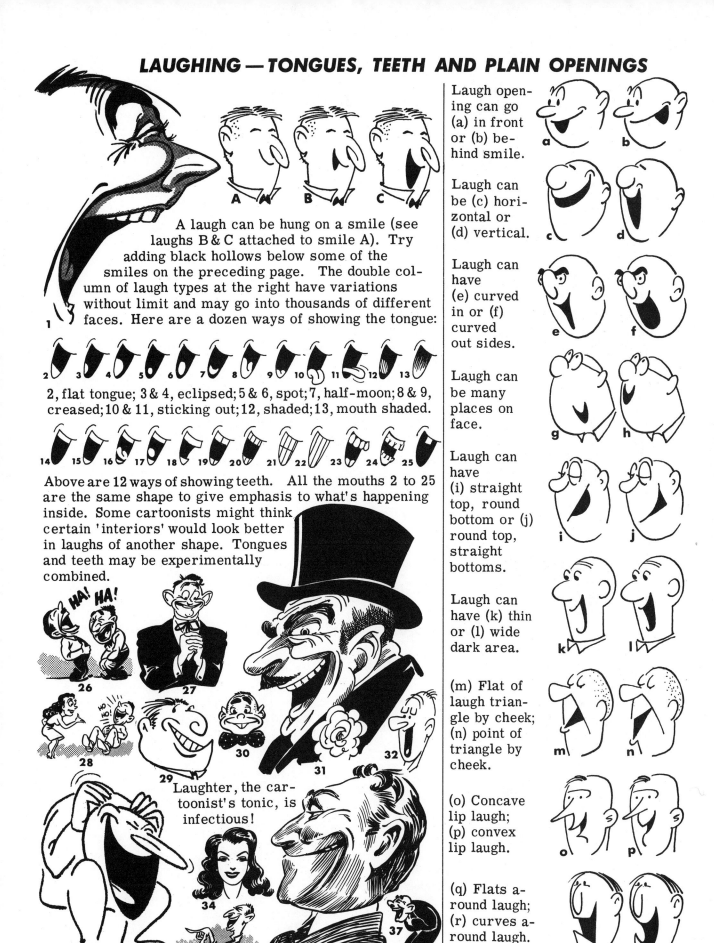

A laugh can be hung on a smile (see laughs B & C attached to smile A). Try adding black hollows below some of the smiles on the preceding page. The double column of laugh types at the right have variations without limit and may go into thousands of different faces. Here are a dozen ways of showing the tongue:

2, flat tongue; 3 & 4, eclipsed; 5 & 6, spot; 7, half-moon; 8 & 9, creased; 10 & 11, sticking out; 12, shaded; 13, mouth shaded.

Above are 12 ways of showing teeth. All the mouths 2 to 25 are the same shape to give emphasis to what's happening inside. Some cartoonists might think certain 'interiors' would look better in laughs of another shape. Tongues and teeth may be experimentally combined.

HA! HA!

HO! HO!

Laughter, the cartoonist's tonic, is infectious!

Laugh opening can go (a) in front or (b) behind smile.

Laugh can be (c) horizontal or (d) vertical.

Laugh can have (e) curved in or (f) curved out sides.

Laugh can be many places on face.

Laugh can have (i) straight top, round bottom or (j) round top, straight bottoms.

Laugh can have (k) thin or (l) wide dark area.

(m) Flat of laugh triangle by cheek; (n) point of triangle by cheek.

(o) Concave lip laugh; (p) convex lip laugh.

(q) Flats around laugh; (r) curves around laugh.

EYELIDS IN CARTOON (WITH ALL EMOTIONS)

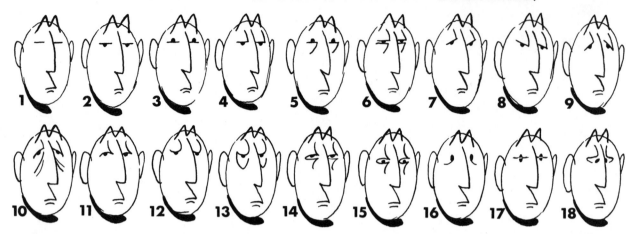

To pretend to present an exhaustive line-up of ways to cartoon eyes would be both foolish and impossible. But here are some of the basics with which it helps to reckon. Sweeping departures from these are many. The above heads are all purposely the same (including the brows which are big factors in cartooning eyes). Too, the eyes here are all in the same location on the head and in relation to the nose. Presently, the main concerns are the eye spots and lids.

Let the student notice what happens to the eye expression when the half-spot is below the line (2) and above the line (3). See the sleepy or unperturbed quality which is introduced when the side of the upper lid is added (4). The lower lid pocket (5) gives the 'bags' below the eye, yet they have alertness (as in 3). In all the eyes where half-spots are used, quarter spots may be tried giving a squint atop the line or a 'sleepier yet' expression below the line. Or even larger eyeballs or simply a dot may enter the experimentation.

Notice the double lid (6), the angled lids (7, 8 & 9), the age lines below (10), the concave lids (11), the convex lids (12) — some of these are 'standard' with certain cartoonists. Observe the hanging eyelid bags (13), the double concave lids (14), the same lids with exposed spots (15), the 'comet tails' (16) — try these tails swinging off the eye spots first one way and then the other. A rather 'knocked out' expression results when the eye spots are split (17), and a crackbrained expression is obtained by turning the lids and eyes inward (18). Now, when these eyes are given a unique setting with special brows, nose, mouth and head contour, one's own brand of hilarity can be created.

EYE LOCATIONS (WITH ALL EMOTIONS)

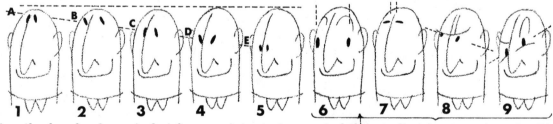

Repeating the heads above is but for one intent: to remind the student to experiment with different eye locations in relation to the nose and head shape. The dotted line A to E suggests the range up and down. The first five heads below illustrate a few of the hundreds of ways to put this into effect. Heads 6 to 9 point up extremes in separating the eyes and angling them.

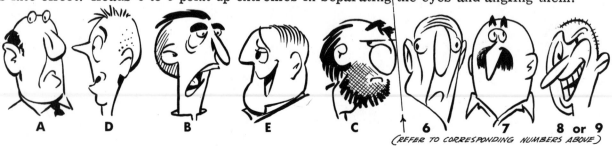

A D B E C 6 7 8 or 9

(REFER TO CORRESPONDING NUMBERS ABOVE)

ALPHABETIZED CATALOG OF EMOTIONS AND EXPRESSIONS
(WITH CROSS REFERENCES)

On these three pages are cartoon versions of most emotions, expressions and facial conditions which are regularly needed by the cartoonist. None of these are to be taken as standards or ideals. If fifty real life people were subjected to the same stimulus, all their faces would not respond the same way. However, there would be a general response pattern caused by their muscles of expression (itemized and diagrammed, pages 22 & 23).

In this listing, single, descriptive words were chosen which come first to mind. Should a facial condition be sought which is not in the listing, very likely a common synonym will be. The cross reference numbers go with the faces (not necessarily the words) which are related in some way. Thus it is possible to check out several comic faces which may assist in one's arriving at the exact expression wanted for a particular situation.

The chief purpose of this catalog is not to offer copying material as such, but simply to suggest facial twists and variations which may be incorporated in one's own cartoon characters so they might become more expressive. Some of these countenances may be too lined; others may be too plain. Some may be

too fat, others too thin. Some may be too old, others too young (in this connection refer to sections on age). To the hundreds of facial features on pages 3 to 8, these expression fundamentals may be applied so that completely new characters never before drawn may be developed. Female hair (p. 8) will transform these men to slapstick women.

If the party is to be saying something in either gag line or balloon talk, imagine that you 'hear'

him rehearse it. Does the talk 'fit' with the face? Is it funny? If not, check out the cross references for other possible variations. Most of these faces are 'extremes.' Seek to control the intensity of feeling by adjusting facial lines in the experimental penciling. Try reducing the number of lines if the overall cartoon treatment is simple. A wrong expression can kill an entire cartoon. The importance of the right expression cannot be overemphasized.

1
AGGRESSIVE
(5, 19, 33, 35, 54, 68, 71, 79, 89, 96, 102, 103, 108, 116, 122)

2
ALOOF
(23, 59, 69, 74, 99, 110)

3
AMAZED
(9, 10, 52, 61, 95, 114, 127)

4
AMUSED
(22, 24, 27, 49, 51, 76, 80, 82, 94, 106, 123, 149)

5
ANGRY
(1, 13, 26, 33, 35, 38, 41, 54, 58, 67, 71, 79, 81, 96, 103, 107, 108, 116, 122)

6
ANTICIPATION
(30, 49, 51, 75, 91, 106, 123, 129, 133, 140, 150)

7
ANXIETY
(10, 25, 30, 36, 42, 52, 61, 72, 88, 115, 127)

8
APATHY
(2, 23, 59, 65, 69, 74, 99, 120, 146)

9
ASTONISHMENT
(3, 10, 25, 30, 52, 61, 72, 126, 127)

10
AWE
(3, 9, 30, 42, 52, 61, 126, 127)

11
BAD
(20, 40, 44, 54, 58, 81, 96, 103, 104, 107, 108, 122, 137, 139, 140)

12
BITING
(5, 15, 103, 133, 140)

13
BITTERNESS
(1, 5, 26, 38, 40, 43, 44, 81, 89, 96, 103, 104, 107, 108, 122, 128, 139)

14
BLINKING
(21, 29, 37, 90, 100, 109, 120, 124, 135, 136, 146)

15
BLUBBERING
(25, 29, 63, 66, 124, 129)

16
BLOWING
(20, 33, 54, 77, 109, 121, 132, 142, 148)

17
BOISTEROUS
(51, 75, 78, 91, 118, 133, 150)

18
BRAVE
(24, 57, 89, 113, 137)

19
BRAZEN
(13, 17, 33, 35, 40, 54, 58, 68, 71, 73, 79, 96, 101, 102, 103, 108, 116, 122, 139)

20
BULLISH
(5, 13, 35, 38, 58, 96, 104, 107, 108, 122, 137)

21
CHOKING
(33, 50, 53, 96, 109, 126, 130, 132, 136, 148)

22
CHUCKLE
(51, 55, 56, 75, 78, 103, 123, 150)

23
CONCEIT
(2, 13, 26, 31, 59, 69, 74, 89, 103, 110, 122)

24
CONFIDENCE
(4, 18, 27, 49, 57, 76, 102, 110, 113, 131, 145)

25
CONSTERNATION
(3, 7, 9, 30, 36, 52, 61, 72, 88, 115, 126, 127)

26
CONTEMPT
(2, 23, 31, 41, 42, 43, 44, 47, 59, 69, 74, 79, 89, 103, 104, 107, 108, 122)

27
COY
(4, 22, 24, 55, 60, 80, 82, 85, 94, 123, 147)

28
CRAZY
(25, 39, 46, 51, 64, 66, 88, 91, 115, 129, 130, 132, 133, 136, 140, 149, 150)

29
CRYING
(14, 15, 37, 39, 42, 45, 48, 83, 87, 92, 100, 105, 111, 117, 121, 124, 136, 143)

30
CURIOUS
(6, 43, 47, 51, 60, 63, 82, 84, 86, 95, 98, 127, 128, 133, 150)

31
CYNICISM
(2, 13, 19, 23, 26, 40, 41, 43, 44, 47, 67, 69, 74, 84, 102, 103, 104)

32
DEFEAT
(7, 36, 37, 39, 42, 45, 48, 61, 87, 90, 100, 105, 111, 117, 124, 135, 141, 143)

33
DEFIANCE
(1, 5, 26, 35, 38, 44, 54, 58, 71, 96, 103, 104, 107, 108, 110, 116, 122, 139, 148)

34
DEJECTION
(7, 29, 32, 36, 37, 39, 42, 45, 61, 83, 87, 100, 111, 124, 141, 143)

35
DEMANDING
(1, 5, 33, 38, 54, 58, 68, 71, 89, 96, 103, 116, 122)

36
DEPRESSION
(7, 32, 37, 39, 42, 45, 48, 61, 83, 87, 100, 105, 111, 117, 120, 124, 135, 141, 143)

37
DESPAIR
(29, 32, 34, 45, 61, 100, 111, 117, 124, 136, 141, 143)

38
DESPERATION
(25, 29, 42, 50, 90, 111, 112, 124, 135, 136)

39
DESPONDENCY
(7, 32, 34, 36, 42, 45, 48, 62, 83, 87, 100, 111, 117, 135, 141, 143)

40
DEVILISH
(11, 20, 54, 58, 103, 104, 107, 108, 139, 140)

41
DISAPPROVAL
(2, 13, 23, 26, 33, 43, 44, 54, 59, 71, 79, 96, 104, 107, 108, 116, 122)

42
DISCOURAGEMENT
(7, 32, 34, 36, 37, 39, 45, 48, 61, 87, 90, 100, 105, 111, 117, 124, 135, 141, 143)

43
DISDAIN
(2, 23, 26, 41, 59, 69, 79, 108)

44
DISGUST
(13, 23, 26, 35, 41, 43, 47, 67, 73, 79, 96, 104, 107, 108, 122)

45
DISMAY
(32, 36, 39, 42, 48, 61, 83, 87, 100, 111, 117, 135, 141, 143)

46
DIZZINESS
(25, 87, 88, 90, 115, 117, 120, 135, 138, 149)

47
DOUBT
(2, 23, 26, 31, 43, 67, 74, 84, 95, 98, 119, 128)

48
DOWNCAST
(7, 32, 34, 36, 37, 39, 42, 45, 61, 83, 87, 92, 100, 111, 124, 135, 141, 143)

49
EAGERNESS
(6, 51, 63, 66, 75, 91, 106, 129, 133, 150)

50
EXHAUSTION
(21, 52, 87, 90, 109, 112, 117, 132, 135, 136, 138, 143)

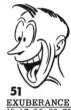
51
EXUBERANCE
(6, 17, 56, 66, 75, 78, 91, 106, 123, 133, 149, 150)

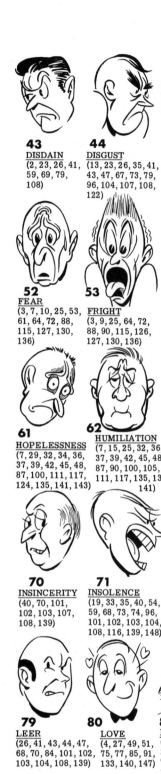
52
FEAR
(3, 7, 10, 25, 53, 61, 64, 72, 88, 115, 127, 130, 136)

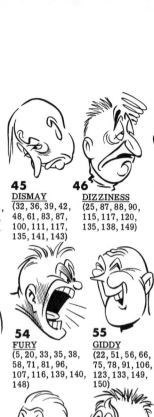
53
FRIGHT
(3, 9, 25, 64, 72, 88, 90, 115, 126, 127, 130, 136)

54
FURY
(5, 20, 33, 35, 38, 58, 71, 81, 96, 107, 116, 139, 140, 148)

55
GIDDY
(22, 51, 56, 66, 75, 78, 91, 106, 123, 133, 149, 150)

56
GLEE
(6, 17, 22, 28, 51, 75, 78, 91, 106, 123, 133, 149, 150)

57
GOOD
(possible assoc. with: 18, 24, 49, 76, 131, 145)

58
HATE
(1, 5, 11, 13, 20, 26, 33, 35, 38, 40, 41, 44, 54, 68, 71, 79, 81, 96, 103, 104, 107, 108, 116, 122, 139, 148)

59
HAUGHTINESS
(2, 23, 26, 35, 41, 68, 69, 73, 74, 102, 103, 110, 122)

60
LISTENING
(30, 47, 82, 84, 93, 95, 98, 99, 114, 119, 127, 128, 134, 147)

61
HOPELESSNESS
(7, 29, 32, 34, 36, 37, 39, 42, 45, 48, 87, 100, 111, 117, 124, 135, 141, 143)

62
HUMILIATION
(7, 15, 25, 32, 36, 37, 39, 42, 45, 48, 87, 90, 100, 105, 111, 117, 135, 136, 141)

63
HUNGER
(6, 10, 15, 30, 36, 51, 66, 86, 91, 129, 133, 150)

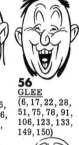
64
HYSTERICAL
(25, 46, 51, 53, 88, 90, 115, 126, 130, 136, 149)

65
ICY
(2, 13, 23, 43, 59, 69, 74)

66
IDIOCY
(6, 28, 46, 51, 91, 115, 123, 136, 149, 150)

67
IMPATIENCE
(1, 35, 41, 44, 79, 84, 108, 116, 122, 139)

68
IMPUDENCE
(19, 26, 35, 44, 54, 59, 101, 102, 103, 104, 108, 122)

69
INDIFFERENCE
(2, 23, 59, 74, 99, 110, 120, 146)

70
INSINCERITY
(40, 70, 101, 102, 103, 107, 108, 139)

71
INSOLENCE
(19, 33, 35, 40, 54, 59, 68, 73, 74, 96, 101, 102, 103, 104, 108, 116, 139, 148)

72
INSULTED
(61, 87, 90, 92, 105, 115, 117, 126, 135, 136, 141)

73
INSULTING
(1, 13, 19, 26, 33, 35, 40, 54, 59, 68, 71, 96, 101, 102, 103, 107, 108, 139)

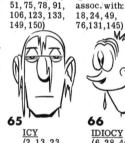
74
JEALOUSY
(2, 13, 23, 26, 41, 43, 59, 101, 103, 104, 108)

75
JOY
(4, 17, 22, 51, 55, 56, 78, 80, 91, 106, 123, 133, 142, 149, 150)

76
KINDNESS
(18, 49, 57, 80, 94, 113, 145)

77
KISSING
(possible assoc. with: 51, 80, 91, 133, 142, love & joy)

78
LAUGHTER
(17, 22, 28, 40, 51, 55, 56, 75, 91, 101, 103, 123, 133, 150)

79
LEER
(26, 41, 43, 44, 47, 68, 70, 84, 101, 102, 103, 104, 108, 139)

80
LOVE
(4, 27, 49, 51, 75, 77, 85, 91, 133, 140, 147)

81
MAD
(1, 5, 11, 13, 26, 33, 38, 41, 44, 54, 58, 68, 71, 79, 96, 104, 107, 108, 116, 122, 148)

82
MEDITATIVE
(8, 27, 31, 43, 67, 69, 93, 95, 98, 99, 125, 147)

83
MELANCHOLY
(32, 34, 36, 39, 42, 45, 48, 61, 87, 100, 105, 111, 117, 125, 141, 143)

84
MISTRUST
(2, 13, 26, 41, 43, 44, 47, 67, 79, 119, 128)

85
MODESTY
(27, 80, 82, 94, 123, 134, 147)

86
MORON
(6, 28, 51, 55, 91, 115, 117, 123, 136, 149, 150)

87
MORTIFIED
(25, 34, 36, 37, 39, 42, 45, 48, 62, 90, 100, 105, 111, 124, 141)

88
NERVOUS
(7, 25, 38, 46, 52, 53, 64, 72, 90, 92, 112, 115, 136)

89
OBSTINATE
(1, 5, 13, 20, 26, 35, 41, 44, 54, 58, 79, 96, 103, 107, 108, 116, 122, 137)

90
PAIN
(7, 21, 29, 32, 34, 37, 39, 42, 45, 48, 50, 62, 83, 87, 111, 117, 124, 135, 148)

91
PASSIONATE
(6, 40, 49, 51, 63, 75, 77, 80, 86, 103, 133, 140, 149, 150)

92
PERPLEXED
(7, 25, 42, 47, 61, 72, 100, 115, 125, 127, 141)

93
PONDERING
(23, 31, 41, 42, 43, 47, 67, 82, 84, 95, 97, 98, 99, 119, 125, 131, 145)

94
QUAINT
(possible assoc. with: 27, 85, 125, 134, 142, 144)

95
QUESTIONING
(2, 23, 26, 43, 47, 67, 79, 82, 84, 98, 99, 119, 127, 128, 134)

96
RAGE
(1, 5, 12, 20, 33, 35, 38, 54, 58, 71, 81, 103, 109, 116, 148)

20

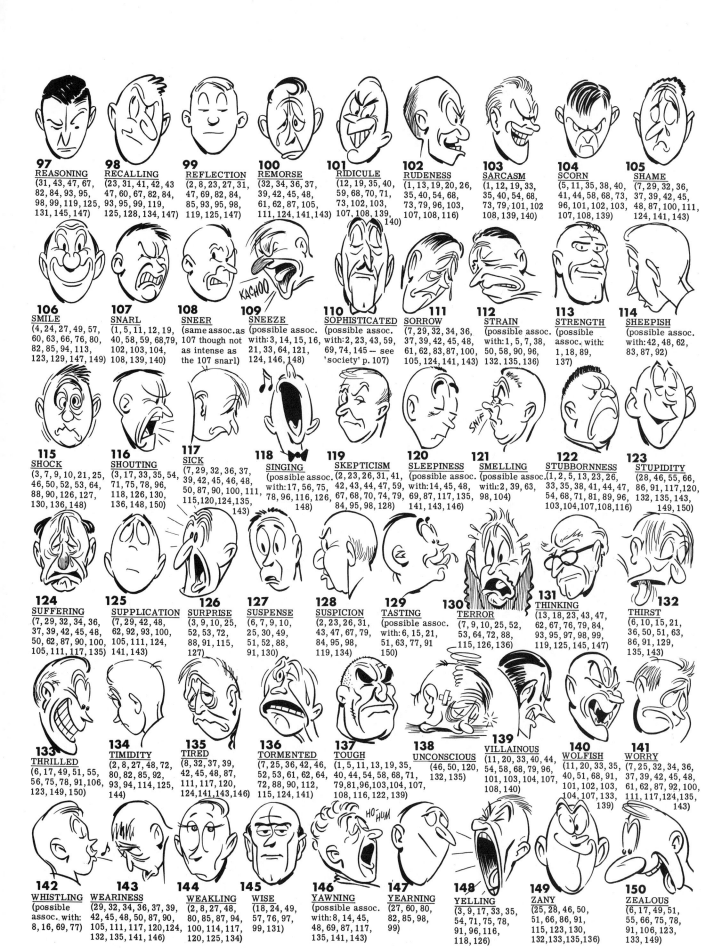

97 REASONING
(31, 43, 47, 67, 82, 84, 93, 95, 98, 99, 119, 125, 131, 145, 147)

98 RECALLING
(23, 31, 41, 42, 43, 47, 60, 67, 82, 84, 93, 95, 99, 119, 125, 128, 134, 147)

99 REFLECTION
(23, 31, 47, 69, 82, 84, 85, 93, 95, 98, 119, 125, 147)

100 REMORSE
(32, 34, 36, 37, 39, 42, 45, 48, 61, 62, 87, 105, 111, 124, 141, 143)

101 RIDICULE
(12, 19, 35, 40, 59, 68, 70, 71, 73, 102, 103, 107, 108, 139, 140)

102 RUDENESS
(1, 12, 19, 20, 26, 35, 40, 54, 68, 73, 79, 96, 103, 107, 108, 116)

103 SARCASM
(1, 12, 19, 33, 35, 40, 54, 68, 73, 79, 101, 102, 108, 139, 140)

104 SCORN
(5, 11, 35, 38, 40, 41, 44, 58, 68, 73, 96, 101, 102, 103, 107, 108, 139)

105 SHAME
(7, 29, 32, 36, 37, 39, 42, 45, 48, 87, 100, 111, 124, 141, 143)

106 SMILE
(4, 24, 27, 49, 57, 60, 63, 66, 76, 80, 82, 85, 94, 113, 123, 129, 147, 149)

107 SNARL
(1, 5, 11, 12, 19, 40, 58, 59, 68, 79, 102, 103, 104, 108, 139, 140)

108 SNEER
(same assoc. as 107 though not as intense as the 107 snarl)

109 SNEEZE
(possible assoc. with: 3, 14, 15, 16, 21, 33, 64, 121, 124, 146, 148)

110 SOPHISTICATED
(possible assoc. with: 2, 23, 43, 59, 69, 74, 145 -- see 'society' p. 107)

111 SORROW
(7, 29, 32, 34, 36, 37, 39, 42, 45, 48, 61, 62, 83, 87, 100, 105, 124, 141, 143)

112 STRAIN
(possible assoc. with: 1, 5, 7, 38, 50, 58, 90, 96, 132, 135, 136)

113 STRENGTH
(possible assoc. with: 1, 18, 89, 137)

114 SHEEPISH
(possible assoc. with: 42, 48, 62, 83, 87, 92)

115 SHOCK
(3, 7, 9, 10, 21, 25, 46, 50, 52, 53, 64, 88, 90, 126, 127, 130, 136, 148)

116 SHOUTING
(3, 17, 33, 35, 54, 71, 75, 78, 96, 118, 126, 130, 136, 148, 150)

117 SICK
(7, 29, 32, 36, 37, 39, 42, 45, 46, 48, 50, 87, 90, 100, 111, 115, 120, 124, 135, 143)

118 SINGING
(possible assoc. with: 17, 56, 75, 78, 96, 116, 126, 148)

119 SKEPTICISM
(2, 23, 26, 31, 41, 42, 43, 44, 47, 59, 67, 68, 70, 74, 79, 84, 95, 98, 128)

120 SLEEPINESS
(possible assoc. with: 14, 45, 48, 69, 87, 117, 135, 141, 143, 146)

121 SMELLING
(possible assoc. with: 2, 39, 63, 98, 104)

122 STUBBORNNESS
(1, 2, 5, 13, 23, 26, 33, 35, 38, 41, 44, 47, 54, 68, 71, 81, 89, 96, 103, 104, 107, 108, 116)

123 STUPIDITY
(28, 46, 55, 66, 86, 91, 117, 120, 132, 135, 143, 149, 150)

124 SUFFERING
(7, 29, 32, 34, 36, 37, 39, 42, 45, 48, 50, 62, 87, 90, 100, 105, 111, 117, 135)

125 SUPPLICATION
(7, 29, 42, 48, 62, 92, 93, 100, 105, 111, 124, 141, 143)

126 SURPRISE
(3, 9, 10, 25, 52, 53, 72, 88, 91, 115, 127)

127 SUSPENSE
(6, 7, 9, 10, 25, 30, 49, 51, 52, 88, 91, 130)

128 SUSPICION
(2, 23, 26, 31, 43, 47, 67, 79, 84, 95, 98, 119, 134)

129 TASTING
(possible assoc. with: 6, 15, 21, 51, 63, 77, 91, 150)

130 TERROR
(7, 9, 10, 25, 52, 53, 64, 72, 88, 115, 126, 136)

131 THINKING
(13, 18, 23, 43, 47, 62, 67, 76, 79, 84, 93, 95, 97, 98, 99, 119, 125, 145, 147)

132 THIRST
(6, 10, 15, 21, 36, 50, 51, 63, 86, 91, 129, 135, 143)

133 THRILLED
(6, 17, 49, 51, 55, 56, 75, 78, 91, 106, 123, 149, 150)

134 TIMIDITY
(2, 8, 27, 48, 72, 80, 82, 85, 92, 93, 94, 114, 125, 144)

135 TIRED
(8, 32, 37, 39, 42, 45, 48, 87, 111, 117, 120, 124, 141, 143, 146)

136 TORMENTED
(7, 25, 36, 42, 46, 52, 53, 61, 62, 64, 72, 88, 90, 112, 115, 124, 141)

137 TOUGH
(1, 5, 11, 13, 19, 35, 40, 44, 54, 58, 68, 71, 79, 81, 96, 103, 104, 107, 108, 116, 122, 139)

138 UNCONSCIOUS
(46, 50, 120, 132, 135)

139 VILLAINOUS
(11, 20, 33, 40, 44, 54, 58, 68, 79, 96, 101, 103, 104, 107, 108, 140)

140 WOLFISH
(11, 20, 33, 35, 40, 51, 68, 91, 101, 102, 103, 104, 107, 139)

141 WORRY
(7, 25, 32, 34, 36, 37, 39, 42, 45, 48, 61, 62, 87, 92, 100, 111, 117, 124, 135, 143)

142 WHISTLING
(possible assoc. with: 8, 16, 69, 77)

143 WEARINESS
(29, 32, 34, 36, 37, 39, 42, 45, 48, 50, 87, 90, 105, 111, 117, 120, 124, 132, 135, 141, 146)

144 WEAKLING
(2, 8, 27, 48, 80, 85, 87, 94, 100, 114, 117, 120, 125, 134)

145 WISE
(18, 24, 49, 57, 76, 97, 99, 131)

146 YAWNING
(possible assoc. with: 8, 14, 45, 48, 69, 87, 117, 135, 141, 143)

147 YEARNING
(27, 60, 80, 82, 85, 98, 99)

148 YELLING
(3, 9, 17, 33, 35, 54, 71, 75, 78, 91, 96, 116, 118, 126)

149 ZANY
(25, 28, 46, 50, 51, 66, 86, 91, 115, 123, 130, 132, 133, 135, 136)

150 ZEALOUS
(6, 17, 49, 51, 55, 66, 75, 78, 91, 106, 123, 133, 149)

21

MUSCLES OF EXPRESSION

Certainly it is not necessary for the cartoonist to learn all the facial muscles. For the sake of completeness all are given here. It is helpful to learn the several major ones for each of the six basic emotional expressions — the seventh is the non-bilateral miscellaneous set. The major muscles are marked three ways: 1. Large asterisk star. 2. Heavy line leading into face. 3. "1st place" in column indicating order of importance. Minor muscles have smaller asterisk and are given 2nd place in order of importance. Incidental muscles are given 3rd place or lower.

Each head is bracketed into upper "a" and lower "b" sections for referral purposes. Actual names of muscles are given in the Master Diagram A & B. For their weight and size, the facial muscles are among the strongest in the body.

They usually are very near or a part of the skin. Many of them originate on bone surfaces and usually merge with a neighboring muscle. Notice the circular sheet muscles "orbiting" the eyes and mouth, which are, afterall, simply slits in the face. There is some similarity in mouth and eye operation. Nearly all the facial muscles of expression run into and fuse with one of these circular muscles.

When we comprehend that some of these facial muscles are more prominent in some people, and in others are completely or partly missing, then we can more fully understand that differences in appearance do not fully depend on the shape of the external features alone. Hence, the millions of unique faces in the world. Dimples and later lines and grooves of habitual facial expression mark the places where these muscles are attached to the skin. The right twist or turn of a facial line or feature can make or break a cartoon. Following are reasons why these "twists and turns" occur:

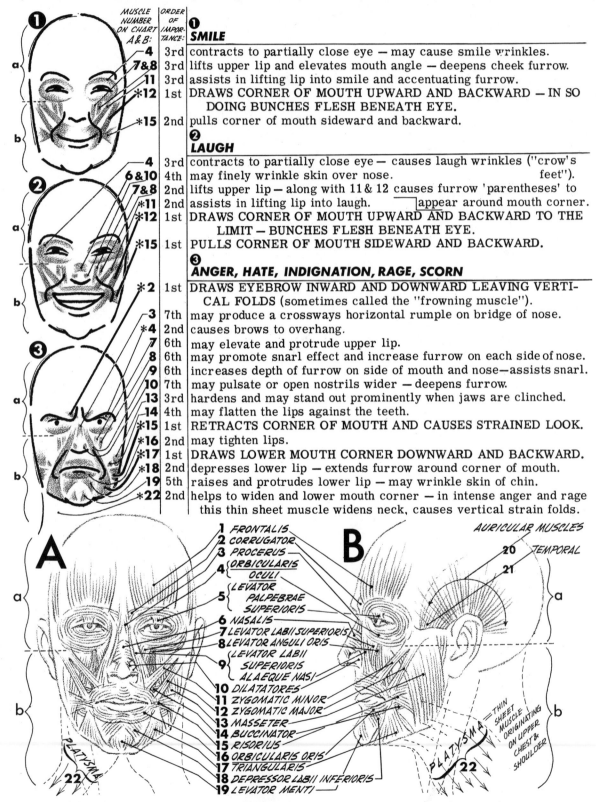

MUSCLE NUMBER ON CHART A & B:	ORDER OF IMPORTANCE:	
		❶ SMILE
4	3rd	contracts to partially close eye — may cause smile wrinkles.
7&8	3rd	lifts upper lip and elevates mouth angle — deepens cheek furrow.
11	3rd	assists in lifting lip into smile and accentuating furrow.
*12	1st	DRAWS CORNER OF MOUTH UPWARD AND BACKWARD — IN SO DOING BUNCHES FLESH BENEATH EYE.
*15	2nd	pulls corner of mouth sideward and backward.
		❷ LAUGH
4	3rd	contracts to partially close eye — causes laugh wrinkles ("crow's feet").
6&10	4th	may finely wrinkle skin over nose.
7&8	2nd	lifts upper lip — along with 11 & 12 causes furrow 'parentheses' to appear around mouth corner.
*11	2nd	assists in lifting lip into laugh.
*12	1st	DRAWS CORNER OF MOUTH UPWARD AND BACKWARD TO THE LIMIT — BUNCHES FLESH BENEATH EYE.
*15	1st	PULLS CORNER OF MOUTH SIDEWARD AND BACKWARD.
		❸ ANGER, HATE, INDIGNATION, RAGE, SCORN
*2	1st	DRAWS EYEBROW INWARD AND DOWNWARD LEAVING VERTICAL FOLDS (sometimes called the "frowning muscle").
3	7th	may produce a crossways horizontal rumple on bridge of nose.
*4	2nd	causes brows to overhang.
7	6th	may elevate and protrude upper lip.
8	6th	may promote snarl effect and increase furrow on each side of nose.
9	6th	increases depth of furrow on side of mouth and nose—assists snarl.
10	7th	may pulsate or open nostrils wider — deepens furrow.
13	3rd	hardens and may stand out prominently when jaws are clinched.
14	4th	may flatten the lips against the teeth.
*15	1st	RETRACTS CORNER OF MOUTH AND CAUSES STRAINED LOOK.
*16	2nd	may tighten lips.
*17	1st	DRAWS LOWER MOUTH CORNER DOWNWARD AND BACKWARD.
*18	2nd	depresses lower lip — extends furrow around corner of mouth.
19	5th	raises and protrudes lower lip — may wrinkle skin of chin.
*22	2nd	helps to widen and lower mouth corner — in intense anger and rage this thin sheet muscle widens neck, causes vertical strain folds.

A **B**

AURICULAR MUSCLES

1 FRONTALIS
2 CORRUGATOR
3 PROCERUS
4 ORBICULARIS OCULI
5 LEVATOR PALPEBRAE SUPERIORIS
6 NASALIS
7 LEVATOR LABII SUPERIORIS
8 LEVATOR ANGULI ORIS
9 LEVATOR LABII SUPERIORIS ALAEQUE NASI
10 DILATATORES
11 ZYGOMATIC MINOR
12 ZYGOMATIC MAJOR
13 MASSETER
14 BUCCINATOR
15 RISORIUS
16 ORBICULARIS ORIS
17 TRIANGULARIS
18 DEPRESSOR LABII INFERIORIS
19 LEVATOR MENTI

20 TEMPORAL
21

PLATYSMA = THIN SHEET MUSCLE ORIGINATING ON UPPER CHEST & SHOULDER

PLATYSMA
22
22

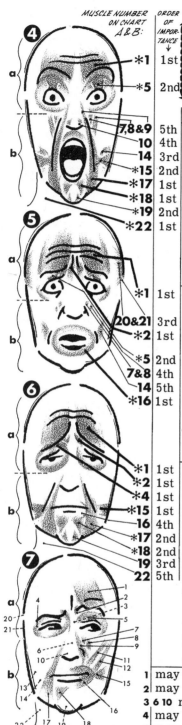

ORDER OF IMPORTANCE ↓

④ SURPRISE, ASTONISHMENT, AWE, SUSPENSE———(can be combined with 4b or 5b or degrees in between)

*1	1st	DRAWS SCALP FORWARD AND FOREHEAD UPWARD — LIFTS EYEBROWS AND WRINKLES FOREHEAD.
*5	2nd	lifts upper eyelid as expression is intensified.

④ YELLING (may operate independently from the above reactions)

7,8&9	5th	these create tension as antagonists to lower face muscles.
10	4th	widens nostrils.
14	3rd	may assist in expelling air (more especially in blowing up balloon).
*15	2nd	opposes muscles above and below mouth, acts to widen mouth.
*17	1st	ELONGATES FURROW ON EITHER SIDE OF MOUTH.
*18	1st	ADDITIONAL DOWNWARD PULL.
*19	2nd	may protrude lower lip.
*22	1st	ASSISTS IN STRETCHING MOUTH — MAY SHOW UP AS SKIN TENSION IN NECK (actual muscles which open jaw are deep-set).

⑤ FEAR, ANXIETY, FRIGHT, HORROR, TERROR——(may be combined with 4b)

*1	1st	DRAWS SCALP FORWARD AND FOREHEAD UPWARD — LIFTS EYEBROWS AND WRINKLES FOREHEAD.
20&21	3rd	may draw back skin of temples making eyeballs look more expanded.
*2	1st	TWISTS INNER EYEBROW UPWARD — PULLS UP AND IN ON SKIN OF EYELID.
*5	2nd	lifts upper eyelid (though brow skin may stretch diagonally across).
7&8	4th	may deepen furrow slightly at wing of nose.
14	5th	may compress cheeks somewhat as air is sucked in.
*16	1st	LIKELY TO PURSE LIPS, BUT NOT ENOUGH TO CLOSE MOUTH WHICH HANGS OPEN HELPLESSLY (by no special muscle action).

⑥ SORROW, PAIN, SHAME, SUFFERING, SUPPLICATION, WORRY———(may be combined with 5b and sometimes 4b)

*1	1st	LIFTS FOREHEAD CENTER CAUSING WRINKLES.
*2	1st	TWISTS INNER BROW UPWARD (pulls up and in on skin of eyelid).
*4	1st	CONTRACTS TO PARTIALLY CLOSE UPPER EYELID.
*15	1st	EXTENDS CORNER OF MOUTH OUTWARD.
16	4th	may compress lips on occasion.
*17	2nd	may influence mouth corner downward (not as much as in Anger, 3b).
*18	2nd	depresses lower lip.
19	3rd	may sometimes raise and protrude lower lip, also wrinkle chin.
22	5th	can cause taut 'strings' to appear in neck under extreme emotion.

⑦ CONTEMPT, CYNICISM, DISDAIN, HAUGHTINESS, IMPATIENCE, JEALOUSY, MISTRUST, QUESTIONING, SKEPTICISM, SNEERING, SUSPICION, ETC.—(often these expressions are not bilaterally symmetrical like 1 through 6 -- they may be combined in part with the others as the need arises)

1	may lift and wrinkle forehead on one side only.
2	may tilt one brow up and the other down — furrow may appear.
3 6 10	may wrinkle parts of nose.
4	may close one eye more than the other.
5	may lift one lid more than the other.
7 8 9	may elevate one side of the mouth or the other causing furrow.
11 12	may draw mouth corner upward and backward.
13	may set jaw.
14	may compress cheek.
15	may draw out angle of mouth.
16	may partially close mouth.
17	may depress mouth angle on occasion.
18	may depress lip on either side.
19	may elevate or eject lower lip.
20	may flex ear — has little or nothing to do with expression.
21	may bring the incisor teeth together in a clinch.
22	may wrinkle skin about neck or may depress mouth.

EXPLANATION to above (7): Muscles shown causing this particular expression are black-lined; positions of muscles not shown are dot-lined. Numbers appearing out of order are to prevent confusing crossing of lines.

EXPLANATION for listing at left: All the muscle numbers are given with their potential for these miscellaneous expressions cited above (7). Check with the Master Diagram A&B.

DRAWING PRETTY GIRLS

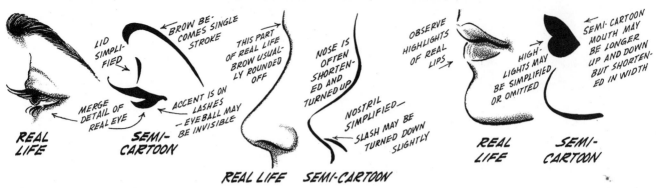

The most often tried subject in the world for a beginning cartoon artist is the human face — the woman -- in profile. 'Strict' cartooning veers from real life considerably, but it takes its cue from it nonetheless. Reference needs to be made to the actual in order to represent it in cartoon. On this page are a number of faces bordering between real life and cartoon. On the following page and elsewhere in this book are examples of female faces drawn even further away from reality. It is safe to say whenever pretty faces are cartooned they will still possess certain accepted essentials else they'll be on the homely side. There will always be a demand for the pretty face. Many a cartoon has the man looking frightful -- not so with the young lady. The order may be: keep her pretty!

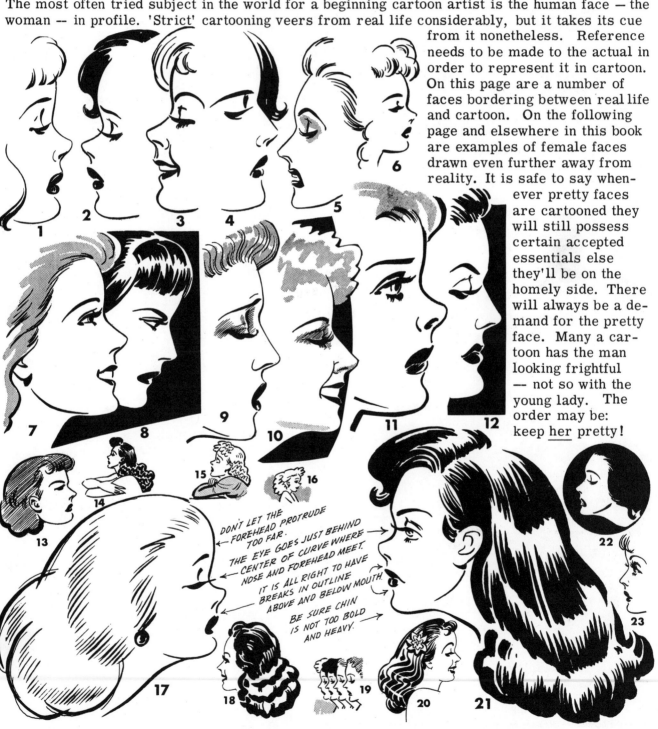

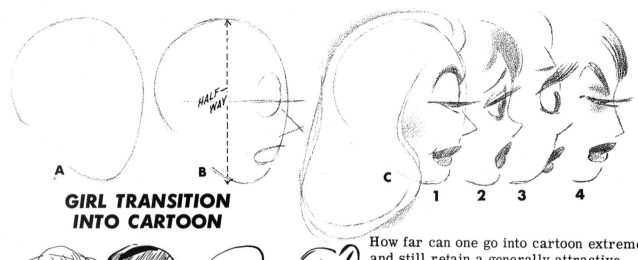

A

B HALF-WAY

C

1 2 3 4

GIRL TRANSITION INTO CARTOON

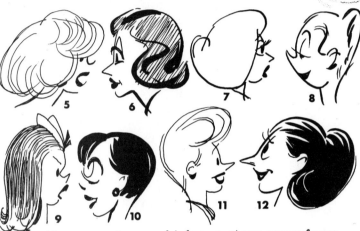

5 6 7 8

9 10 11 12

Above are types which are steps away from the reality on the preceding page. Yet on a cartoon body and incorporated in a given setting, they would be regarded as young and pretty.

How far can one go into cartoon extremes and still retain a generally attractive face? This is an interesting pursuit and the time spent at it will not be wasted. One's own individuality is bound to creep in, and that's good. Since all parts of a cartoon need to be related enough so they belong together, the girl cannot be entirely real-life if others in the picture are far-out slapstick. Though at this stage our primary concern is the face, to illustrate the point, take a look at the two styles of drawing in figs. 13 and 16. It would hardly do to transpose the faces. Fig. 13 calls for a looser, less true-to-life face than 16.

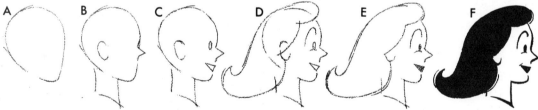

A B C D E F

When examining a head in view of constructing a similar one, look 'through' the hair. Pretend only head F was pictured. Can you see shape A in it? This 6-part succession A to F is prescribed by most cartoonists. Naturally the head pattern may be entirely different.

13

14 15 16

KADIEWAMPUS HATS

FACIAL RANGE CHART

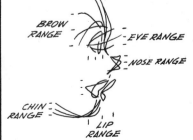

BROW RANGE
EYE RANGE
NOSE RANGE
CHIN RANGE
LIP RANGE

As one draws cute girls he will learn a range within which he must keep his facial parts if the profile is to look pert and pretty. There is no set standard and judgment differs. Practice will help in formulating one's own individual prototype.

TYPES OF GIRL CARTOON PROFILES

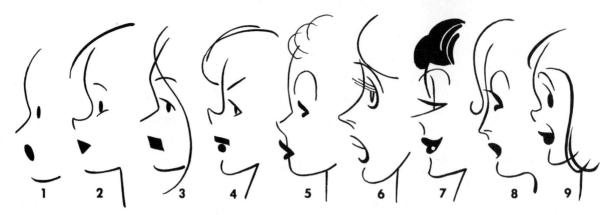

1 2 3 4 5 6 7 8 9

▶ The two lines and two spots of fig. 1 represent the simplest female cartoon profile. The eye should be the smaller spot. If the mouth spot is much larger than the above, it will take on the look of an open, yelling mouth instead of closed lips. Notice the relationship of the eye spot with the point where the nose meets the forehead. Think of this point as an arrow ---) pointing to the place where the eye goes. Occasionally the eye is a little above or below this turn-in point, but as a rule it is safest to set the eye in line with it.

▶ In the first four faces the mouths are geometrical shapes illustrating in part that the right position, rather than just the shape, has a lot to do with making the face look right. In 1, 2, 3 & 4 the eye spot is simply a solid vertical oval. Notice the line is below in 2 (a cheek line), above in 3 (a lid line) and above and below in 4 (an eye's outline). These lines in 2, 3 & 4 are duplicated and lifted as brows, though this sameness surely is not necessary.

▶ In many cartoon profiles the mouth is set down without being connected with nose or chin. Sometimes the bottom of the nose is omitted entirely. In 5 the eye and the mouth shape are identical except for size. Variations of this 'check' mark or 'V' lying on its side may be successfully used as sideview eyes and lips. Here, in 5, the lips are laid on the line from nose to chin. They may be pulled back more into the face. Duplicate shapes are used experimentally for eyes and mouth in No. 6. One of the lash lines of the eye becomes the teeth line in the mouth. In 9 the eye and mouth have a 'comet tail.' This tail is a cheek line in the mouth. It may be swung off the eye spot in a number of different ways ꝶ ꞇ ʃ ꞇ to produce different gazes and expressions. The more pug one makes the nose the younger the character becomes.

THE PRETTY GIRL HEAD
STEP-AT-A-TIME PROCEDURE

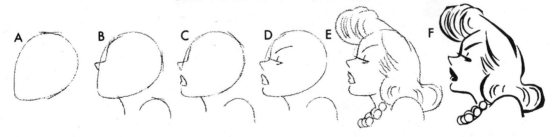

A B C D E F

▶ Above is a suggested sequence for cartooning the female head: A. start with the egg shape. B. sketch the nose and forehead. C. add the mouth. D. sketch the eye and brow. E. decide on the hair style to fit the time and period. F. ink the lightly done penciling. By crossing some of the types in the series 1 through 26 one can arrive at hundreds of possibilities. With twists and your own ingenuity thousands of different heads may be drawn.

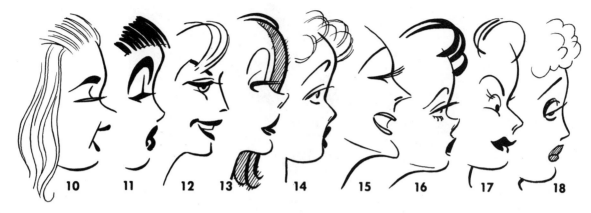

▶ Continuing the pretty cartoon profiles, 10 and 11 as well as others in the series (5, 8, 13, 15 & 20) leave out the eye-ball and depend soley on the eye-lashes. All the above, except for 15 and 17, have some kind of upper lid line -- they are all different. Likewise, compare lids in 6, 7, 20, 23 & 26. Attention should be focused on the variety in brows which are always important in the pretty cartoon. Notice the 'hook' on 14, the extra weight of the brows in 10 and 11, the hair interception in 12, the join of brow and lid in 13, the brow contact made with the forehead in 15, the 'S' curvature in 16, the down angle of 4, 12, 17, 21 & 26, the up angle of 18, 20, 24 & 25, the 'runoff' from the forehead in 6, 7 & 20, the extreme arch of 5, 8, 11, 13, 22 & 23, and the line swell of the brow in 10, 11, 12, 20, 24 & 26. Observe how a thin line eye-ball can cause the character to look to the other side rather than straight ahead, 7, 21 & 25.

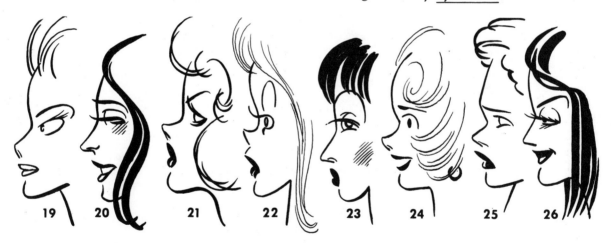

▶ A further word concerning cartoon lips: usually they are darkened to simulate lipstick, but they may be in outline only as in 15 and 19, or they may have a grey value as in 18. Seasonally there are exceptionally light shades of lipstick being used. The little lip highlight can add sparkle. In cartoon it nearly always occurs on the bottom lip only. It may be a round white spot as in 7, the spot may drag off the lip as in 11, it may be a thin white horizontal line such as in 13 and 16 or a white vertical as found in 21 and 22. A white strip of light reflection may be on the front of the bottom lip such as in 17 and 25, or the white may result by omitting some of the fill-in as in 20 and 26. Throughout history some cartoonists have stuck the lips on the face, see 14.

▶ The nose, more often than not, in cartoon is turned up some as in 2, 4, 9, 10, 11, 16, 21 & 24. To a lesser degree it is turned up in a few of the others. The flat face in cartoon is used sparingly, 8 and 18. The nose tip may be a broken pug, 5 and 13. A sharp point or a round blunt will be found intermittently in this series. The nostril may or may not appear. The forehead usually is rounded, but may be partially squared as in 3, 11, 14 & 25.

GOING TO REAL LIFE FOR CARTOON ELEMENTS

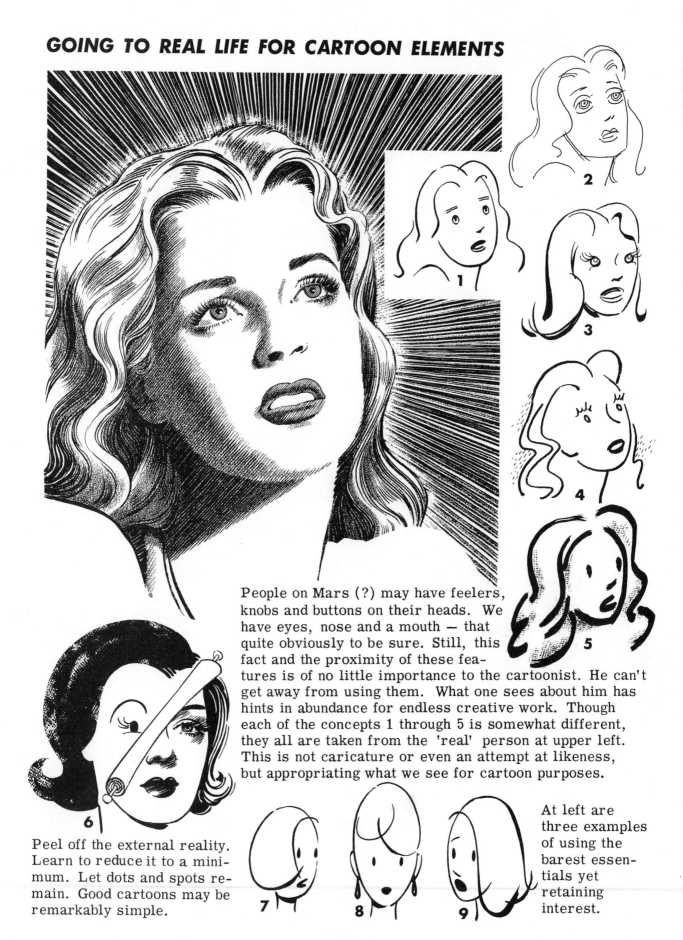

People on Mars (?) may have feelers, knobs and buttons on their heads. We have eyes, nose and a mouth — that quite obviously to be sure. Still, this fact and the proximity of these features is of no little importance to the cartoonist. He can't get away from using them. What one sees about him has hints in abundance for endless creative work. Though each of the concepts 1 through 5 is somewhat different, they all are taken from the 'real' person at upper left. This is not caricature or even an attempt at likeness, but appropriating what we see for cartoon purposes.

Peel off the external reality. Learn to reduce it to a minimum. Let dots and spots remain. Good cartoons may be remarkably simple.

At left are three examples of using the barest essentials yet retaining interest.

28

BREAKING DOWN FACES FOR CARTOON

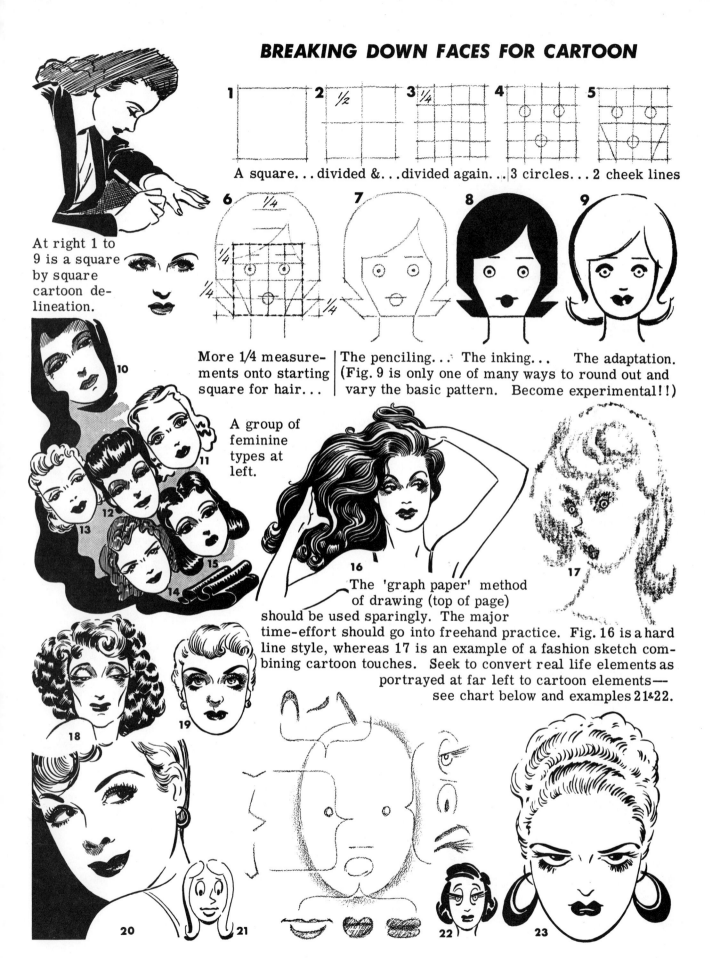

A square. . .divided &. . .divided again. . . 3 circles. . . 2 cheek lines

At right 1 to 9 is a square by square cartoon delineation.

More 1/4 measurements onto starting square for hair. . .

The penciling. . . The inking. . . The adaptation. (Fig. 9 is only one of many ways to round out and vary the basic pattern. Become experimental!!)

A group of feminine types at left.

The 'graph paper' method of drawing (top of page) should be used sparingly. The major time-effort should go into freehand practice. Fig. 16 is a hard line style, whereas 17 is an example of a fashion sketch combining cartoon touches. Seek to convert real life elements as portrayed at far left to cartoon elements— see chart below and examples 21 & 22.

29

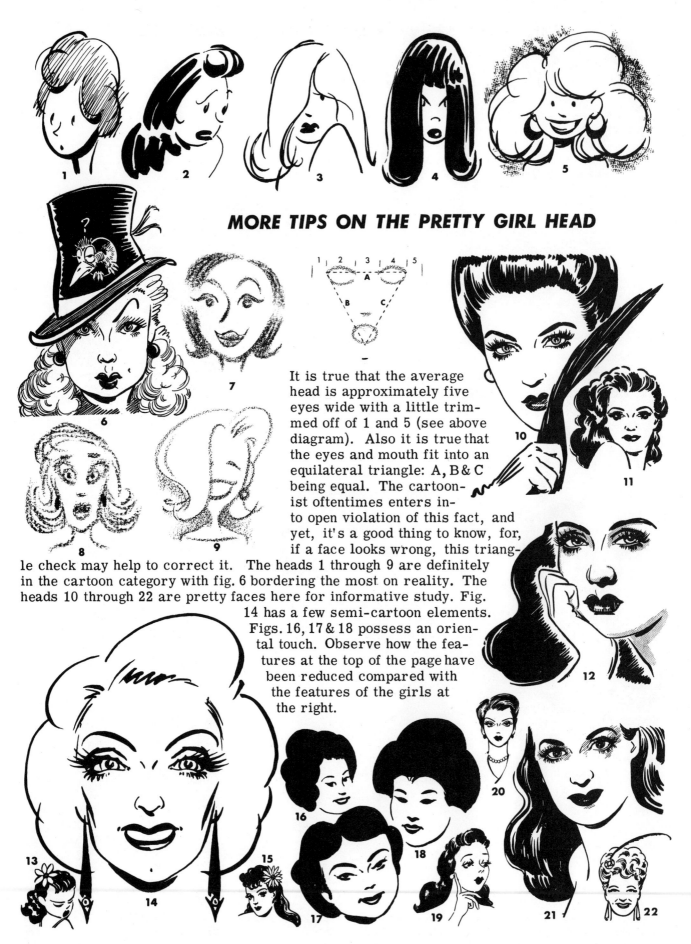

MORE TIPS ON *THE PRETTY GIRL HEAD*

It is true that the average head is approximately five eyes wide with a little trimmed off of 1 and 5 (see above diagram). Also it is true that the eyes and mouth fit into an equilateral triangle: A, B & C being equal. The cartoonist oftentimes enters into open violation of this fact, and yet, it's a good thing to know, for, if a face looks wrong, this triangle check may help to correct it. The heads 1 through 9 are definitely in the cartoon category with fig. 6 bordering the most on reality. The heads 10 through 22 are pretty faces here for informative study. Fig. 14 has a few semi-cartoon elements. Figs. 16, 17 & 18 possess an oriental touch. Observe how the features at the top of the page have been reduced compared with the features of the girls at the right.

EIGHT EASY STEPS IN DRAWING TEEN-AGE GIRLS

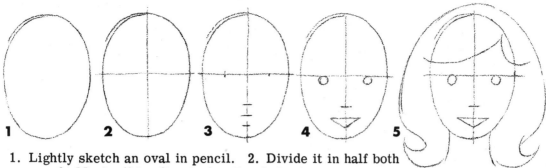

1. Lightly sketch an oval in pencil. 2. Divide it in half both ways. 3. Mark off top line in fourths; halve bottom perpendicular, then divide lower half in thirds. 4. Place eye rounds below top marks; draw triangle lips in middle third of lower marks. 5. Sketch in neck and outline hair.

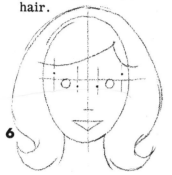

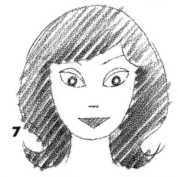

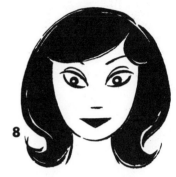

6. Divide top line in eighths to find lid extremities (this may vary in cartoon).
7. Draw eyes connecting dots of fig. 6, also brows. Pencil-in values or go directly to last step. 8. Ink underdrawing with brush (or pen).

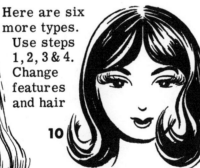

Here are six more types. Use steps 1, 2, 3 & 4. Change features and hair

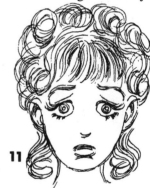

Blonde — brush (size 1 or 2 round) and ink. Light pressure on hair.

Dark brunette — brush and ink. Heavy pressure on hair.

'Redhead' — pen and ink. Keep strokes open, light and airy.

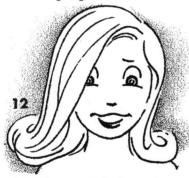

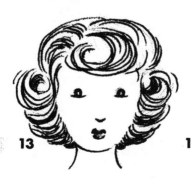

Blonde, extra light — fine felt pen. Background very hard litho crayon or pencil.

Middle brunette — India ink ball point. (Try interchanging facial features.)

Light brunette — 935 Prismacolor pencil (semi-flattened) on coquille fine.

31

HIGHLY STYLIZED CARTOON GIRL HEADS

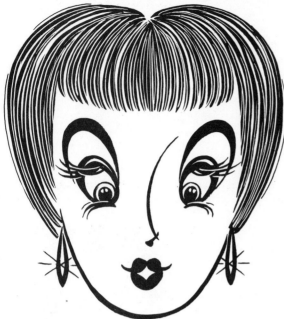

1 Rounded face — heavy arched brows, repeat shape around eyes, hair heavy brush strokes split with retouch white.

2 Wide face — big-orbed eyes, two brushed top lashes, penned bottom lashes, heavy lower lip, slight chin.

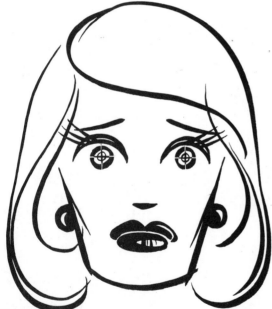

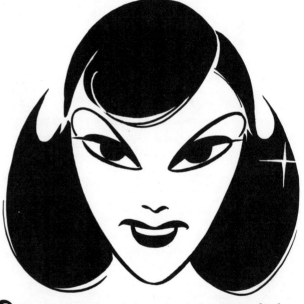

3 Squared face — half-moon upper lids, triple lashes, gun-sight eyes, brows turned up, heavy lips highlighted.

4 Pointed face — brows running into dark almond-shaped eyes, single eyelash, velvet blacks, no highlights, one sparkle in coal-black hair.

1 2 3 4 5 6

Heavy brush-lined miniatures, front and profiles. Stylize some of your own!

THE ART OF CARICATURE

Caricature is the art of distorting by exaggeration a person so that he still retains his identity. This ability is a great asset to the editorial and sports cartoonist. Commercial, strip, gag, animating and lecturing cartoonists use it on occasion, too. Suggested procedures are presented on these pages.

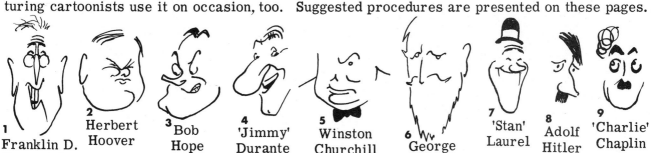

1 Franklin D. Roosevelt
2 Herbert Hoover
3 Bob Hope
4 'Jimmy' Durante
5 Winston Churchill
6 George Bernard Shaw
7 'Stan' Laurel
8 Adolf Hitler
9 'Charlie' Chaplin

Above are a few of the often-caricatured personalities through the years. 'Economy' of line in caricaturing is a good exercise. The steps: 1. Obtain good likenesses of the subject. 2. Decide on the unusual aspects of the face. 3. Play these up; at the same time minimize or omit the rest. Notice: Fig. 1 has a vertical concentration, whereas fig. 2 has a central concentration. Caricatures 3 & 4 rely chiefly on the nose, secondarily on the chin, mouth and eyes; fig. 5 on the mouth and jaw; fig. 6 on whiskers and brows; fig. 7 on mouth and chin; figs. 8 & 9 on the mustache with secondary features, the hair and eyes. A perfectly 'normal or regular' face is difficult to caricature. In this case borderline differences must be sought out. Consider the black line in diagram 10 as normal or regular (set your own imaginary standard). The several random lines about it are simply possible differences. Study 10's notations. Faces 11 & 13 have had these principles applied in caricatures 12, 14 & 15.

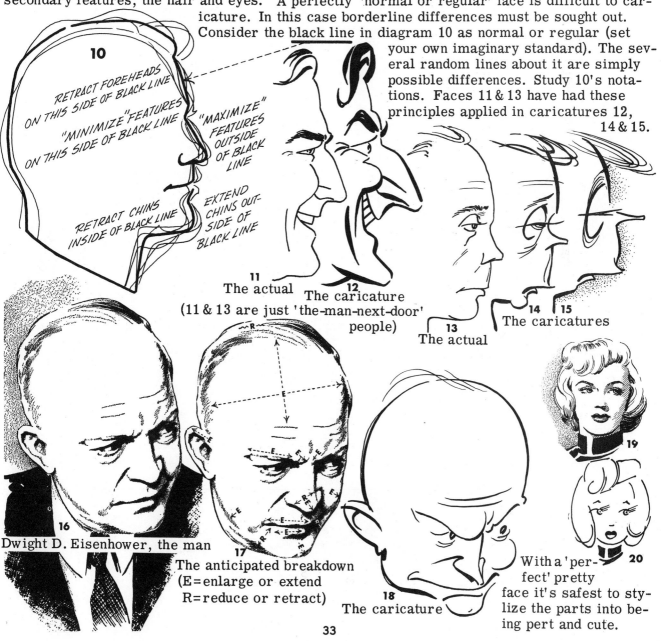

10
RETRACT FOREHEADS ON THIS SIDE OF BLACK LINE
"MINIMIZE" FEATURES ON THIS SIDE OF BLACK LINE
"MAXIMIZE" FEATURES OUTSIDE OF BLACK LINE
RETRACT CHINS INSIDE OF BLACK LINE
EXTEND CHINS OUTSIDE OF BLACK LINE

11 The actual
(11 & 13 are just 'the-man-next-door' people)
12 The caricature
13 The actual
14 15 The caricatures

16 Dwight D. Eisenhower, the man
17 The anticipated breakdown
(E=enlarge or extend
R=reduce or retract)
18 The caricature

19
20
With a 'perfect' pretty face it's safest to stylize the parts into being pert and cute.

33

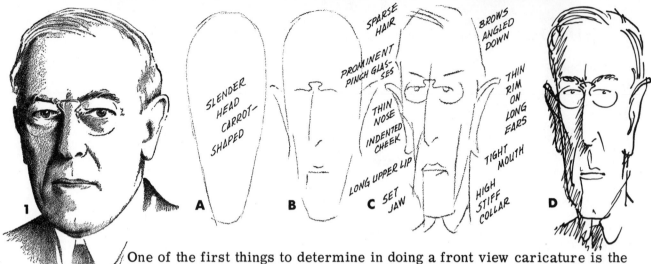

Woodrow
Wilson

One of the first things to determine in doing a front view caricature is the head shape. Is the head more round or square, longer or wider than usual? Does it resemble, even remotely, an egg, a carrot, a potato, a pear, a banana, a gourd, a ball, a block, a spindle, a bottle, an axe, a diamond, a triangle, etc.? Exaggerate the head's outline into this associated shape. Next, take note of the prominent features and make them 'overly dominant.' Try experimentally distorting these in easily erased lines. It pays to make several preliminary sketches. If time permits, put them away. One may say, 'I'm it,' when you look at them later. Or test them out on friends for recognition value.

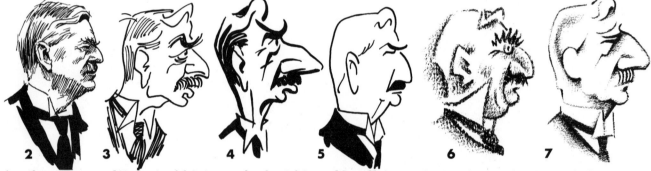

Another personality out of history who lent himself well to caricature was the British Statesman Neville Chamberlain. In a side view an associated 'thing' shape is not as important as the front or semi-front views. Here it is the outlandish deviation from the norm that counts. With it all, of course, identity must be retained. Fig. 2 is the actual subject for reference (it is not necessary to draw a portrait; consult photo copy — rarely does one work from life, except in a demonstration or performance). Compare all the facial features above 3 through 7 with the man himself 2. Take them one by one. Fig. 3 is pen, 4 is brush, 5 is pen and brush (observe simplification), 6 is pencil on a coarse board and 7 is pencil on a finer surface.

Caricaturing girls and women is a risky business, and because of the delicacy of their features, is more difficult. The tactician treads lightly and may do 'semi-caricature' (see B). Or, if the subject can stand it, bold distortion may be applied (as in C). A is C dotted and shaded and laid over 8's outline.

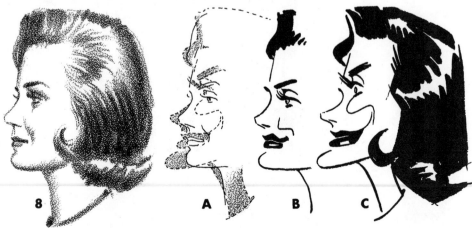

BUILDING CARTOON FIGURES ON THE SIMPLE OVAL

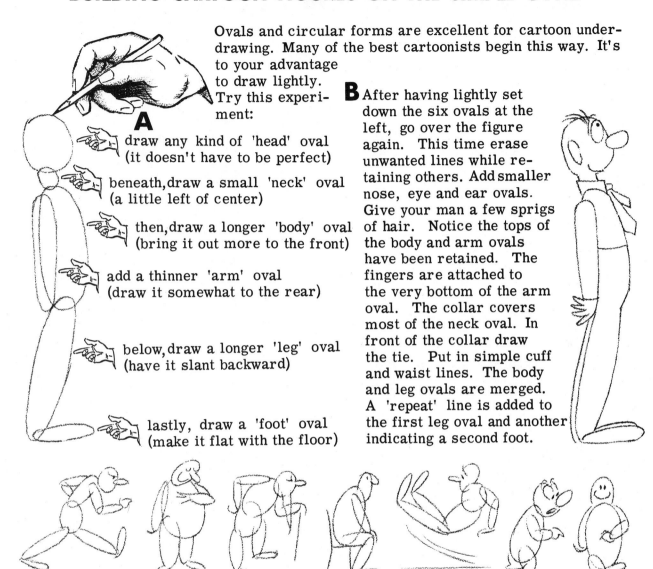

Ovals and circular forms are excellent for cartoon under-drawing. Many of the best cartoonists begin this way. It's to your advantage to draw lightly. Try this experiment:

A

draw any kind of 'head' oval
(it doesn't have to be perfect)

beneath, draw a small 'neck' oval
(a little left of center)

then, draw a longer 'body' oval
(bring it out more to the front)

add a thinner 'arm' oval
(draw it somewhat to the rear)

below, draw a longer 'leg' oval
(have it slant backward)

lastly, draw a 'foot' oval
(make it flat with the floor)

B After having lightly set down the six ovals at the left, go over the figure again. This time erase unwanted lines while retaining others. Add smaller nose, eye and ear ovals. Give your man a few sprigs of hair. Notice the tops of the body and arm ovals have been retained. The fingers are attached to the very bottom of the arm oval. The collar covers most of the neck oval. In front of the collar draw the tie. Put in simple cuff and waist lines. The body and leg ovals are merged. A 'repeat' line is added to the first leg oval and another indicating a second foot.

Above are examples of little comic characters built on ovals. Seldom will you draw a perfect circle. Compass-like circles are stilted and cold-looking. In smaller figures draw the body oval (2, 4, 6 & 7) or ovals (1, 3 & 5) first. It's not a bad practice to usually establish the body before adding head, arms and legs, regardless of figure size.

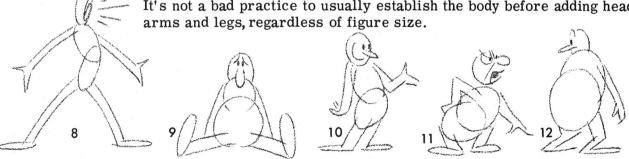

Whereas figs. 1 through 7 have ovally drawn arms and legs, 8 through 12 have semi-parallel lines for these apendages. As one progresses in cartooning, this method is preferred as a rule. All the above figures are 'skeletons.' They are without the finishing touches such as coat, tie, hat or whatever you wish to add. Try a dozen of your own!

BEGINNING THE SIDE VIEW FIGURE ON A TRIANGLE

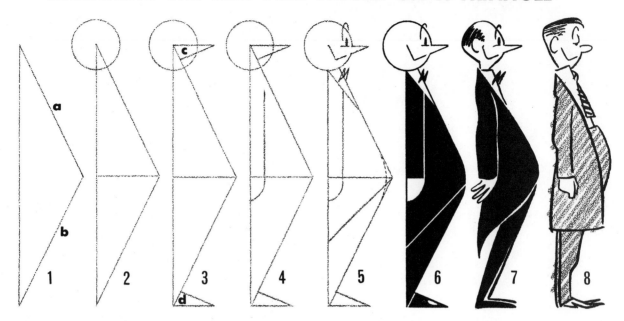

1 Draw (very lightly in pencil) a triangle with 'a' and 'b' the same length.

2 Divide the triangle in two; draw a circle with the tip of the top triangle as its center.

3 Draw alike two small triangles 'c' and 'd' at top and bottom.

4 Place arm line above center division with curved hand below center. (Further urgency: avoid pressing with pencil -- draw lightly!)

5 Draw diagonals for lapel and coat tail. Round off stomach to desired girth. Spot in a little vertical eye oval with

lifted brow as shown. Erase bits of the lines in the circle leaving the little cheek line under eye and the smile line. Indicate where bow tie will go.

6 Ink lines and areas for dark suit coat and pants. Shoe highlight is optional; this may be solid.

COMMENT: As we go along we'll quickly abandon the ruler and compass to rarely take them up again. Even in this exercise, the beginning student may sketch freehand, for an interesting informal line is of more worth to a cartoonist than a ruled one. However, in order to stress the simple geometrical understructure, the above approach has been mechanically presented. This geometrical little man of fig. 6 or similarly drawn figures may serve a purpose as part of a commercial insignia or trademark, but it should be made clear that reliance upon a hard ruler and compass is to be avoided. Such dependence will be detrimental to the student of cartoon.

7 & 8

The looseness of line as exemplified here is generally preferred over the mechanical line treatment of fig. 6. Observe that the legs of 7 come out from the <u>front</u> of the stomach area, whereas the legs of 8 seem to come out from the <u>back</u>. This is important to remember, for either will lend a touch of humor to your creation. Microscopic shoulders and chest and extra thickness in the midriff may not be coveted in real life, but in cartoon society Mr. 7 & 8 couldn't care less. Literally hundreds of characters can be built on the simple triangle at the top of the page. Try some of your own!

THE TRIANGLE MODIFIED AND REVERSED

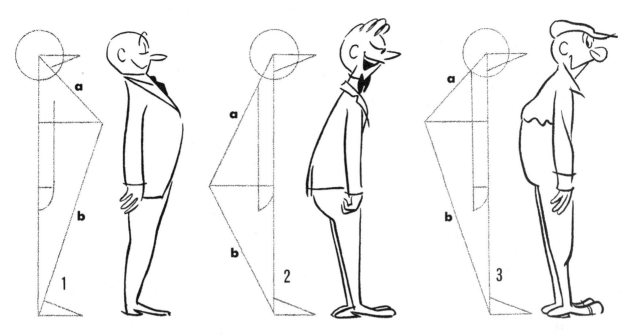

One of the funniest stances for a cartoon character, whether it be adult, child or beast, is the pert posture of the perpendicular back line running up to the base of the skull (see figures on previous page, also fig. 1 above). The head may jut out in the back (as in these cases) or it may be in line with the rigid spine. One reason for this piquancy is that it is the way a small child stands, unbent from the world's woes. It is a 'cute' stance even for an old man. Little animated creatures thrive on it. It is also funny to have the rear of a cartoon body protrude as in figs. 2 and 3 above. So consider these three in their order:

1 Here the triangle's middle has been lifted. Lines 'a' and 'b' are no longer the same length.

2 The triangle is reversed, and the perpendicular becomes the front with 'a' and 'b' equal again.

3 Still reversed, the triangle has lines 'a' and 'b' of different length such as in fig. 1.

THE VALUE OF THE DANGLING ARM

Notice that all the profile figures on these two pages have dangling arms. This adds to the humor of a cartoon. Of course, at times it is necessary for the person to be doing something with his hand and arm. If one hand will suffice, it is suggested that the arm opposite come up and do the work, thus preserving the dangling arm touch on this side. This again is a device of the animator but need not be monopolized by him. As is pointed out in the section on Animation, the Walk and the Run, the dangling arm may still be used (despite its sometimes being of unnatural carriage) for a funny appearance.

THE JUTTING HEEL

When one uses the reversed triangle with protruding rear, it is best to have a jutting heel on the shoe (see finished figs. 2, 3 & 5). Otherwise the extra weight in the rear will overbalance the figure. For variety, figs. 4 & 5 have back of skull <u>in line</u> with spine.

THE FRONT VIEW FIGURE ON A TRIANGLE

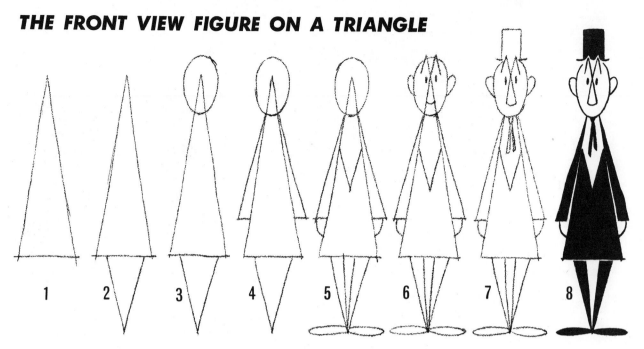

1 2 3 4 5 6 7 8

The profile figures began with mechanically-drawn triangles and circles. Now let's go freehand in developing a front view man which has the middle area as the widest part. These isosceles triangles (two sides the same) in figs. **1** and **2** could be done with a hard straight-edge, but it will be better to have them crooked than to become chained to a ruler. Attention is called to: **3** Sketching the head oval so the triangle tip is above center (this top end becomes the nose later on). **4** No shoulders; upper arm starts with nothing. **5** A 'V' for coat lapel, and a 'V' for inside of bow legs. **6** The triangle sides extended upward run into the brows. **7** The brows retain their lively arch by being left exposed under the hat brim. This is cartoon license, even though it couldn't actually happen. Notice the ankles diminish like the shoulders. Later we will discuss the value of the closed coat line from which spindly legs appear.

9 10 11 12 13 14 15

The characters above were all fashioned on the isosceles triangle skeleton. Each has been treated differently to demonstrate that there is no end to the possibilities. Although other methods will be presented, this simple plan has much merit. Most of the width of each figure is between the dotted lines or near the base of the underlying triangle begun in fig. 1 (top).

EXPANDING THE 'STICK' FIGURE

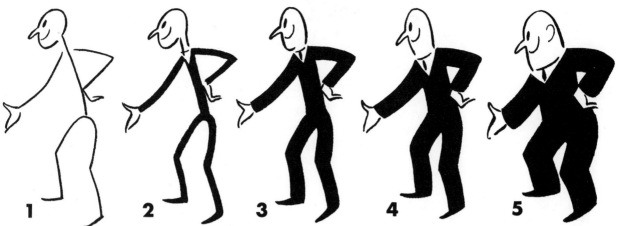

Anyone can draw a stick figure with very little practice. Actually, the leg bones of the human skeleton attach at the <u>sides</u> of the hips. In a front or semi-front view (as the above) one may use an inverted 'U' at the hips. True, the arm bones don't grow out of the neck, but in many cartoon males they're funnier without shoulders. Figures 2 through 5 are simply stick figures with the sticks progressively widened.

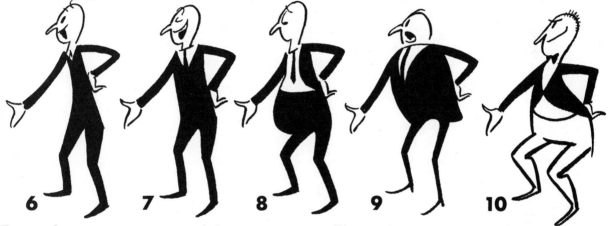

Figure 6 begins a variation of this same pose. The stick parts are not of the same width as they are 1 through 5. The arms and legs are fairly consistent 6 to 8, but the torsos vary. In 9 we go to bird legs under a wide body. In 10 the shoulders are missing, but the hips are doubled. Notice the distance between the legs. The suit is 'two-tone.' Belt line is showing as in 8.

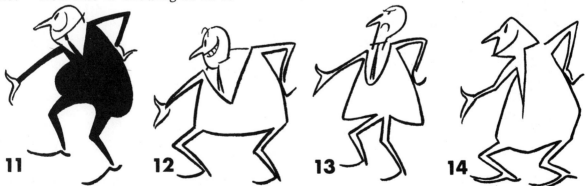

The bottom row has examples of more extreme variations. In 11 skinny arms and legs grow out of bulges. The shirt collar is high on a wide neck. In 12 the legs are set at the <u>outside</u> edge in contrast with 13 where they come from the <u>center</u> of the coat line. The figures could be dark, light or shaded. Fourteen is a further abstraction. Examine the head attachments in each. Invent some of your own variations.

STEPPING OUTSIDE THE 'NORMAL' INTO THE CARTOON WORLD

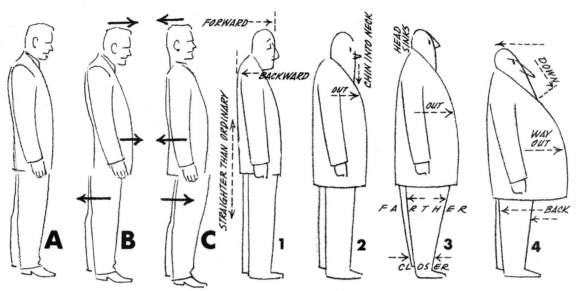

All of cartooning is a 'take-off' on real life. To be sure, some of the results are not only 'off' but so 'far out' as to be hardly related to anything living or dead. Some of the more absurdly outlandish phases will be dealt with elsewhere in this book. For the most part, cartoons are made up of overdone or underdone realism. Fig. <u>A</u> above is normally proportioned. By pushing body sections of <u>A</u> back and forth as in <u>B</u> and <u>C</u> we begin to 'think' cartoon. Then by exaggerating and simplifying these sections we invade the cartoon world. Close examination will reveal that most funny ink people are made so by deviating from the normal. If a line would 'normally' swing in, try swinging it out. If a line would probably go up, consider bringing it down. All the while keep in mind a person. As humor in the realm of words is often overstatement or understatement, so humor in the realm of cartoon is overdoing or underdoing a line or its position on paper.

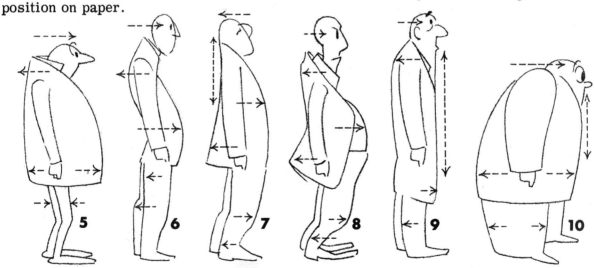

Granted, figures 5 through 16 are exaggerated to the extreme, but we're flexing our cartoon muscles. We are getting away from concept <u>A</u> (the normal) at the top of the page. Though most people cannot draw a real-life person, they are unwittingly chained to mental pictures of real life. Notice the 'in' and 'out' arrows above, all departures from the normal. Occasionally the exaggeration will not be a greater protrusion or indention but a severe straightening or flattening (see the 'up and down' arrows in 1, 7, 9 & 10).

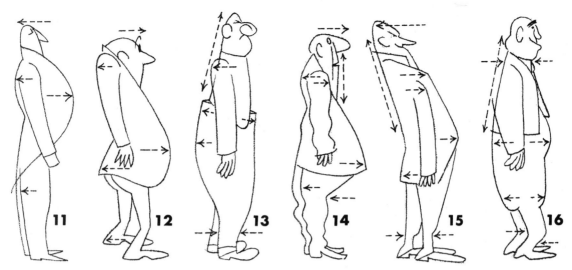

Let's continue having fun with experimental characters. The arrows 'in' & 'out,' 'up' & 'down' were explained earlier. Fig. 11 is the 'butler' type with more puff than chest. On the previous page, figs. 1, 2, 3, 4, 9 & 10 had no knees showing. Above, all the bumpkins have pants with a protrusion at the knee. In 11 and 13 it is slight. Knees in cartoon can be funny; elbows, too, but to a lesser degree. Through the rest of the book you'll see more male elbow protrusions. So far most of the arms have been without elbow pouches. Ill-fitting clothes are often worn in cartoon. Many coat and shirt sleeves have all but covered the hand. On the page just passed the hands were showing with one knuckle (the index finger). Figs. 12 to 16 have four fingers exposed.

Attention is called to the shortness between knee and foot as compared with the rest of the body. This is often done. Too, the legs of many cartooned people are exceptionally short (see fig. 16 and the cartoon breakdown below). For further examples of this, refer to the section on the Walk. Pant cuffs may or may not show. Not a few cartoonists merge the pant leg with the shoe showing no cuff at all (see figs. 1 to 16; exceptions 13, 15).

USUALLY CARTOON HEADS ARE LARGER, BODIES SMALLER

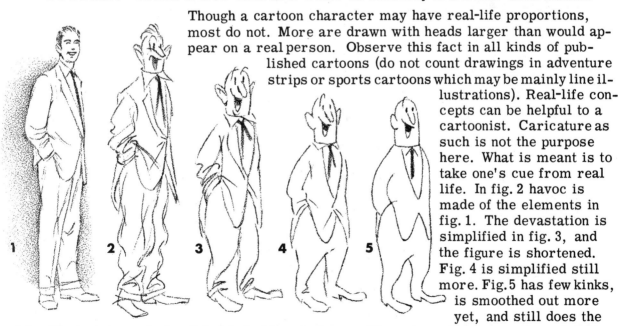

Though a cartoon character may have real-life proportions, most do not. More are drawn with heads larger than would appear on a real person. Observe this fact in all kinds of published cartoons (do not count drawings in adventure strips or sports cartoons which may be mainly line illustrations). Real-life concepts can be helpful to a cartoonist. Caricature as such is not the purpose here. What is meant is to take one's cue from real life. In fig. 2 havoc is made of the elements in fig. 1. The devastation is simplified in fig. 3, and the figure is shortened. Fig. 4 is simplified still more. Fig. 5 has few kinks, is smoothed out more yet, and still does the job. There is no rule for this kind of break-down. There is no 'wrongness' or 'rightness' to it, but there are more effective ways of doing it. It is up to the individual cartoonist. The point is: a cartoon is a turning-aside from real life. You, yourself, become the unrestricted creator! But it is wise to learn the best, the funniest & easiest ways.

CARTOONING ON A 'HAIRPIN'

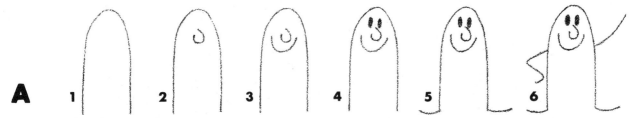

A

On a 'hairpin' when the head is to be exceptionally large inside the framework, it is well to commit the head space first. Locate the nose, then the rest of the face. Follow up as these simple steps illustrate. What's left will receive the arms and legs.

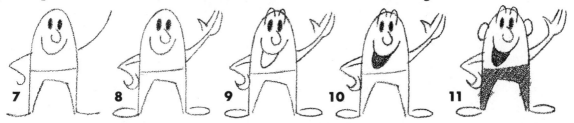

Notice that such a cartoon may have the arms coming out of the lower part of the head or neck. The 'waistline' is simply a division of the hairpin. The legs taper and are wide apart.

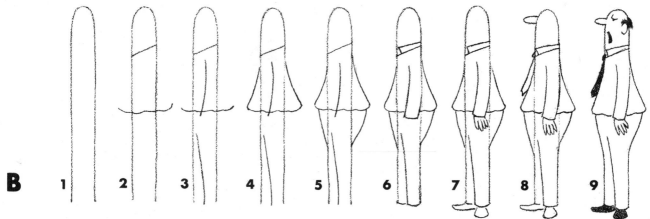

B

Above is a thin 'hairpin' which becomes the center stalk of the figure. In the midsection there is a protrusion fore and aft. The neck seems to slide into the rather unmanly chest and shoulder area.

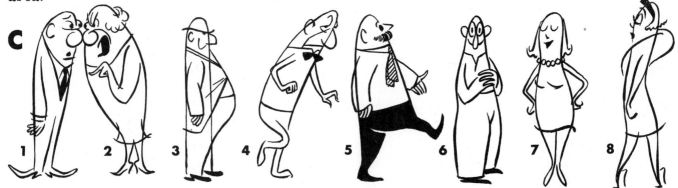

C

Most cartoon approaches begin with an inner buildup of some kind, but with the 'hairpin' type the outer confinement is sketched first. Here are some examples of modifying this outer hairpin shape. If the hairpin line falls behind part of any added portion, it may be retouched out.

DRAWING THE 'FUNNY MAN'

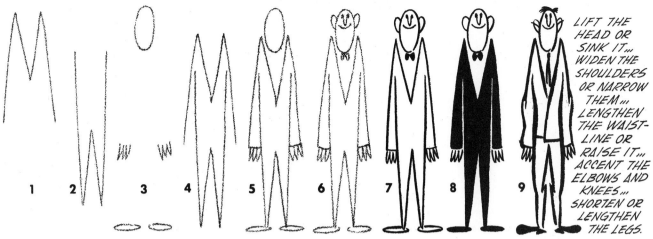

LIFT THE HEAD OR SINK IT... WIDEN THE SHOULDERS OR NARROW THEM... LENGTHEN THE WAIST-LINE OR RAISE IT... ACCENT THE ELBOWS AND KNEES... SHORTEN OR LENGTHEN THE LEGS.

Here is a suggested approach for a straight-on view funny man: an 'M', a 'W', smaller but similar shapes at the end of sleeves (fig. 3) plus ovals for head and feet. The combination (4 & 5) can be carried to any of the last three stages (7, 8 or 9). Variations of this theme are unlimited. A few suggestions are at the right of fig. 9. This is a <u>front</u> <u>view</u> approach. The figures below are sides and semi-fronts and are best started with circular underdrawing (see examples throughout book).

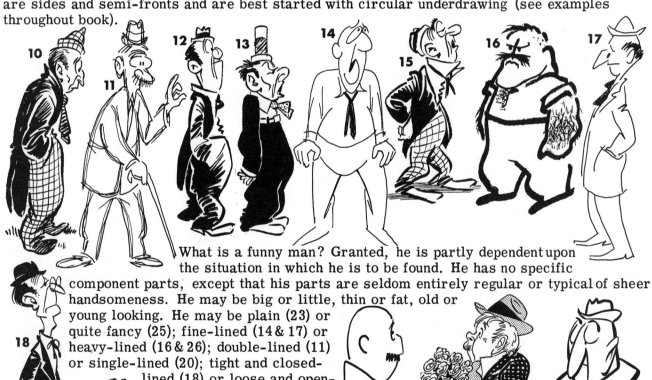

What is a funny man? Granted, he is partly dependent upon the situation in which he is to be found. He has no specific component parts, except that his parts are seldom entirely regular or typical of sheer handsomeness. He may be big or little, thin or fat, old or young looking. He may be plain (23) or quite fancy (25); fine-lined (14 & 17) or heavy-lined (16 & 26); double-lined (11) or single-lined (20); tight and closed-lined (18) or loose and open-lined (22). Try some of your own!

43

DRAWING THE 'COMIC LADY'

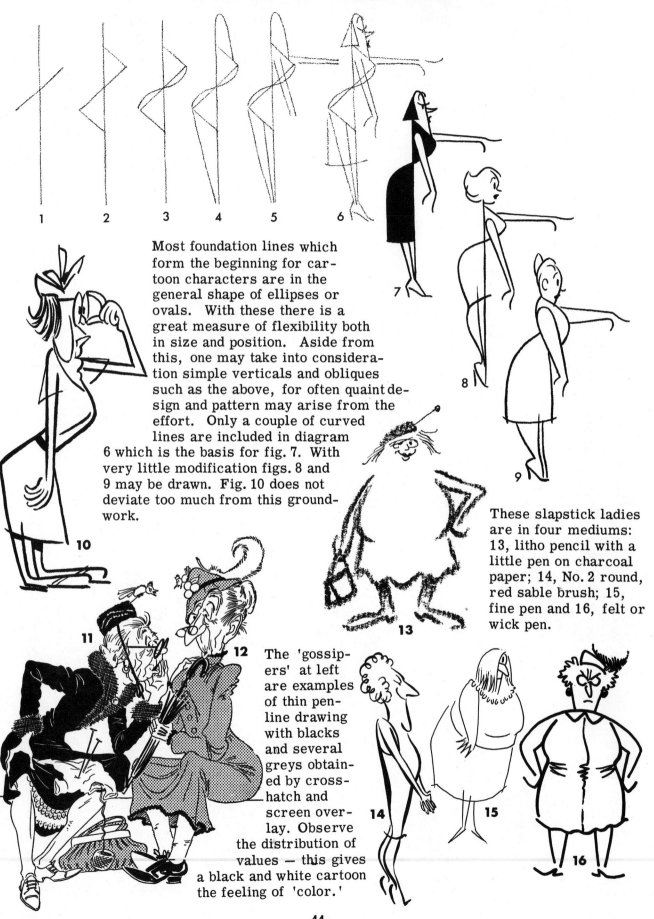

1 2 3 4 5 6

Most foundation lines which form the beginning for cartoon characters are in the general shape of ellipses or ovals. With these there is a great measure of flexibility both in size and position. Aside from this, one may take into consideration simple verticals and obliques such as the above, for often quaint design and pattern may arise from the effort. Only a couple of curved lines are included in diagram 6 which is the basis for fig. 7. With very little modification figs. 8 and 9 may be drawn. Fig. 10 does not deviate too much from this groundwork.

These slapstick ladies are in four mediums: 13, litho pencil with a little pen on charcoal paper; 14, No. 2 round, red sable brush; 15, fine pen and 16, felt or wick pen.

The 'gossipers' at left are examples of thin pen-line drawing with blacks and several greys obtained by cross-hatch and screen overlay. Observe the distribution of values — this gives a black and white cartoon the feeling of 'color.'

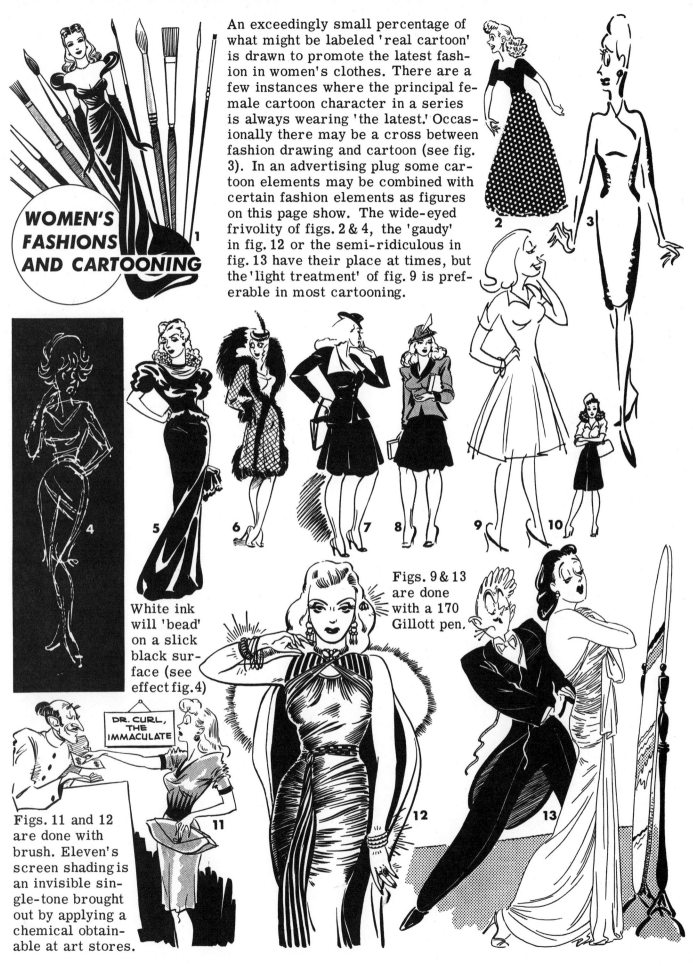

WOMEN'S FASHIONS AND CARTOONING

An exceedingly small percentage of what might be labeled 'real cartoon' is drawn to promote the latest fashion in women's clothes. There are a few instances where the principal female cartoon character in a series is always wearing 'the latest.' Occasionally there may be a cross between fashion drawing and cartoon (see fig. 3). In an advertising plug some cartoon elements may be combined with certain fashion elements as figures on this page show. The wide-eyed frivolity of figs. 2 & 4, the 'gaudy' in fig. 12 or the semi-ridiculous in fig. 13 have their place at times, but the 'light treatment' of fig. 9 is preferable in most cartooning.

White ink will 'bead' on a slick black surface (see effect fig. 4)

Figs. 9 & 13 are done with a 170 Gillott pen.

Figs. 11 and 12 are done with brush. Eleven's screen shading is an invisible single-tone brought out by applying a chemical obtainable at art stores.

DR. CURL, THE IMMACULATE

THE SIDE VIEW FEMALE CARTOON

One way of cartooning a petite standing female figure from the side is to: (1) Drop a perpendicular line from the pit of the neck (black dot) to the floor where it will divide the foot. (2) Lightly sketch simplified circular shapes for chest and hips. (3) Add stomach and front leg line. Knee hits perpendicular line. Back of calf of leg is in line with back of torso. (4) Add arm and rest of leg. (5) Complete penciling of face, hair and attire. (6) Ink, then erase any light under lines showing.

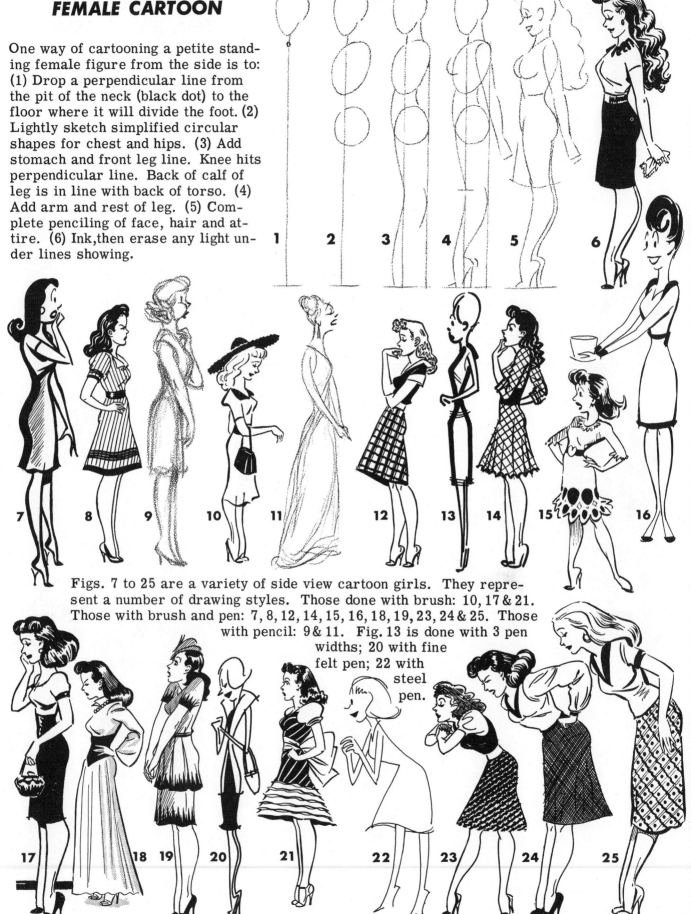

Figs. 7 to 25 are a variety of side view cartoon girls. They represent a number of drawing styles. Those done with brush: 10, 17 & 21. Those with brush and pen: 7, 8, 12, 14, 15, 16, 18, 19, 23, 24 & 25. Those with pencil: 9 & 11. Fig. 13 is done with 3 pen widths; 20 with fine felt pen; 22 with steel pen.

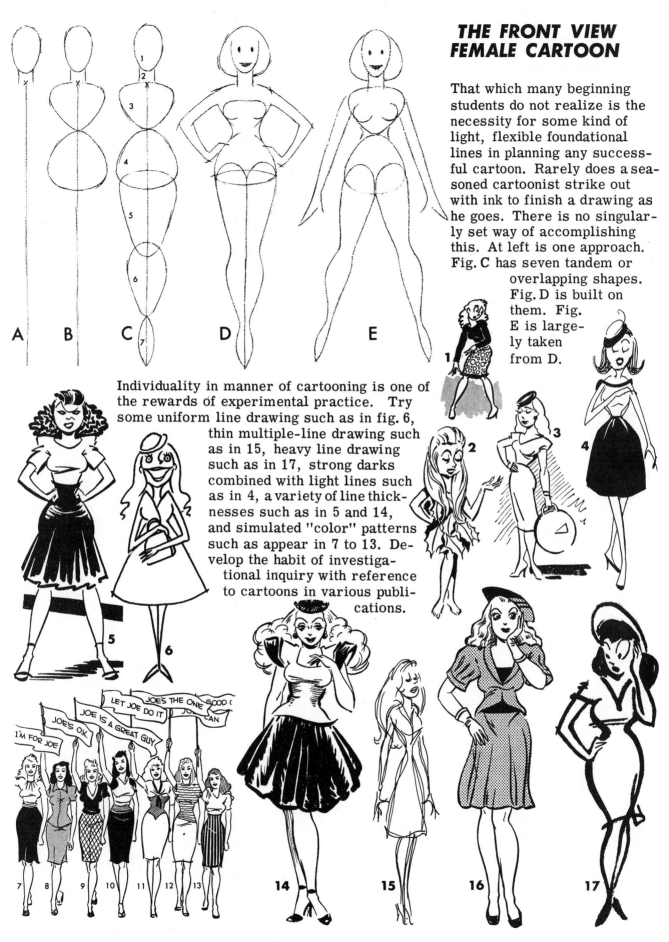

THE FRONT VIEW FEMALE CARTOON

That which many beginning students do not realize is the necessity for some kind of light, flexible foundational lines in planning any successful cartoon. Rarely does a seasoned cartoonist strike out with ink to finish a drawing as he goes. There is no singularly set way of accomplishing this. At left is one approach. Fig. C has seven tandem or overlapping shapes. Fig. D is built on them. Fig. E is largely taken from D.

Individuality in manner of cartooning is one of the rewards of experimental practice. Try some uniform line drawing such as in fig. 6, thin multiple-line drawing such as in 15, heavy line drawing such as in 17, strong darks combined with light lines such as in 4, a variety of line thicknesses such as in 5 and 14, and simulated "color" patterns such as appear in 7 to 13. Develop the habit of investigational inquiry with reference to cartoons in various publications.

I'M FOR JOE

JOE'S O.K.

JOE IS A GREAT GUY

LET JOE DO IT

JOE'S THE ONE

GOOD

SIX SIMPLIFIED METHODS OF FEMALE CONSTRUCTION

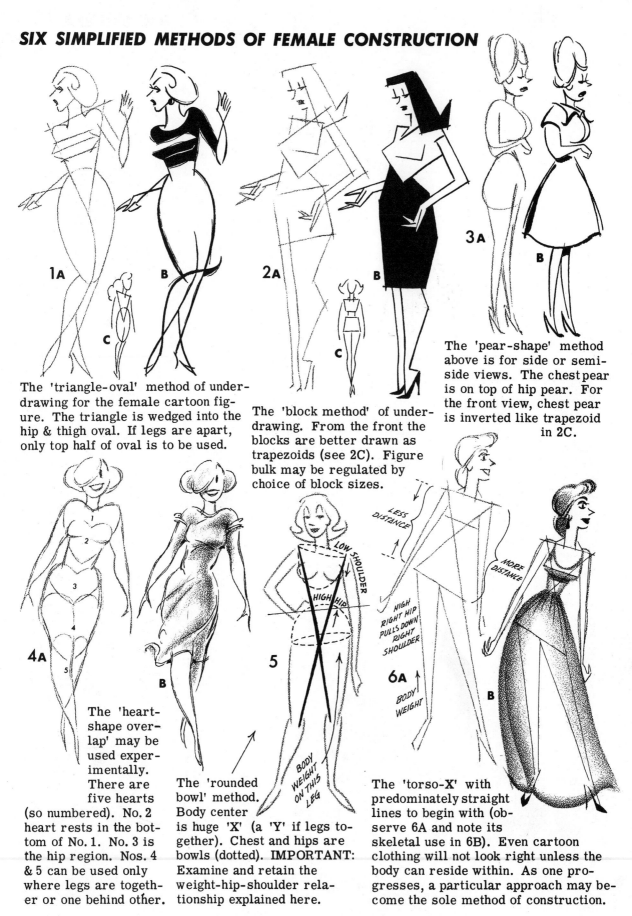

The 'triangle-oval' method of under-drawing for the female cartoon figure. The triangle is wedged into the hip & thigh oval. If legs are apart, only top half of oval is to be used.

The 'block method' of under-drawing. From the front the blocks are better drawn as trapezoids (see 2C). Figure bulk may be regulated by choice of block sizes.

The 'pear-shape' method above is for side or semi-side views. The chest pear is on top of hip pear. For the front view, chest pear is inverted like trapezoid in 2C.

The 'heart-shape over-lap' may be used experimentally. There are five hearts (so numbered). No. 2 heart rests in the bottom of No. 1. No. 3 is the hip region. Nos. 4 & 5 can be used only where legs are together or one behind other.

The 'rounded bowl' method. Body center is huge 'X' (a 'Y' if legs together). Chest and hips are bowls (dotted). IMPORTANT: Examine and retain the weight-hip-shoulder relationship explained here.

The 'torso-X' with predominately straight lines to begin with (observe 6A and note its skeletal use in 6B). Even cartoon clothing will not look right unless the body can reside within. As one progresses, a particular approach may become the sole method of construction.

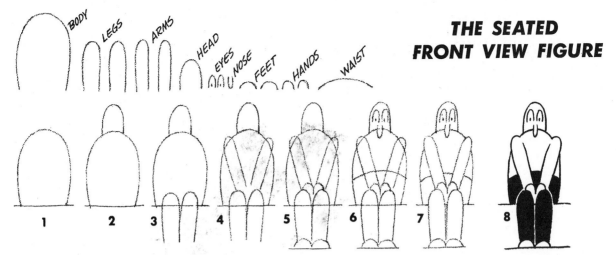

There are people who think of cartooning as very complex. Some of it may be, but lots of excellent cartooning is quite simple. This little fellow (figs 1 through 13) we might call the 'U' man. He is made entirely of U's, mostly inverted. Take a look at the isolated parts on the top row.

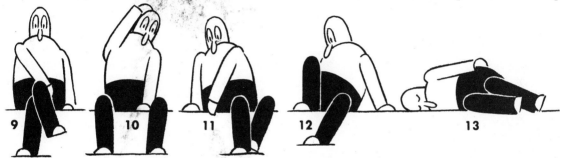

There is a dual purpose in including the 'U' man. He can help us in understanding some of the principles of the front view sitting posture in which our concern is from the waist down. Examine figs. 8 through 12 (in 13 he gives out on us and goes to sleep). Pay special attention to the legs. Notice the thighs are not there; only the lower legs from the knees down appear. It would be no problem to run a short line off the top of the knee to represent the thigh. This would be the foreshortened part which often seems to give so much trouble. The point is: in a straight front view sitter, think of the lower legs from the knees down; establish these, then become concerned with the foreshortened thigh.

It is well to be observant of sitters both in real life and cartoon. They are not difficult to draw if one remembers the principles mentioned above.

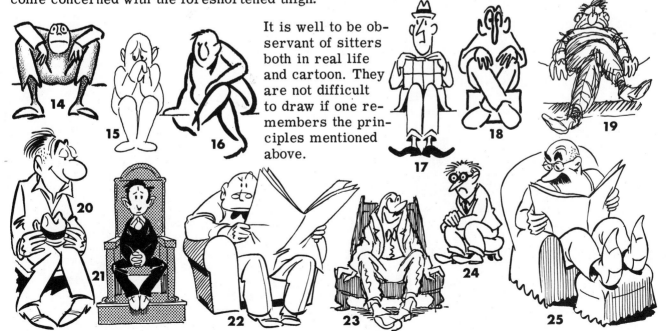

THE SEATED SIDE VIEW MALE

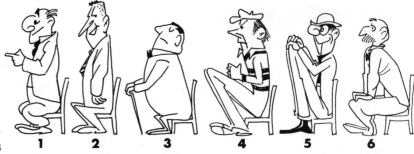

1 2 3 4 5 6

The beginning student will often go for years without realizing that many cartooned people have extremely short legs -- more often than short arms. This radical departure from real life goes completely unnoticed by the average layman. Here are some examples of different handlings, legs parallel, in the side view sitting position. Figs. 1, 2 & 3 have short legs in comparison to the rest of the body: 1, round; 2, thin and angular; 3, 'birdlegs.' Figs. 4, 5 & 6 have varying lengths of long legs: 4, sits on a point; 5, abnormally long legs (not often done); 6, long thighs & shorter lower legs. Watch for cartoon leg lengths and how they bend when seated.

ALERT NORMAL RELAXED SORROWFUL DEFEATED

1 2 3 4 5

EXHAUSTED 6

DISGUSTED 7

SITTING AND EMOTIONS

Throughout this book there are scores of sitting figures. Even so, to discuss specifically some of the factors involved helps when it comes to the actual drawing. The degree of backbend when seated can aid in the expression of feelings and emotions. Certainly this is not essential to the emotions in all cases. The face, the set of the head, the hands -- all are talebearers of the emotions; but the body proper can convey a lot, too.

SITTING WITH LEGS CROSSED

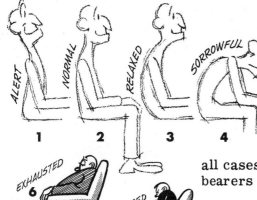

A B C

D

At right is a breakdown of a simple figure sitting cross-legged, semi-side view.

8

9

In drawing crossed legs one must make the disappearing portion of the legs come out correctly on the other side (see figs. 14 and 15). In penciling the leg lines, they may be permitted to run through and across each other as the dotted lines indicate. These are long legs -- try several lengths, even extremely short legs as in 12 and 13.

FAR LEG CROSSED

NEAR LEG CROSSED

LOOKING UNDER CUFF

LOOKING OVER CUFF

SHOE TOP

SHOE BOTTOM

LEGS APPEAR TO BEGIN AT SAME PLACE

10

11

12 13

14

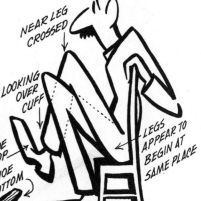
15

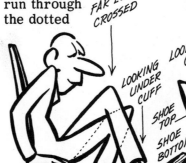

THE SEATED FEMALE

Two triangles can be useful in learning to cartoon the seated female.

1

A

Lightly sketch triangles, the bottom being larger.

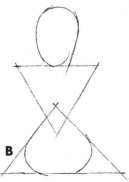

B

Add head oval and hip outline.

C

↑ Block in figure with simple penciling.

D

Finish cartoon in pencil or ink.

There are many kinds and ways of cartooning the female sitting down. First, one must decide what is wanted: a cute or pretty cartoon type, a semi-cartoon type or one of a slap-stick variety. The purpose in doing the drawing will help in the decision. A gag line may call for 'corny' characters which are dealt with in several sections of this book (see example 2 at left). Or the purpose may invite a portrayal which is only semi-cartoon (such as figs. 3, 4, 7 or 12). Some would judge others on this page as being in the semi-cartoon class. The extent one digresses from the possible is strictly up to the cartoonist. Follow the simple blocking procedure recommended in preceding pages. With the sitting posture it is well to lightly set down the trunk of the figure first in both the side and front views. Indicating the head and legs usually comes next, then the arms, hair and finally the various details.

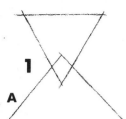

2

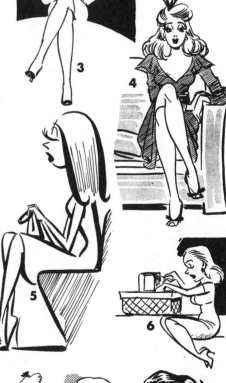

3

4

5

6

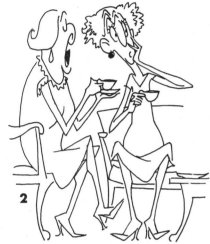

7

8

9

10

11

12

13

14

THE KNEELING AND BOWING POSITION

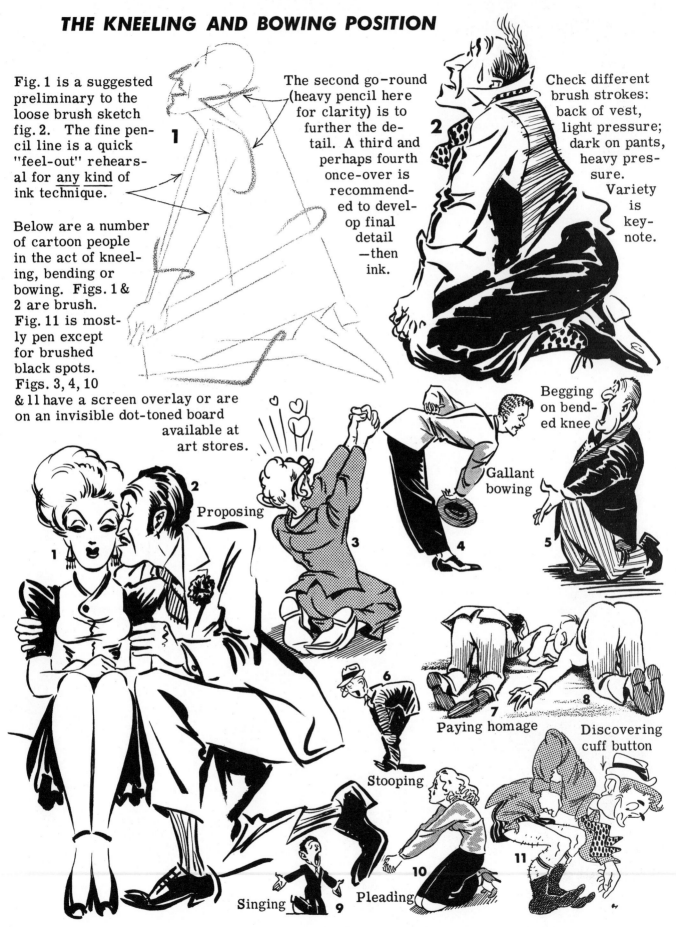

Fig. 1 is a suggested preliminary to the loose brush sketch fig. 2. The fine pencil line is a quick "feel-out" rehearsal for any kind of ink technique.

Below are a number of cartoon people in the act of kneeling, bending or bowing. Figs. 1 & 2 are brush. Fig. 11 is mostly pen except for brushed black spots. Figs. 3, 4, 10 & 11 have a screen overlay or are on an invisible dot-toned board available at art stores.

The second go-round (heavy pencil here for clarity) is to further the detail. A third and perhaps fourth once-over is recommended to develop final detail —then ink.

Check different brush strokes: back of vest, light pressure; dark on pants, heavy pressure. Variety is keynote.

Proposing

Gallant bowing

Begging on bended knee

Paying homage

Discovering cuff button

Stooping

Singing

Pleading

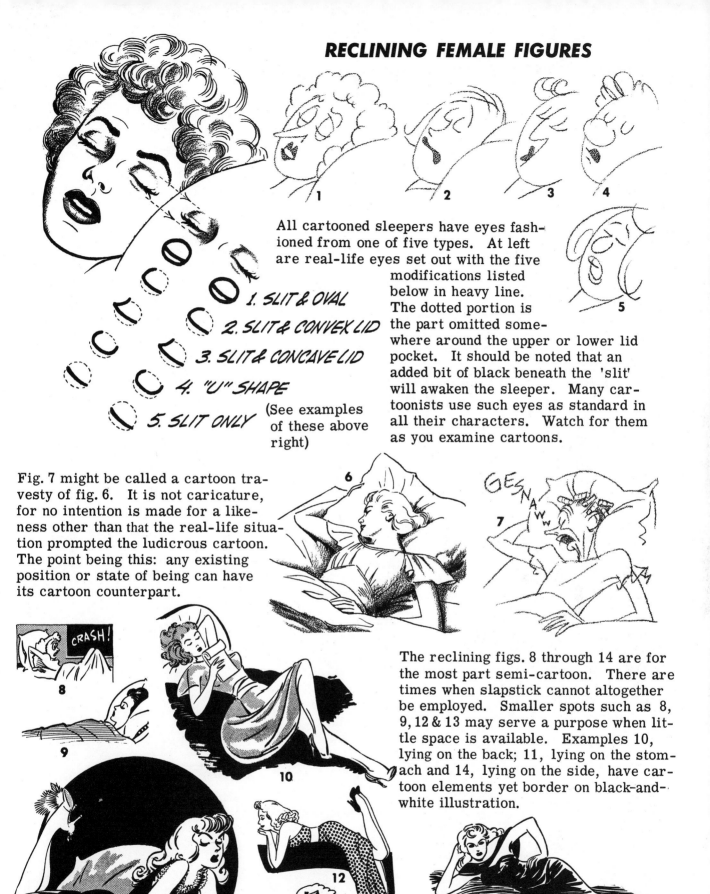

RECLINING FEMALE FIGURES

1 **2** **3** **4**

5

All cartooned sleepers have eyes fashioned from one of five types. At left are real-life eyes set out with the five modifications listed below in heavy line. The dotted portion is the part omitted somewhere around the upper or lower lid pocket. It should be noted that an added bit of black beneath the 'slit' will awaken the sleeper. Many cartoonists use such eyes as standard in all their characters. Watch for them as you examine cartoons.

1. SLIT & OVAL

2. SLIT & CONVEX LID

3. SLIT & CONCAVE LID

4. "U" SHAPE

5. SLIT ONLY (See examples of these above right)

Fig. 7 might be called a cartoon travesty of fig. 6. It is not caricature, for no intention is made for a likeness other than that the real-life situation prompted the ludicrous cartoon. The point being this: any existing position or state of being can have its cartoon counterpart.

6

GESNAWW **7**

CRASH! **8**

9

10

The reclining figs. 8 through 14 are for the most part semi-cartoon. There are times when slapstick cannot altogether be employed. Smaller spots such as 8, 9, 12 & 13 may serve a purpose when little space is available. Examples 10, lying on the back; 11, lying on the stomach and 14, lying on the side, have cartoon elements yet border on black-and-white illustration.

11

12

SOB **13**

14

CARTOONING MALES IN BED
—SIDE VIEW

It is always a problem to know how simple or complex to make beds and characters lying in them. Fig. A is about as simple as they come. It is flat with little feeling of dimension. On occasion in cartoon this may be acceptable, but rarely. Ordinarily more modeling is wanted. Fig. B has a little perspective in the bed, more shape indicating a body under the sheet or blanket and an indented pillow. Fig. C has still more contour changes in the bed clothes but only one interior wrinkle from the knees and a slit in the pillow slip. Fig. D shows some interior wrinkles in both the pillow and bed clothes. Even the mattress bends to conform with the body. In fact there is nothing more wrinkly than slept-in sheets on a bed, and blankets run a close second depending on their thickness. When you run across a comic of somebody in bed, clip it and file it. This will add to your cartoon knowledge.

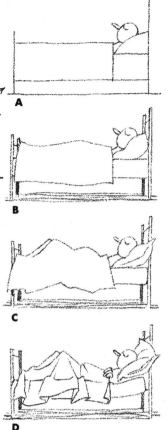

The insomnia sufferer of fig. 1 has his sheet in a hopeless snarl. In fig. 2 the thoughtful wife is prepared for the coffee shortage. Notice the shape of the lazy burglar squished down in his bed, fig. 3. A partial outline of the character is sufficient. The disheveled sleeper snoring great 'Z's' in drawing 4 must have tossed and turned earlier. It is well to stop and examine pillows on this and all the sleeping pages. See how part of the face or head is 'cut off' by this side of the pillow's puff. Draw the head, then hide part of it by a curve from the pillow. The young grad is having a nightmare in 5. Both 6 and 7 are GI's on steel cots, the latter having had an unfortunate accident. Bare feet sticking out of bed are always good in cartoon (see 1, 5, 6 & 7).

1 INSOMNIA

IT'S COFFEE...HUSH AND GO TO SLEEP

2

BR·R·R·R — IT'S TOO COLD TO CONDUCT BUSINESS

TOOL KIT

3

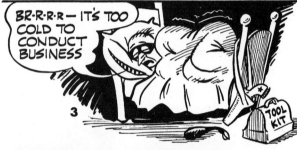

YOU FLUNKED

OH NO-NO NO

5

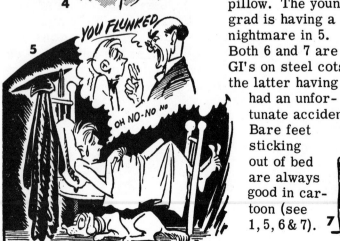

4

6

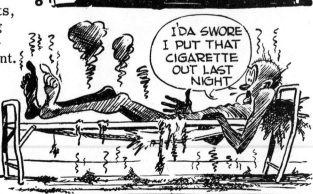

I'DA SWORE I PUT THAT CIGARETTE OUT LAST NIGHT

7

MALE RECLINERS —ADDITIONAL POSITIONS

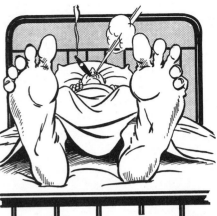

1

2

3a

3b

When one is to cartoon a body in bed, it is of importance to determine the size of the bed first of all. Fig. 1 is the top of the bed drawn by simple laws of perspective; that is, if the dotted lines were continued on either side they would eventually meet. Fig. 2 shows fig. 1 repeated to make a box, the headboard being added afterward. Then, still in fig. 2, the simplified character is laid to rest. There is no need to develop him completely, for he is to be covered up. Of course, he could be covered as in 3b which calls for only a head, but it's more interesting to drape the cover over the simple 'bumps' of fig. 2: the tummy, the knees and toes. Try some simple figures of your own!

8

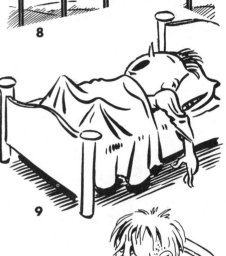

9

It is true, not everyone sleeps with his shoes on as in fig. 4. In cartoon the bed posts are often slanted out or in as in figs. 5 and 10. Notice the drapes over the form in 6, 8, 9 & 10. There are other beds (of nails) in 7 and the couch sleeper 11. Fig. 12 has asthma, is a wheezer, and 13 just awakened with that 'dark brown' taste.

4

5

6

It is said, cartoonists love to recline (?). Study yourself!

10

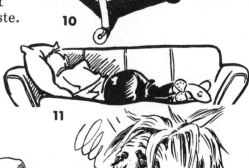

11

I SEE WHERE THESE AMERICANS ARE PAMPERING THEMSELVES AGAIN

7

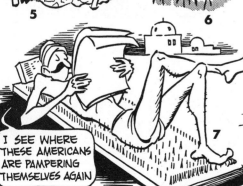

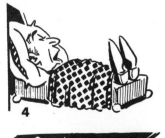

BLAAA FAAA

12

13

THE WALK IN CARTOON — ANGULAR AND ROUNDED BEGINNINGS

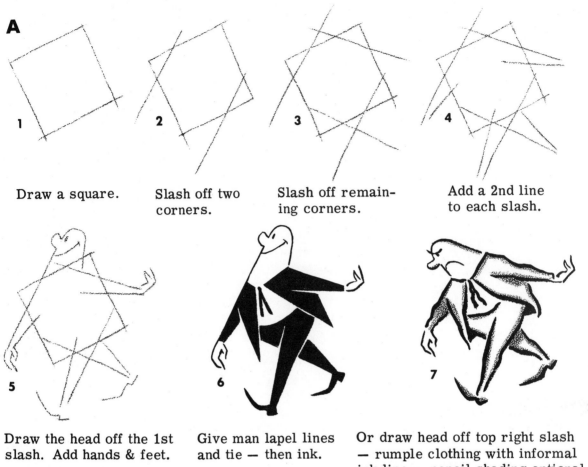

A

1 — Draw a square.

2 — Slash off two corners.

3 — Slash off remaining corners.

4 — Add a 2nd line to each slash.

5 — Draw the head off the 1st slash. Add hands & feet.

6 — Give man lapel lines and tie — then ink.

7 — Or draw head off top right slash — rumple clothing with informal ink line — pencil shading optional.

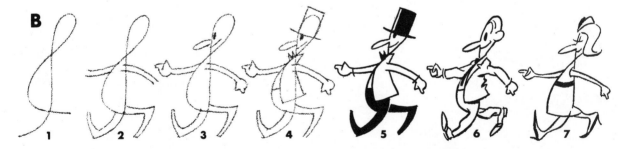

B

From a modified 'treble clef' build a formal or informal little man — or woman.

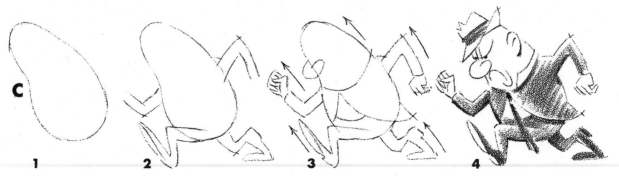

C

From a bean or pear shape one can do a thousand things — like this very determined walker. Notice the drive forward (arrows in fig. 3). The pear shapes may be different.

OVER 150 SIDE VIEW WALKING COMBINATIONS

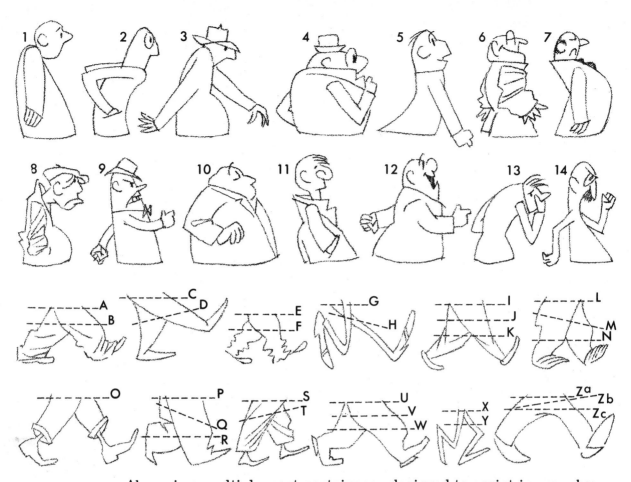

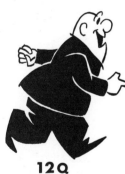

12Q

11H

Above is a multiple-part contrivance designed to assist in new character creation as well as teach the student much about the cartoon walk. There are over 150 possible combinations using a new set of legs each time for figures 1 through 14. These little men are simple and easy to duplicate or transfer onto tracing paper for the sake of the exercise. Simply lower the bodies onto the legs. Place the waist line directly over the dotted line which fits best. Some of the bodies will look better joined with a lower dotted line than a higher dotted line on a particular set of legs.

For example, 10M looks better than 10L, whereas the L legs look all right with body 5. As one gets into the exercise, he will learn to pass his own judgment as to the best waist line settings on the various legs. A few of the legs have dotted line tilts suggested. This does not mean a body cannot be tilted on another set of legs. Often a rear back looks quite funny — try 7T or 4D. Similarly, the body thrown forward such as the 12Q pairing (example at left) gives a jaunty walk. 11H (below left) is another example of an interesting combination. In some cases the legs may be shifted to the front or back of the body, or they may be centered.

If one wishes the 'other' leg to lead out (so the leg and arm on one side are opposite as in a natural walk), then alter the legs' positions with a few line changes. Ink the walkers using different black and white patterns.

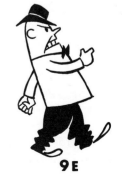

9E

THE 'WALK WHEEL'...OVER 125 FRONT VIEW WALKING COMBINATIONS

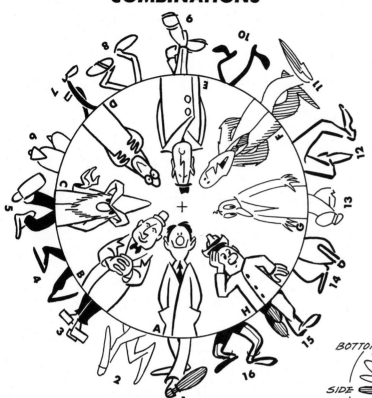

Above is a device featuring eight bodies and 16 different pairs of walking legs. It is not necessary for the student to fashion one of these wheels — a quick outline on tracing paper will suffice if one wishes to check out a combination experimentally. Any of the bodies may be rotated over any of the legs.

The size of the pencil, pen or brush and one's own individual manner of handling will tend to relate the variations in most cases. The coats may be opened or shortened and the waistline of the pants drawn in. Many cartoonists habitually have little legs come out of large bodies. There is no law that says one can't try anything under the sun. That's one reason why cartooning is genuine fun.

Observe:

❶ A slight twist so the legs are not walking exactly toward the viewer (as in 2 & 13) still looks right over a straight-on body.

❷ Seldom do cartoon folk walk pigeon-toed, but the feet many times flop out abnormally.

❸ When the bottom of the foot shows, it may be squared (5), pointed (6 & 11), rounded (1 & 13), sides parallel (14) or an oval. (Study next column before continuing observations)

LEG AND FOOT FACTORS

To put one's best foot forward is to know what to do with it once it's out there. The front view walk is more difficult to draw than the side view walk. It envolves foreshortening which to the beginner is puzzling. However, once one has compared and discussed the possibilities, the solutions come much more easily. As a cartoonist acquaints himself with a walk of any kind, he must knowingly or otherwise deal with the following factors (these diagrams are not meant as models to incorporate in actual drawing; only to explain a principle):

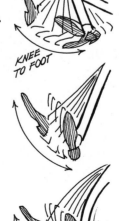

Consider:

A
THE FOOT —its angle and exposure, whether bottom, side, top or foreshortened.

B
THE UPPER LEG —its angle and exposure (in a walk it's seldom lifted above 'x' marking).

C
THE LOWER LEG —its angle and exposure (all the indications from A through E are the right leg).

D
THE STRAIGHT WHOLE LEG —its angle and exposure (oftentimes there is no bend at the knee).

E
THE ARCHED WHOLE LEG —its angle and exposure (in cartoon this curvature often occurs).

(cont'd from under the 'walk wheel')

❹ In keeping with item No. 2, for there is some connection, notice how very often cartoon characters walk with their knees out (see legs 4, 5, 8, 10, 11, 12, 14 & 16 on the wheel besides countless examples throughout the cartoon world).

❺ Considering the 'Leg and Foot Factors' in the preceding column, keep in mind that it's best to sketch the outline of the front-most leg first as one attaches these underpins to the body. This is especially true if there's overlap in the legs (1, 2, 3, 6, 7, 9, 11, 13, 14 & 15). Moreover, don't fully complete any part of your concept until it's all blocked-in lightly on the paper.

❻ The heel may be expressed by a single line (2), a double line (8), a drop-off from the sole (5 & 6) or a build-out from the sole (11 & 13). Indeed, there may be no heel at all (wheels 4, also 20, 24, 26, 27 & 28 below). Note the spur-like heel (wheels 7 & 10).

❼ Occasionally try silhouetted legs under any kind of body (see legs 4 & 10 on the wheel). Such may be very thin even though the arms may not be.

❽ Experiment some with a shadow on the legs under the hem of the coat (15 & 16 on the wheel besides 23 below).

❾ Rather outlandishly big feet (wheels 1, 2, 9 & 11) or extraordinarily small feet (4 & 7 — more especially 27 below) may amply hold up the cartoon man.

Note: When the arms swing freely, feet swing opposite in the stride; hence, in 17 the right elbow is back, the right leg forward; in 18, right arm forward, right leg back; etc. (this is usually true unless hands are doing something like 22's finger-in-mouth or 23's clutching newspaper to chest). Hands by side and one foot simply lifted makes 26 look like he's just rocking back and forth getting nowhere. Even a thumb or finger in

front of the body and the other hand behind helps the stride (see 19, 20, 25, 27 & 28). Despite 27's having both feet flat on floor, he appears to be in a fast walk. The reason for this is partially perspective, a larger leg in front of a smaller one (notice the overlap and distance between feet), also the arms are swinging vigorously. Check the light, airy touch of the heel-toe walk of 21; the slow flat-footed shuffle of 24; the stiff jolt of 30 (a semi-abstraction — heavy lines on advancing leg, light lines on retreating leg). Check the shadows on foot soles: the lengthwise lines in front of 19's heel; crosswise lines in front of 31's heel; all-over shadow of No. 1 on the wheel; the white sole of 23 and black sole of 30.

59

CREATING FORWARD MOTION IN THE FRONT VIEW WALK

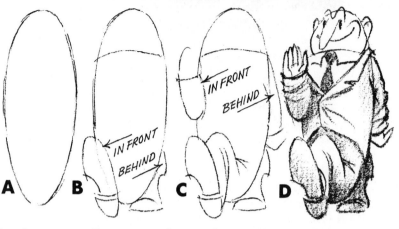

The dumpy little fellow at the right will serve to illustrate further the walking principle of getting something to lead in front of something else in order to create forward motion. In fig. B one foot is in front, the other behind. In fig. C one arm is in front, the other behind. Naturally, of the two, the lower limb is more important in walking. The arms simply help the stride.

There are only four ways an artist can produce the illusion of forward motion (back to front) in two dimensions: 1. By perspective (things getting larger as they come forward, smaller as they go back), 2. By overlap (one thing in front of another), 3. By values (dark and light) and 4. By color (its several attributes). The cartoonist must use the first two almost exclusively. When one or more cartoon characters are considered apart from their surroundings, item 2. overlap assumes priority over all other ways. In the case of 'Mr. Dumpy' above, the foot overlaps the lower leg, the lower leg overlaps the upper leg, the whole leg overlaps the body and the body overlaps the remaining foot in the rear. NOT ONLY IN THE FRONT VIEW WALK, BUT IN ALL CARTOON ACTIVITY, THE FOREGOING IS MOST SIGNIFICANT.

PERSPECTIVE AND OVERLAP IN THE WALK

Sometimes it's possible to work in a feeling of PERSPECTIVE plus OVERLAP in creating forward motion in the front view walk. In E it is obvious that the leg arc gets larger as it comes forward. In F the back leg is smaller but has been bent to allow for overlap. The heel is hidden, the root of the back leg is hidden and in both E and F the top of the lead foot is hidden behind the sole.

THE WALKING FRONT VIEW WOMAN

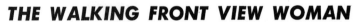

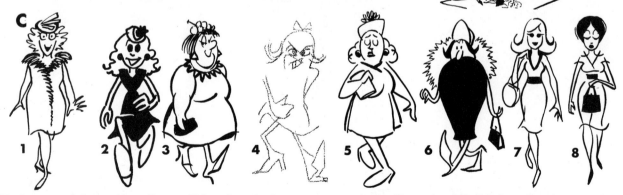

We have not forgotten the walking front view woman. Actually, most initial male cartoon beginnings may be changed into a comic lady. Here are several types. No. 6 is just an overturned vase. Although perspective and overlap apply in drawing the walking female, as a rule this may not appear as pronounced due to a lack of the wide pant leg. Still, notice the smaller leg in back (perspective) in 1 & 8. Also find some form of overlap in all eight figures.

THE MAGIC OF 'STRAIGHTS' IN A CARTOON WALK

Some of the funniest cartoon walks are built on 'straights' running through the body (see 1B and 2B at right). The arms dangle, and the body either leans forward (1) or leans backward (2). 1D and 2D are two of the many variations. Notice, too, that figs. 4, 8 & 10 lean back, while figs. 3, 5, 7 & 9 lean forward. Try some of your own creations constructed on the 1A and 2A plans. Use different heads and clothes.

1A **B** STRAIGHT STRAIGHT STRAIGHT **C** **D**

2A **B** STRAIGHT STRAIGHT STRAIGHT STRAIGHT **C** **D**

3 ARF!

4 5 6 7 8 9 10 11 12

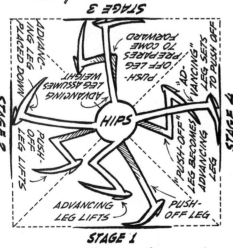

STAGE 3

ADVANCING LEG PLACED DOWN

"OFF LEG" PREPARES TO COME FORWARD

ADVANCING LEGS ASSUMES WEIGHT

PUSH-OFF LEG LIFTS

"PUSH-OFF" LEG SETS TO PUSH OFF

HIPS

"ADVANCING" LEG BECOMES ADVANCING LEG

STAGE 2

STAGE 4

ADVANCING LEG LIFTS

PUSH-OFF LEG

STAGE 1

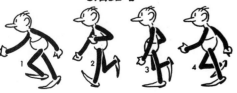

1 2 3 4

At left are four possible stages of a side view walk. They are illustrated in simple drawings below the square. Stage 4 makes a '4'.

The 'rolling' walk. Arms and legs curve in.

13 14

BACK VIEW WALK

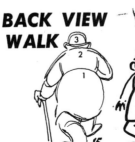

Sketch area 1 first, then 2 & 3 overlapping.

15 16 17 18 19 20

THE RUN IN CARTOON

Making a cartoon figure run is partly 'positional.' Fig. 1 appears to be running faster than fig. 2 and both 1 and 2 seem to be going at a greater pace than the plodding fig. 3, yet all are identically the same figure. First, it is necessary to get your running figure off the ground. Second, he is made to travel faster by a tilt, one way or the other. Third, 'speed lines' trailing off the body move him faster yet. The number of speed lines is up to the cartoonist, but they should never be above or below the actual extremities of the figure. Indeed, it is a good idea to have one or two coming off of the extremities besides the few in between. Some cartoonists use a few dust clouds even in an immaculately-kept interior or elsewhere very unlikely to have dust, and that's all right too — it's the illusion of speed that counts.

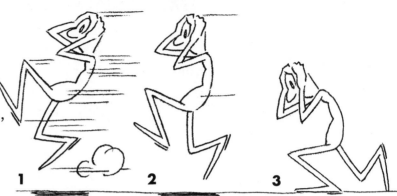

THE 'REACHING' RUN

A good exercise is to take some kind of shape like the fat oval (fig. 1) and see how fast it can be made to run. Of itself it is a somewhat clumsy shape, but then so are a lot of cartoon people which are to be turned into runners. This is a 'reaching' run with both arms in a parallel stretch, an example of cartoon license, for no one can run very fast and keep his arms in this position. Usually a reaching run denotes one of the following: extreme joy and anticipation, great urgency, a fearful effort to escape, anger, excitement or a hectic chase.

1

The oval

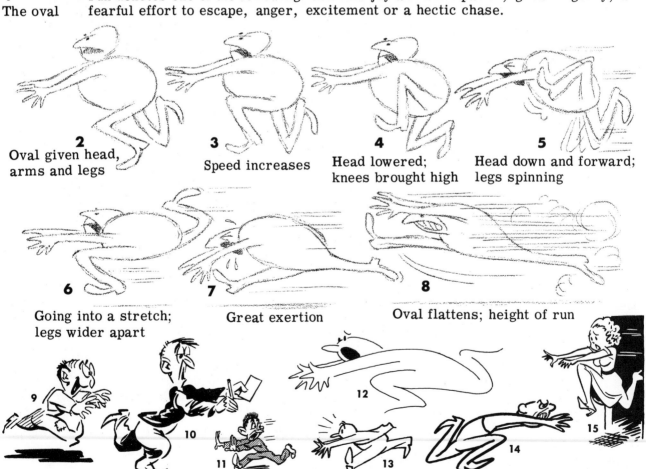

2
Oval given head, arms and legs

3
Speed increases

4
Head lowered; knees brought high

5
Head down and forward; legs spinning

6
Going into a stretch; legs wider apart

7
Great exertion

8
Oval flattens; height of run

THE 'DESPERATION' RUN

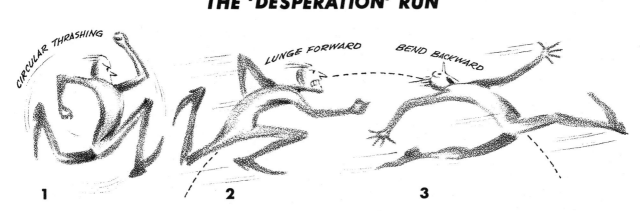

The cartoonist must decide on whether or not his side view runner will tend to be upright (1), lunging forward (2) or bending backward(3). Anyone of these can be made a 'desperation' run, which is often desired in cartoon. The above are stringbean types, lean and lank; but the same

general action can be squatted down in a rotund type of figure (see Nos. 4, 5 & 6 at the left). The 1st and 4th runners are chesty and determined. At the right is a fellow with legs and arms in very much the same

position except that his whole torso is underslung. The curvature of his spine is exactly the opposite, and one can well imagine his motive in running is entirely different.

When building up the underdrawing for a cartoon runner under great strain, one should ask himself: is this the limit of strain that might be expected from each given part of the body? Are the elbows, shoulders, knees, ankles, even the face — all straining to the limit? Think the position in the process — in short, mentally become the runner. Below is one way of doing it, but there are many ways. Experiment!

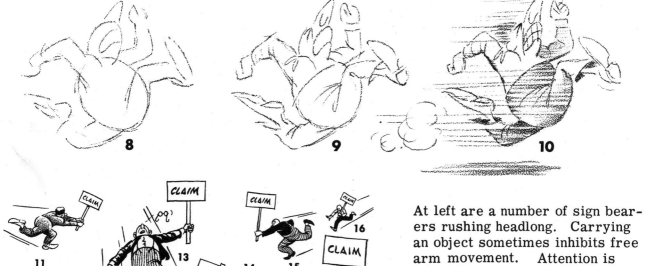

At left are a number of sign bearers rushing headlong. Carrying an object sometimes inhibits free arm movement. Attention is called to the position of the head, often lowered. A camera would catch some of them as the legs passed each other, but in a cartoon usually the legs are separated noticeably.

RUNNING FIGURES — IN EASY FOLLOW-THROUGH STAGES

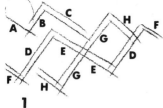

It is possible to create a running figure carrying many 90° angles throughout. At left are the general lines (out of position) of fig. 3: A, face; B, neck; C, spine; D, lower leg; E, thigh; F, foot; G, upper arm; H, lower arm. Fig. 2 is the stick action (notice head's position thrust forward). Fig. 3, the double line core. Fig. 4, modeling on the core. Fig. 5, light inking with underdrawing erased.

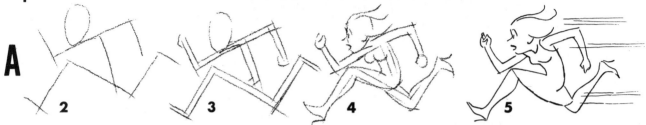

Below is a runner coming toward us. Check the notations around fig. 5. Each contributes to the use of perspective in bringing the runner forward. Retreating dust clouds under fig. 4 and a shadow on the ground may be employed.

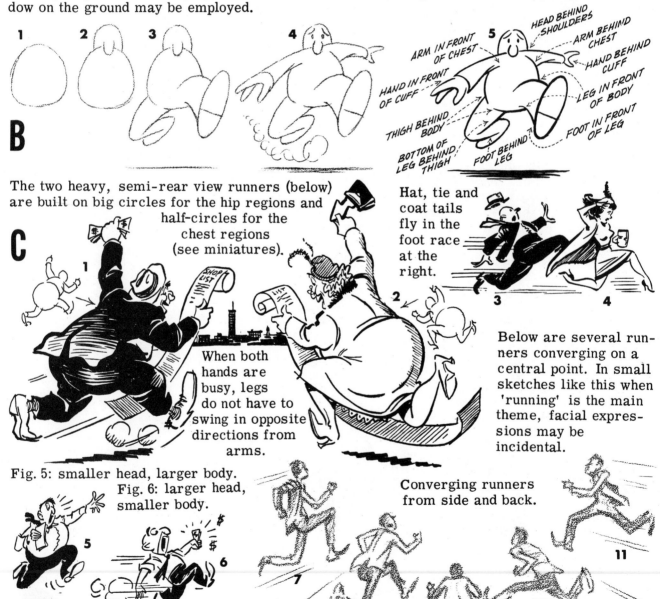

The two heavy, semi-rear view runners (below) are built on big circles for the hip regions and half-circles for the chest regions (see miniatures).

When both hands are busy, legs do not have to swing in opposite directions from arms.

Hat, tie and coat tails fly in the foot race at the right.

Below are several runners converging on a central point. In small sketches like this when 'running' is the main theme, facial expressions may be incidental.

Fig. 5: smaller head, larger body.
Fig. 6: larger head, smaller body.

Converging runners from side and back.

THE HAND IN CARTOON — A SIMPLIFIED GUIDE: EIGHT BASIC HAND GROUPS

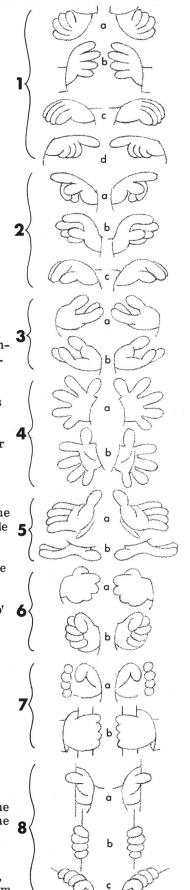

From the 8 basic hand groups in the right-hand column one can make his cartoon character do about anything. Some cartoonists use less than these and get along quite well. These 8 are the 'inflated' cartoon type without nails or knuckles. A number of famous cartoonists, comic, gag and commercial, have used this type. Thinner or 'knuckled' fingers could be run through these same patterns. Here several variations of each basic pattern are given which may prove helpful in particular instances. Also, both left and right hands are shown as an added help.

It is suggested that the student practice these in three ways: <u>One</u>, as they are. <u>Two</u>, by choosing a different finger or palm shape (see assorted styles on the following pages) and drawing them in these basic hand positions. <u>Three</u>, by devising still different positions after a working familiarity with these 8 has been attained.

1 This group has a parallel feeling running through the fingers without the thumb (which is on the other side) being shown. In <u>1d</u> the index finger has been lifted out as a pointing hand, but it may be curved in and around easily like the remaining fingers. <u>1a</u> may be hand hanging at side. It also may be considered a very elemental position for reaching, waving or holding (notice fingers overlap and fan). <u>1b</u> and <u>1c</u> may serve the purposes mentioned for <u>1a</u>. <u>1c</u> will lie flatter on a surface of some kind. Stand a pencil behind the index finger of <u>1c</u> and it will appear to be writing. (ALL THESE HANDS IN THE ENTIRE COLUMN MAY BE DRAWN AT DIFFERENT ANGLES, EVEN TURNED UPSIDE DOWN, DEPENDING ON THE ARM AND DESIRED GESTURE.)

2 This group is from the thumb side. <u>2a</u> is the point. <u>2b</u> is grasping or reaching or even holding an object (for simplicity the palm line inside has been omitted). <u>2c</u> may be resting on a surface, or it will take a pen or pencil as if writing (see section on writing).

3 The open receiving hand is shown from the thumb side <u>3a</u> and the little finger side <u>3b</u>. Just two fingers may be drawn or the others behind them may barely show. In <u>3b</u> a palm line at the root of the fingers might ordinarily be drawn, but here, for the sake of simplicity, it is left out.

4 The spread fingers of <u>4a</u> and <u>4b</u> are often good to express excitement or some strong emotion. <u>4b</u> is really <u>4a</u> with two palm lines which change it to an inside hand. (In all these hands the sleeve may be pushed back or pulled down.)

5 Here we have the outstretched palm with fingers together. <u>5a</u> has a multitude of uses. Nearly always the <u>5a</u> hands are raised to some degree. Certain cartoonists make all the fingers the same length; others make them staggered as in real life. <u>5b</u> hands may be pressed on some surface or held up saying 'stop' to whatever someone is doing. Like <u>3a & b</u> only two fingers need show — more may be drawn, however, with just the top lines barely showing.

6 The clinched fist outside, <u>6a</u>, and inside, <u>6b</u>. Notice the thumb position in each. In <u>6b</u> the fingers fan slightly (as do your own — clinch them). These hands may hold wires, ropes and any thin strippings.

7 These holding hands are somewhat like the fist, but a thicker object inside reduces the clinched effect. Nothing has been put in <u>7a</u>; many things could be. The finger tips, like little round balls, peek around the object. <u>7b</u> could have a knuckle line with a little more of the fingers in evidence.

8 A thousand objects could be held by hands <u>8a</u>. The student may pick up the paper on which he is drawing and observe his own thumb. Especially notice the fleshy thumb base which is part of the palm. In holding an open newspaper, the cartooned figure may do it with <u>1b</u> left and <u>8b</u> right. Sometimes a big object will have the <u>8b</u> fingers reduced to <u>7a</u> proportions. <u>8c</u> fingers may be hanging from a ledge or when drawn upside down may 'backhand' a load of some kind. After thoughtful practice the student will be able to curl a straightened finger, straighten a folded one, lift a thumb or tackle head-on any kind of hand problem.

THE FOUR 'SHAPE TREATMENTS' IN CARTOON HANDS

The cartoon hand usually has one of four general shape treatments (apart from the technique itself). Below is an open hand illustrating these on each finger:

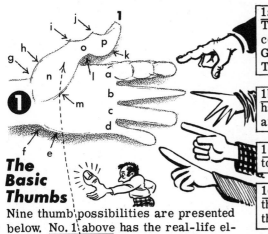

The Basic Thumbs

1a.] Some kind of exaggeration of the fingerbones and flesh pads. This is more likely to occur in editorial cartooning than on the comic page where the same character is repeated many times. Gag cartoonists use this some as do commercial cartoonists, but TV animators never.

1b.] Some form of a slenderized or pointed finger. This form of hand often appears to be 'scratched-in' zig-zag fashion. It may attend very informal, loose sketch drawing.

1c.] A somewhat 'box' treatment. The sides of the fingers tend to be more parallel, and the tips are modified squares.

1d.] A rounded bulge somewhere along the finger or throughout the entire finger. This may be done exactingly or informally to the point of looking hastily done.

Nine thumb possibilities are presented below. No. 1 above has the real-life elements, most of which are overdone. Many cartoonists let one or more of these characteristics flourish in their drawing. A few play up the arrowed

▶(Of course, there are some exceptions, and there are some hands which are combinations of several of the foregoing. As a rule, however, a cartoon hand will fall in one of the four categories.)

points (e to m); others consistently use only a few. It is a good practice to develop a habit of tracking down and identifying a successful cartoonist's pet points. That doesn't mean one has to copy him; but, afterall, a thumb has to look something like a thumb; it can't look like a knee joint. No one has a corner on the essentials.

① (Above left) Watch for the emphasis or lack of it at the heel of the hand (f & g). Many cartoon hands have a prominent thumb base (n). Look at the various thumb features from drawings 2 through 9 (identifying points comply with thumb No. 1 — all these thumbs are in proportion to hand No. 1):

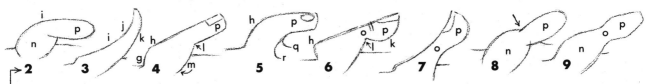

② Rounded thumb with heavy base (n), back of thumb rounded (i), rounded tip (p) — this thumb usually takes fingers answering to the description of 1d. *⟨SEE BOTTOM OF PAGE EXAMPLES⟩*

③ Tapered thumb with back concave (i-j), pad (k) rounded — usually takes fingers 1b, may take 1d.

④ Squared thumb with straight back, prominent drop-off at base (h to g), marked indention (l), palm line (m) always carried in — usually takes fingers 1c.

⑤ Thumb hooked with rounded back (h), parallel sides (p), inside thumb curves into hand anywhere from q to r, sometimes an oval thumbnail is used with this shape — usually takes fingers 1c.

⑥ Straight-backed thumb prominent at points h and k, thin across first joint (o), deep nick (l) — usually takes fingers 1d, perhaps 1c or 1a.

⑦ Bulbous thumb (p) with concave back, thin middle (o) — usually takes fingers 1d; will take all others surprisingly well.

⑧ 'Inflated' thumb much like No. 2 except at arrow (see hands in Eight Basic Groups on previous page) — usually takes heavy fingers of 1d variety.

⑨ 'Hammerhead' thumb (p), variation of actual real-life shape — usually takes some form of fingers 1a, but may take 1c and sometimes (rarely) 1d.

WAYS OF DRAWING CARTOON HANDS

One doesn't have to travel far to find hands. They're ever before us. Why then the difficulty in drawing them, even in cartoon? The reason is these five-digited instruments can assume so many shapes and do so many things — and that is well. With them we learn to draw. Moreover, we must learn to draw them too, for our characters can't forever sit on their hands or keep them in their pockets.

Many side view positions may be built on a triangle.

Many top or bottom view positions may be built on a modified circle.

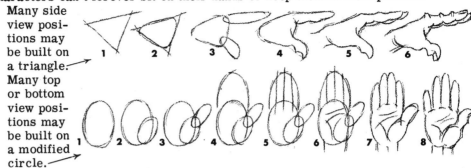

It is not possible to assemble every way of cartooning a hand. However, somewhere on the following pages are most of the ways. They have been classified according to function and position. They include various styles and techniques. Any given hand may be redone (with perhaps some alteration) in a different line width to more properly relate itself to the rest of the drawing. This fact remains: the more one examines, studies and draws hands, the better he may draw them entirely on his own. For this purpose these hands were set down.

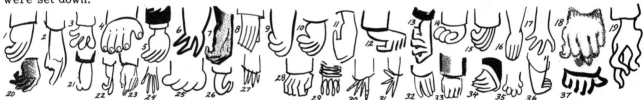

❶ HANDS HANGING BY THE SIDE — This is the position drawn most by the cartoonist. The thumb is toward the front or turned in toward the body. On a side view person the thumb may be out of sight as the arm hangs. As for the fingers, they curve toward the rear or toward the body when they are not straight and stiff (which they may be occasionally in cartoon).

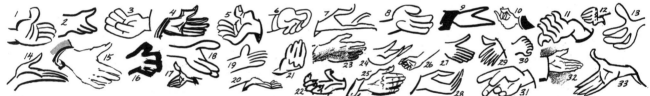

❷ HANDS REACHING OR EXPLAINING — First, the cartoonist should 'feel' (in his imagination) the position, whether the palm is laid open, fingers extended, or fingers partially closed. The extra finger on hands 27, 29 & 30 or the lack of a finger as in 8, 13 & 18 is 'cartoon license.' The former is sometimes used (but rarely) with the utterly irrational concept; the latter with the cute, pixy type (born with animation). The no-finger hand, 9, is ocassionally used for simplification or design (but is devoid of expression).

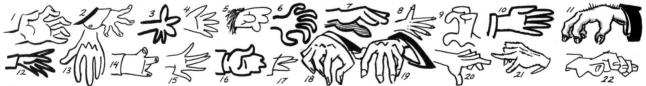

❸ HANDS GRASPING — This gesture is related to the one preceding, but may be more vigorously executed.

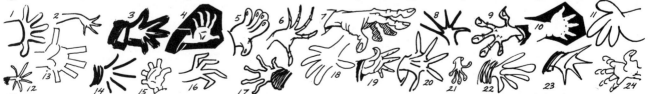

❹ HANDS 'EXPLODING' — These are the cartoon hands which express fright, fear, surprise or astonishment. The fingers appear to fly in all directions. This kind of hand is indispensable to the cartoonist.

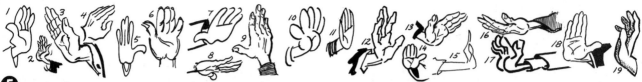

5 HANDS EXPRESSING 'NO, HALT OR STOP!'— Usually such hands are at right angles with the wrist. The fingers are grouped together more often than not, and the hand is forceably opened.

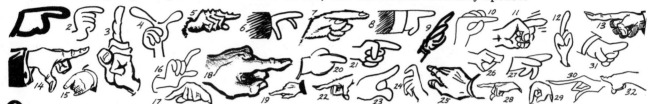

6 HANDS POINTING — This is a common position in cartoon, the index finger being extended and the other fingers usually closed. The thumb may be out, folded in, or, from the opposite side, hidden from view.

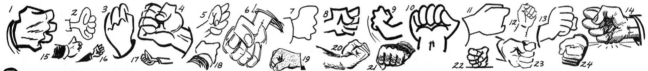

7 HANDS CLINCHED — The fist demands that the thumb and all the fingers be pulled in. More anger, belligerence or determination is expressed when the fingers are tightened and the thumb has both joints bent as much as possible. The nail section of the thumb usually lies alongside the first two fingers.

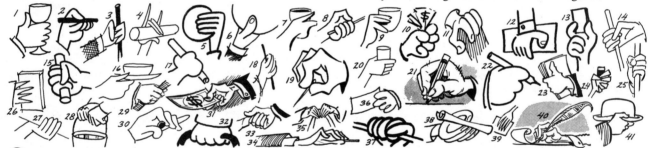

8 HANDS HOLDING OBJECTS — There is no end to these positions, for they partly depend upon the shapes of the objects held. The above, however, takes in a good many of them.

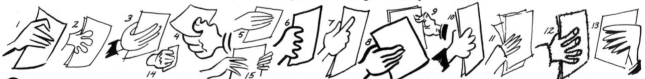

9 HANDS HOLDING LETTERS, CARDS OR PAPERS — These are grouped separately for quicker reference. When drawing a second hand on a cartoon character (if the other one shows — and this applies to every category of hands) it obviously should be related to the first, so that they both 'belong.'

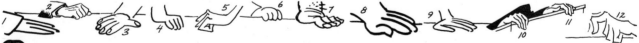

10 HANDS RESTING OR LEANING ON A FLAT SURFACE — The fingers usually are out parallel with the surface, but they may be tucked under on occasion.

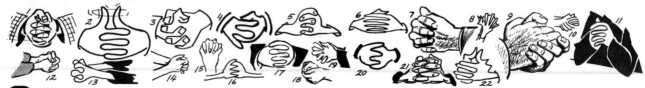

11 HANDS FOLDED — For a simple front view it is best to draw the fingers as a spring: ⧢ then add the backs of the hands and the thumbs after that.

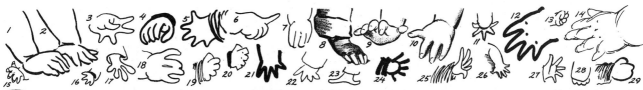

12 HANDS OF BABIES AND SMALL CHILDREN — Such hands are stubbier with the wrist as thick as the hand itself. Shorter fingers of babies taper suddenly from the tips, or the whole finger may be fatter.

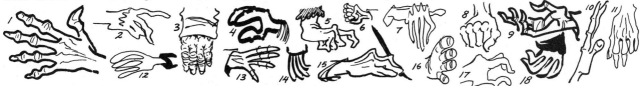

13 HANDS OF OLD FOLKS — In the cartoon world any hand can be used on anybody, and, if it pleases, who is to say it needs changing? On the other hand, actual age brings gnarls and wrinkles. Cartoon emaciation may be portrayed in hand as well as face.

14 HANDS OF WOMEN — Here again, in many cartoons the hands of women and men do not differ at all. Slapstick female hands can match those of a rock crusher. However, if the situation calls for it, the hands of a comic lady may need a daintier or lighter touch.

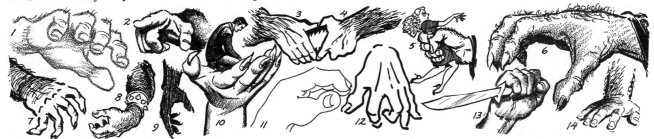

15 HANDS THAT ARE MASSIVE OR GRUESOME — The brutish or sinister character can better play the part with a different kind of hands. They need not be as detailed as some of the above examples. Heavy, thick fingers and thumb may suffice; or long, knotty fingers may fit the distortion one is after.

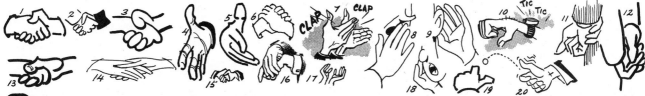

16 HANDS IN MISCELLANEOUS ACTION — It would be impossible to picture but a fraction of these positions. Here are a few which may help solve some puzzles. Use a mirror. Save and classify picture clippings.

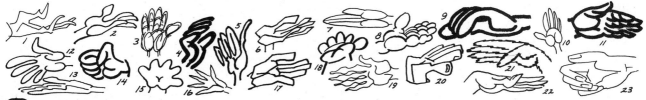

17 HANDS EMPHASIZING THE 'HEEL' ON THE LITTLE FINGER SIDE — The only reason for this listing is that most cartoon students are never aware of the back part or 'heel' of the hand, especially on the little finger side. Examine each closely. Such knowledge can be helpful. In the long run you'll save time.

CARTOONING LEGS AND FEET

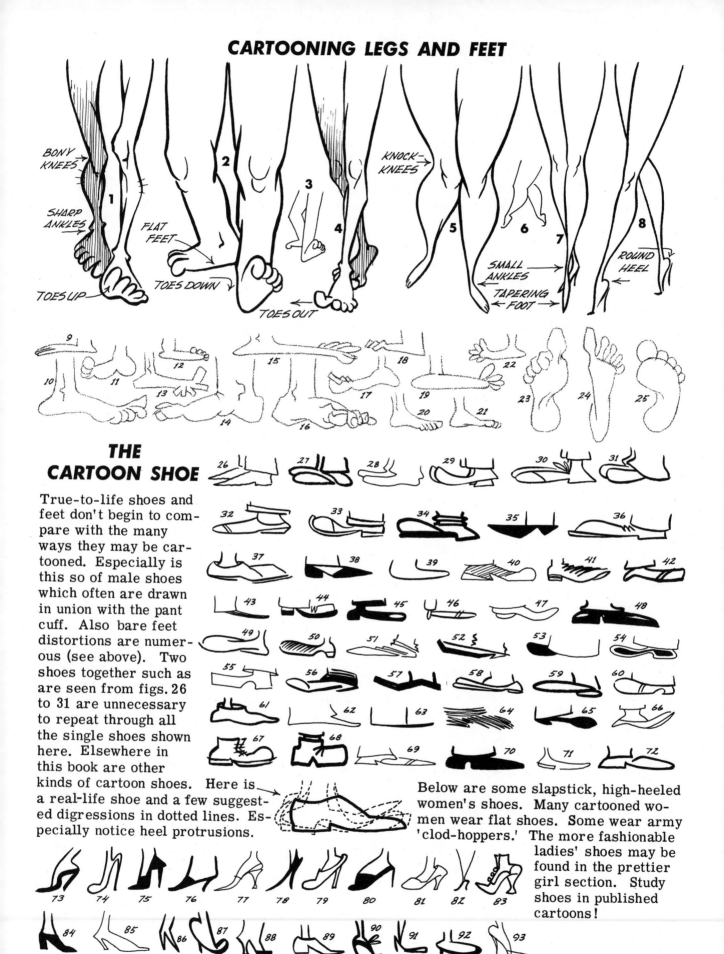

BONY KNEES

SHARP ANKLES

TOES UP

FLAT FEET

TOES DOWN

TOES OUT

KNOCK-KNEES

SMALL ANKLES

TAPERING FOOT

ROUND HEEL

THE CARTOON SHOE

True-to-life shoes and feet don't begin to compare with the many ways they may be cartooned. Especially is this so of male shoes which often are drawn in union with the pant cuff. Also bare feet distortions are numerous (see above). Two shoes together such as are seen from figs. 26 to 31 are unnecessary to repeat through all the single shoes shown here. Elsewhere in this book are other kinds of cartoon shoes. Here is a real-life shoe and a few suggested digressions in dotted lines. Especially notice heel protrusions.

Below are some slapstick, high-heeled women's shoes. Many cartooned women wear flat shoes. Some wear army 'clod-hoppers.' The more fashionable ladies' shoes may be found in the prettier girl section. Study shoes in published cartoons!

CARTOON CLOTHING AND FOLDS

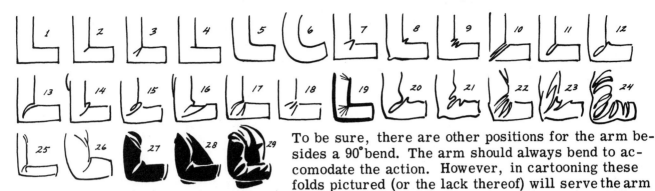

To be sure, there are other positions for the arm besides a 90° bend. The arm should always bend to accomodate the action. However, in cartooning these folds pictured (or the lack thereof) will serve the arm bent at any angle. Some cartoonists never bother to put in a clothing fold where the body bends. This is permissible. Certainly the sleeve does not have to be a particular width. These are set down to act as 'carriers' for the various folds. There are cartoonists who prefer a one-line fold (fig. 2), a two-line fold (3) or simply an extended line from the half-arm (4). Fig. 7 is a a 'V' ; 8 is a small fold which breaks to the outside (notice optional elbow bump); 11 breaks to the inside. Examples of multiple folds are : 9, 10, 16, 17, 18, 19, 21, etc. Fig. 9 is a short rumple; whereas 10 goes clear across arm. Figs. 12, 14 & 16 are definite 'tucks' which approach real life. An elbow fold may or may not be repeated in part of the shoulder (see 14, 16, 19, 22, 25 & 26). Figs. 22, 23 & 24 are loose crush folds. Figs. 27, 28 & 29 are white on black — any of 1 to 26 may be so reversed. A white fold may be left in or whited in on solid black.

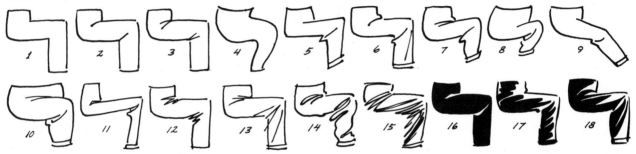

Very likely the pant leg fold will be treated similarly to the arm fold both at the hip and the knee. In fact, it is advisable to follow the same fold system throughout. A greater than 90° bend can call for an accented fold, or a less than 90° bend, a lesser fold. In cartooning a particular fold may become more or less all-purpose. Observe the fold policies of other cartoonists!

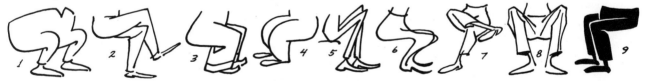

In connection with this fold study, refer to the section on sitting beginning on page 49.

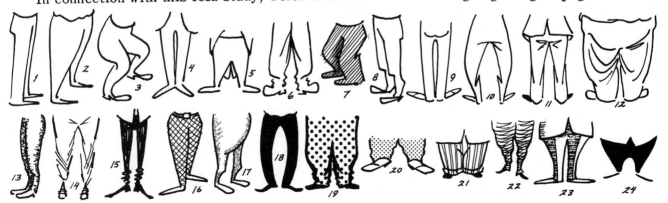

Above are fold suggestions for the standing figure, side, front and back. In these cases the patterns are incidental to the way the material hangs. Inspect folds elsewhere throughout this book.

(also see pp. 91 & 115)

CARTOON CLOTHING AND FOLDS — (CONTINUED)

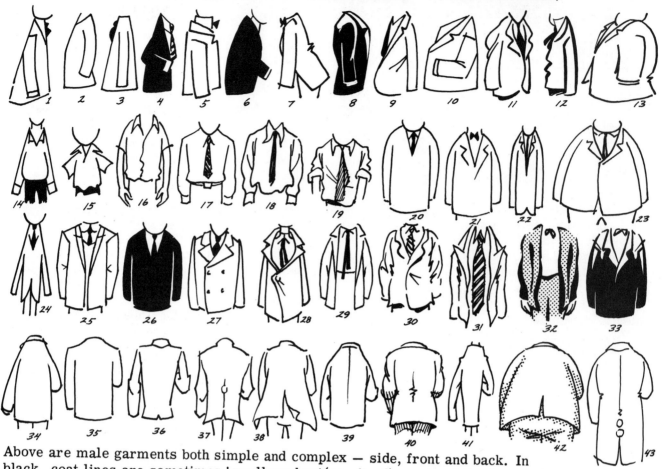

Above are male garments both simple and complex — side, front and back. In black, coat lines are sometimes 'swallowed up'(see fig. 6), or in white they may be ultra-simple (1, 2, 3, 20, 34 & 35), or even fragmentary (see 21). Become aware of fellow-cartoonist's work.

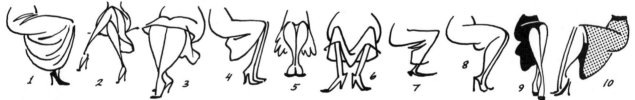

In considering seated skirt folds, check again the section on sitting female figures, p. 51.

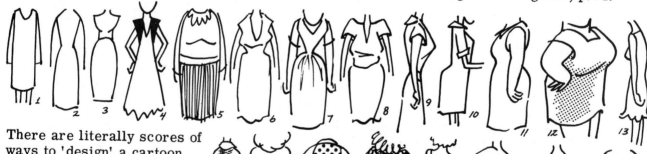

There are literally scores of ways to 'design' a cartoon dress. Just how fashionable does one need be in a given situation? The answer depends on the cartoon's purpose. Practice line only, in learning — the texture samples at right are the rub-on, 'transfer' kind.

BREAKING THE CHAIN OF TIGHT CONFORMITY

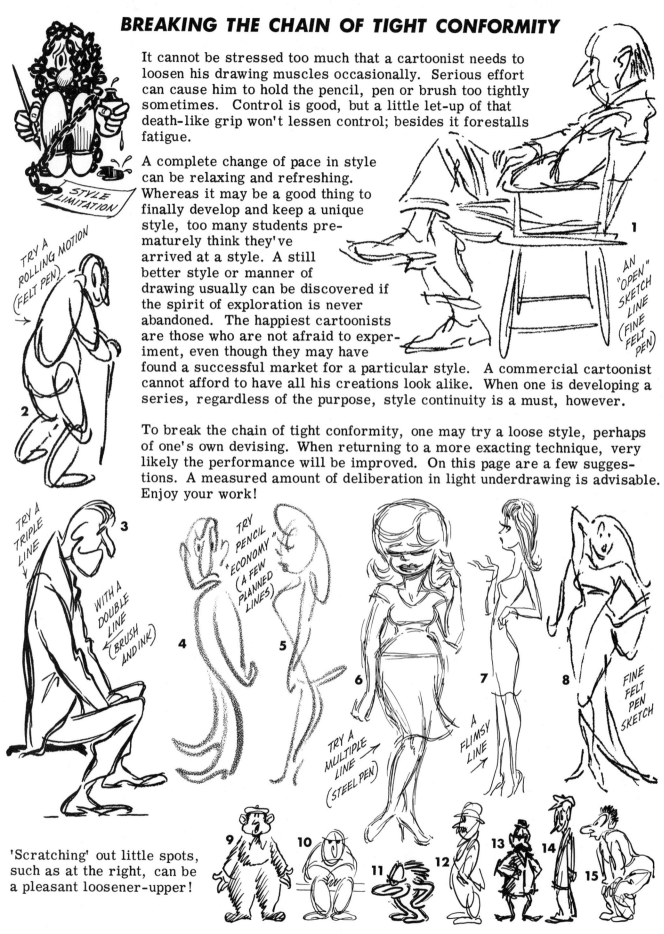

It cannot be stressed too much that a cartoonist needs to loosen his drawing muscles occasionally. Serious effort can cause him to hold the pencil, pen or brush too tightly sometimes. Control is good, but a little let-up of that death-like grip won't lessen control; besides it forestalls fatigue.

STYLE LIMITATION

1

AN "OPEN" SKETCH LINE (FINE FELT PEN)

A complete change of pace in style can be relaxing and refreshing. Whereas it may be a good thing to finally develop and keep a unique style, too many students prematurely think they've arrived at a style. A still better style or manner of drawing usually can be discovered if the spirit of exploration is never abandoned. The happiest cartoonists are those who are not afraid to experiment, even though they may have found a successful market for a particular style. A commercial cartoonist cannot afford to have all his creations look alike. When one is developing a series, regardless of the purpose, style continuity is a must, however.

TRY A ROLLING MOTION (FELT PEN)

2

To break the chain of tight conformity, one may try a loose style, perhaps of one's own devising. When returning to a more exacting technique, very likely the performance will be improved. On this page are a few suggestions. A measured amount of deliberation in light underdrawing is advisable. Enjoy your work!

TRY A TRIPLE LINE

3

WITH A DOUBLE LINE (BRUSH AND INK)

TRY PENCIL "ECONOMY" (A FEW PLANNED LINES)

4

5

TRY A MULTIPLE LINE (STEEL PEN)

6

7

A FLIMSY LINE

8

FINE FELT PEN SKETCH

'Scratching' out little spots, such as at the right, can be a pleasant loosener-upper!

9

10

11

12

13

14

15

73

STYLE AND TECHNIQUE POSSIBILITIES ARE UNLIMITED

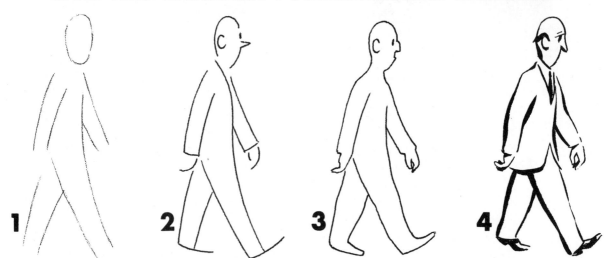

The figures on the next two pages are all built on the basic outline of No. 1. Coquille board fine is used throughout. A drawing ink ball-point makes simple lines of 2 and 3. In 3 collar and cuff lines are ignored. Four is thick and thin brush line with major emphasis behind and below form parts.

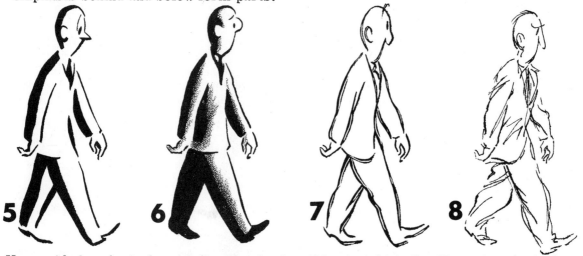

Very wide brush stroke at left with a broken thin at right in 5. Heavy brush stroke combined with black 935 pencil in 6. Seven is brush stroke split with retouch white. Eight is an informal flexible pen sketch. Notice breaks and occasional double line.

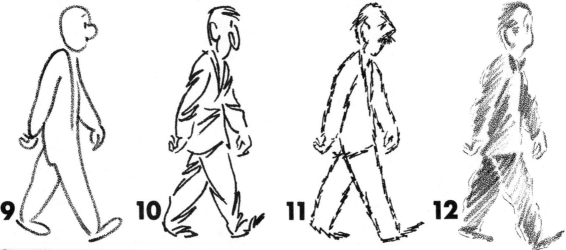

Nine is a rather wide line pencil. Observe rounded cuffs on coat and pants with rounds repeated on head, hands and feet. In 10, zig-zag folds with fine wick marker. Steel pen, lightning-like edging in 11. Twelve, back and forth pencil inside; fine line outside.

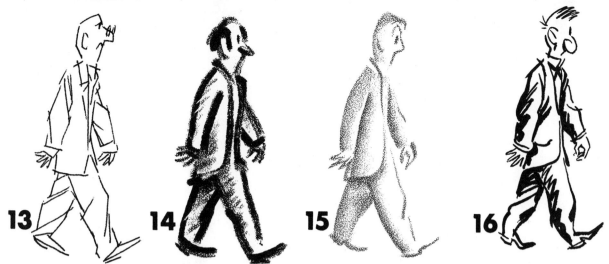

Fine ball-point (indelible ink) straight slashes in fig. 13. In 14, wide wick marker with another old semi-dry marker for shading plus few slashes of retouch white. Fig. 15 is square copal hard litho crayon with pressure left and feathering right. Thinner lines are 935 pencil. In 16, No. 2 brush and ink sketch. Notice variety of line and breaks.

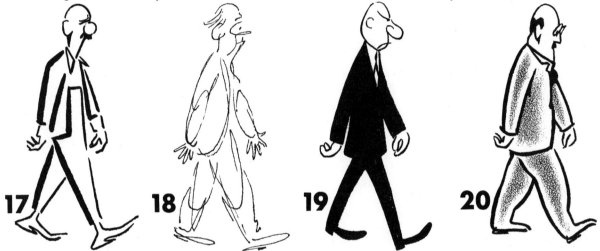

Seventeen, somewhat of a design in brush line. In 18, fine pen sketch with sectional feeling. First outline, then solid fill-in for example 19. In 20, brush outline; inside 935 pencil shading mostly 'floating' (touching under arm, under coat and under leg).

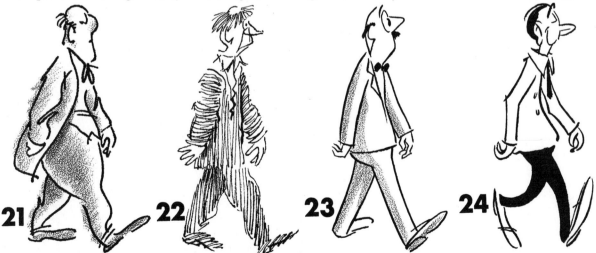

Informal handling of fine wick marker with shading overlapping backside in 21. In 22, steel drawing pen sketch. Notice line direction. Portrayed in 23 is a 'stiff bolt' walk done with brush outline; body parts in severe half-shadow. In 24, 'rolling' walk drawn with brush. Back leg lifted to accomodate long foot. Try your own innovations!

THE 'WANDERING' PEN LINE

Just as a relaxer, step aside into the world of the <u>wandering pen line</u>. Select a size-able piece (at least 10'x 12') of smooth plate finish bristol of good quality (one-ply will do). In your little creations you will need to go in every direction with your Hunt 99 pen or Gillott 170 pen (or the equivalent). A porous or rough paper would catch the point and spatter, and you need to <u>glide</u>.

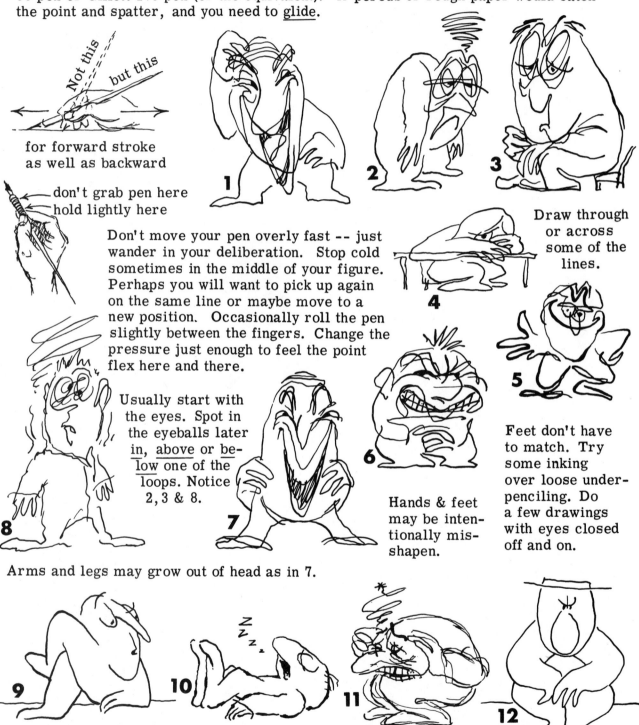

for forward stroke
as well as backward

don't grab pen here
hold lightly here

Don't move your pen overly fast -- just wander in your deliberation. Stop cold sometimes in the middle of your figure. Perhaps you will want to pick up again on the same line or maybe move to a new position. Occasionally roll the pen slightly between the fingers. Change the pressure just enough to feel the point flex here and there.

Usually start with the eyes. Spot in the eyeballs later in, <u>above</u> or be-<u>low</u> one of the loops. Notice 2, 3 & 8.

Draw through or across some of the lines.

Feet don't have to match. Try some inking over loose under-penciling. Do a few drawings with eyes closed off and on.

Hands & feet may be intentionally mis-shapen.

Arms and legs may grow out of head as in 7.

This sort of cartoon is a good change of pace for an advertisement or a sophisticated story illustration. Keep in mind some of the basic principles discussed in the section on facial and body expression. Incorporate these in wandering lines.

'AERATING' A CARTOON

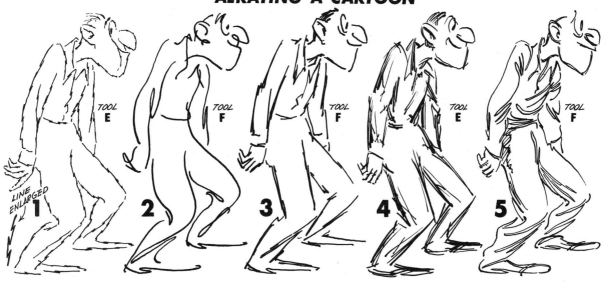

TOOL E
TOOL F
TOOL F
TOOL E
TOOL F
LINE ENLARGED
1 **2** **3** **4** **5**

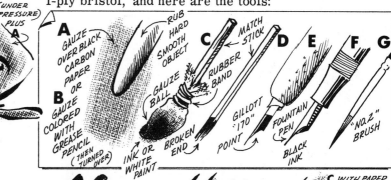

'Aerating' simply means giving a drawing a feeling of openness or freshness. Hard continuous-line cartooning has its place, and it can be very good, but many experienced cartoonists prefer more freedom of line. Ways of achieving this: 1. Breaks in the line. 2. Variety in the line. 3. Looseness with the line. This applies to shading as well. A style can be heavy and still be loose and fresh. All these figures 1 to 12 were done on smooth 1-ply bristol, and here are the tools:

A GAUZE OVER BLACK CARBON PAPER OR
B GAUZE COLORED WITH GREASE PENCIL (THEN TURNED OVER)
RUB HARD SMOOTH OBJECT
GAUZE BALL
RUBBER BAND
INK OR WHITE PAINT
BROKEN END
C MATCH STICK
D GILLOTT "170" POINT
E FOUNTAIN PEN BLACK INK
F
G "NO.2" BRUSH

6 TOOL E
7 FLEX POINT / TOOL E (UNDER PRESSURE) PLUS A

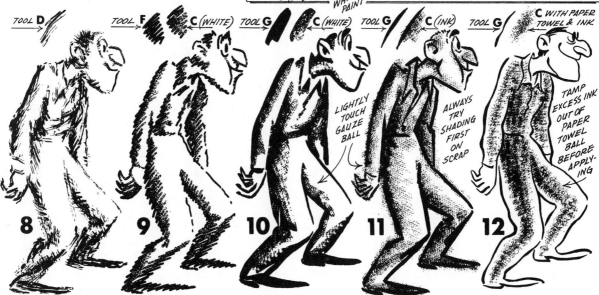

TOOL D
TOOL F C (WHITE)
TOOL G C (WHITE) LIGHTLY TOUCH GAUZE BALL
TOOL G C (INK) ALWAYS TRY SHADING FIRST ON SCRAP
TOOL G C WITH PAPER TOWEL & INK TAMP EXCESS INK OUT OF PAPER TOWEL BALL BEFORE APPLYING

8 **9** **10** **11** **12**

APPROACHING THE EDITORIAL CARTOON

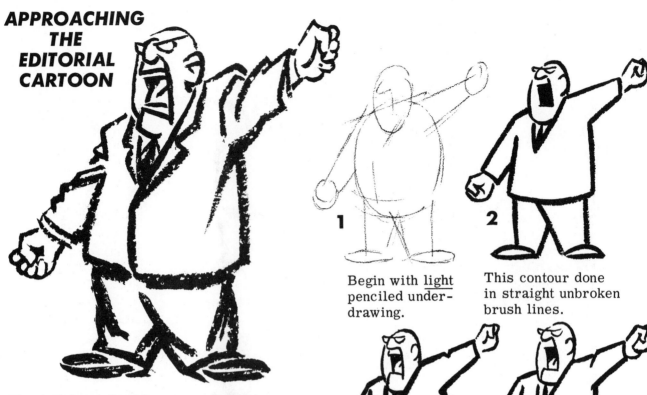

1 — Begin with light penciled under-drawing.

2 — This contour done in straight unbroken brush lines.

The 'all-'round bold' treatment on these two pages is often used in political and editorial cartooning. The lone (sometimes completely by themselves) drawings on the type-filled editorial page are generally done in a heavier, more direct manner than any other kind of cartooning. As an editorial without conviction and sincerity is flat and spineless, so an editorial cartoon done in light, flimsy lines lacks punch and power. There are many styles of editorial drawing. These two pages are presented to give the student a start toward a stronger expression than perhaps has been heretofore tried.

These 18 figures have been but slightly reduced in size from the originals. The same character is repeated so that we may concentrate on a number of differences in handling black and white media. All the exercises were done on coarse-grained coquille board with the exception of the large figure above which is brush and ink on medium-surfaced water-color paper. Notice in this particular sketch how extra weight is added to the lines as they proceed down through the figure. Though this is not necessary, such can add strength and solidity to a drawing just as a building or one of its columns widens as it reaches the earth. The following examples are given here to stimulate the student's imagination into launching out on his own with experimental techniques (see pages 74, 75, 77, 80, 81 & 104 ff. also)

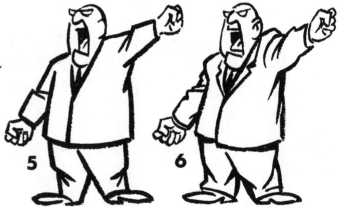

3 — Similar to fig. 2 except 'nicks' inside elbows and at knees.

4 — Staggered line and single-line fold inside elbow and at knees.

5 — Stagger and double-line fold inside elbows and at knees.

6 — Contour fashioned to conform more with man inside — shoulder humps introduced, and more 'natural' folds throughout.

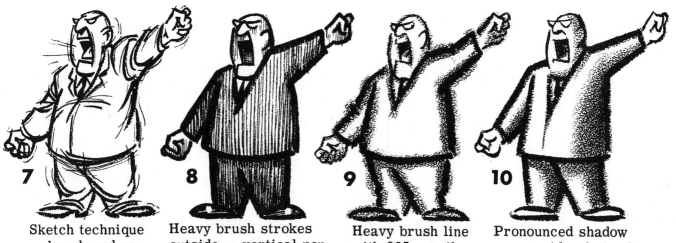

7 Sketch technique — brush and pen combined.

8 Heavy brush strokes outside — vertical pen line grouping inside.

9 Heavy brush line with 935 pencil 'splash-over.'

10 Pronounced shadow on one side of simple cylindrical forms.

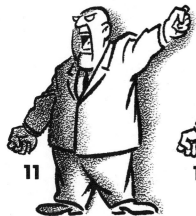
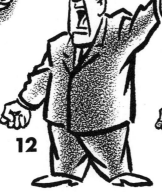
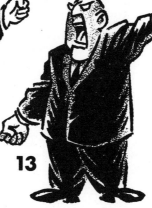

11 Heavy shadow on one side — 'background' shadow opposite.

12 'Floating' shading inside.

13 Semi-solid brush — some of white edging greyed with pencil.

14 Heavy India ink ball-point pen sketch.

15 Fairly wide wick marker with slashes of pen and retouch white.

16 Bold 935 pencil strokes conforming to shape beneath.

17 Pencil slashing obliquely — dark accents in folds.

18 'Diamond' hatch brush lines with 'x' pen line pricks on edges plus some retouch white 'x's' on blacks.

TIPS ON EDITORIAL CARTOONING

A very good method in developing a cartoon layout is to sketch it on tracing or thin layout paper (taking into account its being reversed) then quickly transferring it as described in fig. A. If the pencil lead is not too hard (a good grade is HB or F), it may be transferred several times if needs be. Advantages to this tissue method: Looking through from the back gives one a 'fresh beholding' so any errors can be immediately corrected. Also, the tissue can be shifted to expand or condense any part.

It is well to keep on hand three Prismacolor Black 935 pencils sharpened to different points (see above). These used in fig. 2 with square crayon (diagram B).

The treatment in fig. 4 is bolder and heavier both in outline and interior shading (which in places merges completely with outline).

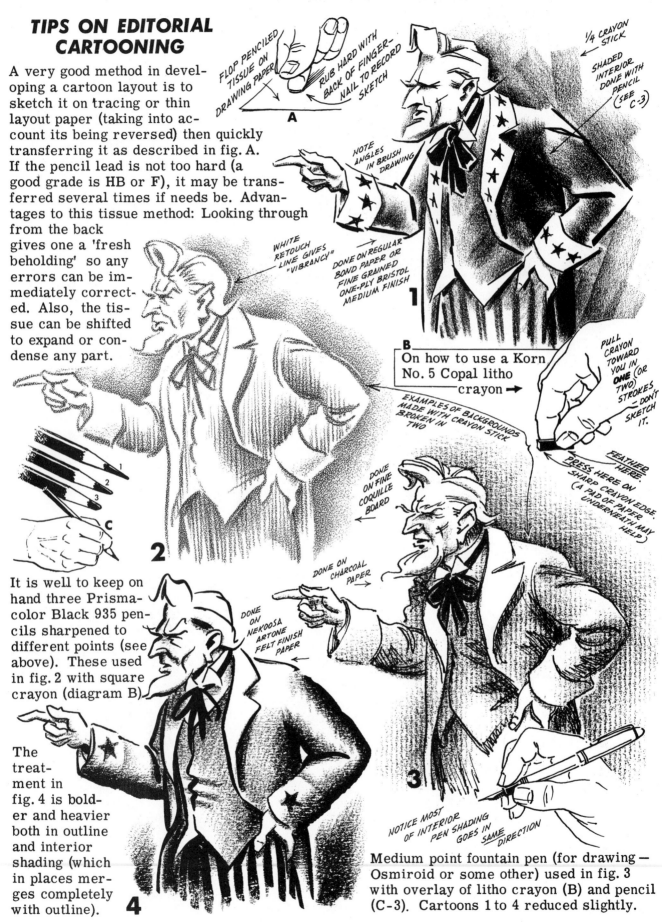

FLOP PENCILED TISSUE ON DRAWING PAPER

RUB HARD WITH BACK OF FINGER-NAIL TO RECORD SKETCH

A

¼ CRAYON STICK

SHADED INTERIOR DONE WITH PENCIL (SEE C-3)

NOTE ANGLES IN BRUSH DRAWING

DONE ON REGULAR BOND PAPER OR FINE GRAINED ONE-PLY BRISTOL MEDIUM FINISH

1

WHITE RETOUCH LINE GIVES "VIBRANCY"

B

On how to use a Korn No. 5 Copal litho crayon ➤

PULL CRAYON TOWARD YOU IN **ONE** (OR TWO) STROKES — DON'T SKETCH IT.

EXAMPLES OF BACKGROUNDS MADE WITH CRAYON STICK BROKEN IN TWO

FEATHER. PRESS HERE ON SHARP CRAYON EDGE (A PAD OF PAPER UNDERNEATH MAY HELP)

DONE ON FINE COQUILLE BOARD

2

DONE ON CHARCOAL PAPER

DONE ON NEKOOSA ARTONE FELT FINISH PAPER

3

NOTICE MOST OF INTERIOR PEN SHADING GOES IN SAME DIRECTION

4

Medium point fountain pen (for drawing — Osmiroid or some other) used in fig. 3 with overlay of litho crayon (B) and pencil (C-3). Cartoons 1 to 4 reduced slightly.

'FLUORO' WASH CARTONING

A specially developed process for "laying a screen" with wash.

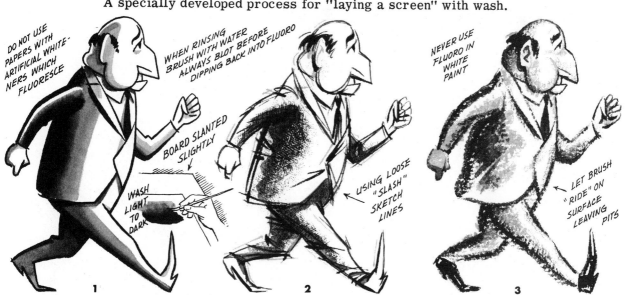

DO NOT USE PAPERS WITH ARTIFICIAL WHITE- NERS WHICH FLUORESCE

WHEN RINSING BRUSH WITH WATER ALWAYS BLOT BEFORE DIPPING BACK INTO FLUORO

NEVER USE FLUORO IN WHITE PAINT

BOARD SLANTED SLIGHTLY

WASH LIGHT TO DARK

USING LOOSE "SLASH" SKETCH LINES

LET BRUSH "RIDE" ON SURFACE LEAVING PITS

1 2 3

Above are three examples of wash drawings using Fluoro instead of water plus lamp or ivory black, ink or Fluoro black. When purchasing Fluoro materails request simple direction booklet.

1 Outline figure in ink or dark solution with brush or pen. Use good illustration board. Work wash blend from light to dark on a slanting surface — for this turn board with figure's head to left, feet to right. Have brush fairly wet with Fluoro.

2 Sketch with outline less mechanically done. Barely touch pigment in the solution for lightest areas. Always work with from 3 to 5 shades, no more. Black does not need Fluoro. Light shading applied with gauze folded into ball.

3 Rougher brush sketch on coarse water color paper. In Fluoro work always overplay details. Plenty of the solvent must be applied in light gray washes. Drop-out white may be used to cover mistakes. Mark copy Fluoro for engraver.

'DRY' TRANSFER SCREEN CARTOONING

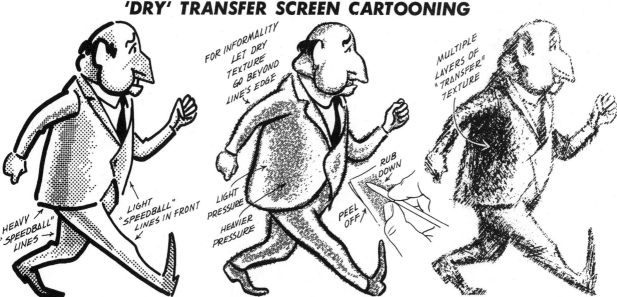

FOR INFORMALITY LET DRY TEXTURE GO BEYOND LINE'S EDGE

MULTIPLE LAYERS OF "TRANSFER" TEXTURE

HEAVY "SPEEDBALL" LINES

LIGHT "SPEEDBALL" LINES IN FRONT

LIGHT PRESSURE

HEAVIER PRESSURE

RUB DOWN

PEEL OFF

4 Shading on the three above figures was done with a "dry" type of transfer pattern. Lay screen sheet over inked out- line and rub pattern off with a burnisher or plastic ballpoint lid. For second shade (under arm) move sheet and rub off another layer of dots.

5 Informal outline here done with brush, then with screen sheet taped (on one side) in place, first rub over all lines (allowing "splash-over") with semi-sharp lid on ballpoint. Lift up sheet occasionally to check progress. Finally bur- nish or rub off center shading.

6 This third pattern accom- plished by making drawing on tracing paper then taping onto transfer sheet. Tape both to bristol board, then rub off a- round outline. Rest of effect obtained by twisting (untaped) sheet many directions and rubbing off repeated layers.

THE COMMERCIAL CARTOON

Actually any cartoon can be called a 'commercial' cartoon when and if it is adapted for advertising purposes. On the other hand many cartoons that are tied with an advertising message would be hard-pressed in successfully filling cartoon demands in other areas. One cannot say that a commercial cartoon has to have certain characteristics of itself, for it cannot be fairly judged apart from the advertising copy. If the drawing in question prompts an affirmative answer to these two questions, then it can be considered successful: Does the cartoon grab the reader's attention? And does it augment and support the message?

Above are some creatures which seem to say, 'We belong in ads.' Each one is different. Note the very simple basic shapes. They are drawn with an inexpensive felt or wick marker pen. Study this line-up by isolating parts: look at all the noses, then look at all the other features — head shapes, bodies, legs, feet, etc. Try some innovations of your own.

AD 'EYE CATCHERS'

In fig. 7 interior is fine-lined except for tie. All folds are line 'bursts' (good commercial touch). Outside surrounded by hard litho crayon edging on dappled paper. 8. Flat oval head (done lots commercially). Felt pen. 9. Fine steel pen plus brush for blacks. 10. Body, head and hat on abstract shape. Mouth and brows point to each other as do 'arrow' eyes. 11. Pencil (935) on coquille board fine. 12. Heavy brush line. Background litho crayon pencil on ribbed paper.

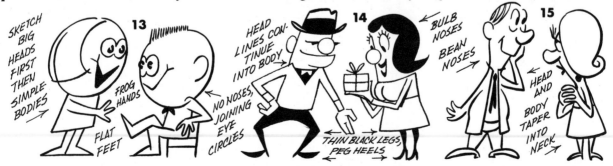

Sometimes an ad calls for two people conversing. Here are a few possibilities.

LINE WIDTH IN A COMMERCIAL CARTOON

One thing every cartoonist needs to consider as he begins the inking process is the width of his line. The pen in hand, if it is of a non-flexible nature, may determine this width -- still the pen must be selected. However, any instrument which responds to pressure, be it pen or brush or even a reproduction pencil, needs to be governed. Especially a commercial spot line-drawing may be heavier in order to catch attention. Also this treatment adds a subtle and some-

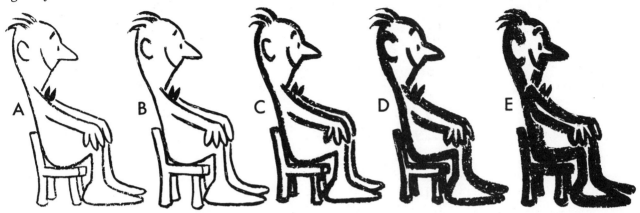

times sophisticated air to the message. A finer line than in 'A' (above) could be used, but a not much heavier line than in 'E' could be employed without the figure being all black (resembling a film negative) with a white line interior. Even in 'E' a partial white line has been added to preserve the expression (front of mouth and brow) and to more clearly define the shoulder and tie. In 'D' and 'E' it seems best to let the wide line swallow up the arm and leg on the far side. More of a variation (thick and thin) in line could be used in the same figure, probably letting the thick come underneath and at the left. All the above are brush (the line at times being built up and the brush not too ink-saturated) on a watercolor paper which allows a few light flecks and a little raggedness for crispness in appearance. If the brush makes too wet a line in some areas, pick at the line with retouch white. This treatment may be applied to scores of different, simple cartoons. They're terrific in advertising. Try some!

CARTOON MESSAGE BEARERS

A special announcement or message can be paraded across an ad by a couple of cartoon workmen. They may not be too congenial as in the 1st drawing. Ordinarily they should be happy about their good news. No. 1 is brush with pencil on coquille board fine. No. 2 is brush thick and thin, no ears, nose on outside of head oval, no cuffs on shirts or pants. No. 3 is felt pen on absorbent paper, pen and retouch nicks to further rough-up clothing edges.

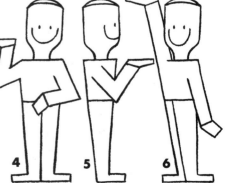

At right are three little wooden-like characters all drawn in straight lines except for a few curves in the heads. They may be carrying a product of which they are tremendously proud. Notice flat shoulders, tapered bodies.

USING VARIOUS PAPERS IN THE COMMERCIAL CARTOON

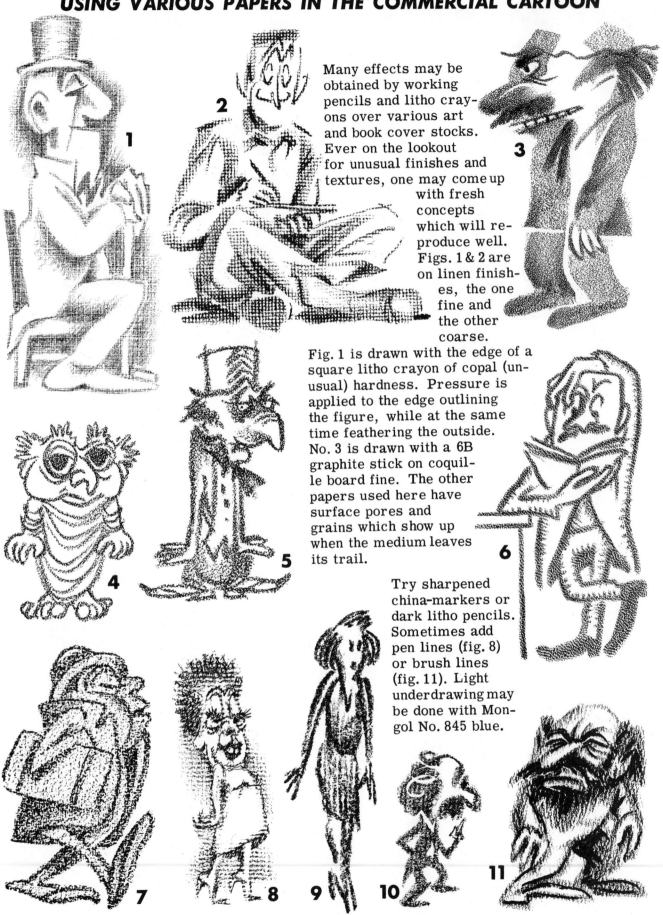

Many effects may be obtained by working pencils and litho crayons over various art and book cover stocks. Ever on the lookout for unusual finishes and textures, one may come up with fresh concepts which will reproduce well. Figs. 1 & 2 are on linen finishes, the one fine and the other coarse.

Fig. 1 is drawn with the edge of a square litho crayon of copal (unusual) hardness. Pressure is applied to the edge outlining the figure, while at the same time feathering the outside. No. 3 is drawn with a 6B graphite stick on coquille board fine. The other papers used here have surface pores and grains which show up when the medium leaves its trail.

Try sharpened china-markers or dark litho pencils. Sometimes add pen lines (fig. 8) or brush lines (fig. 11). Light underdrawing may be done with Mongol No. 845 blue.

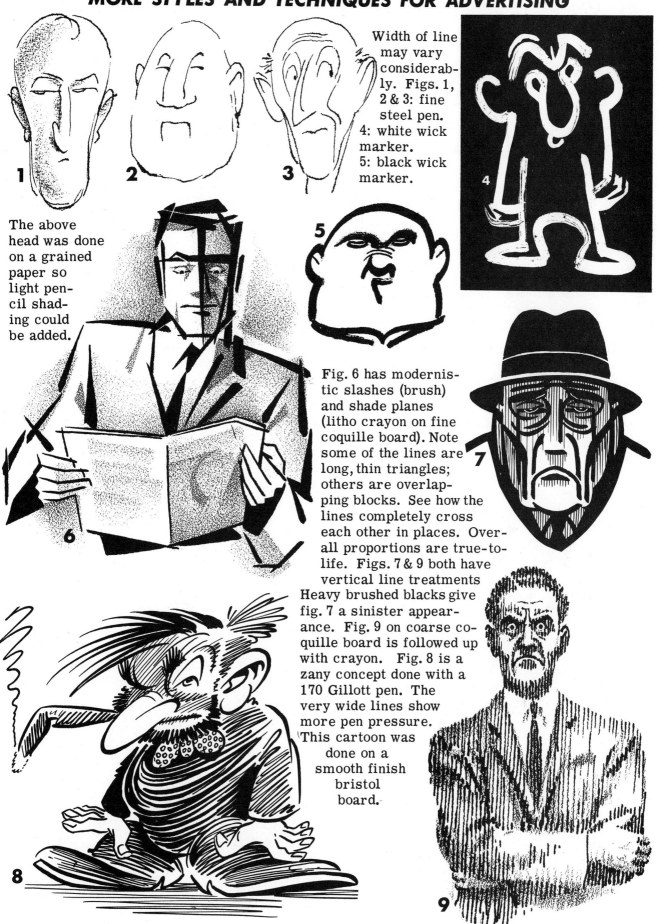

Width of line may vary considerably. Figs. 1, 2 & 3: fine steel pen. 4: white wick marker. 5: black wick marker.

The above head was done on a grained paper so light pencil shading could be added.

Fig. 6 has modernistic slashes (brush) and shade planes (litho crayon on fine coquille board). Note some of the lines are long, thin triangles; others are overlapping blocks. See how the lines completely cross each other in places. Overall proportions are true-to-life. Figs. 7 & 9 both have vertical line treatments Heavy brushed blacks give fig. 7 a sinister appearance. Fig. 9 on coarse coquille board is followed up with crayon. Fig. 8 is a zany concept done with a 170 Gillott pen. The very wide lines show more pen pressure. This cartoon was done on a smooth finish bristol board.

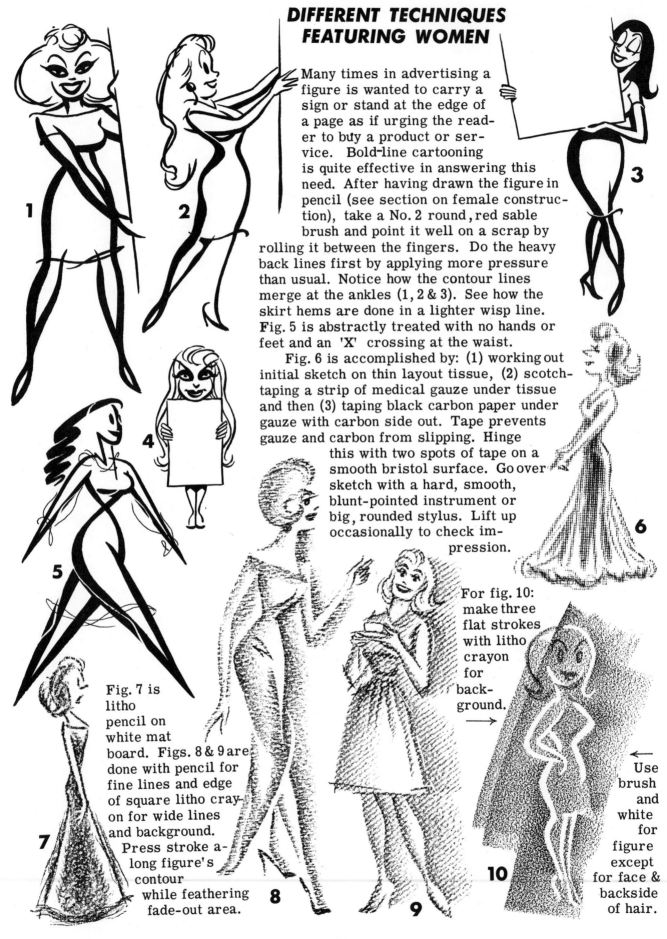

DIFFERENT TECHNIQUES FEATURING WOMEN

Many times in advertising a figure is wanted to carry a sign or stand at the edge of a page as if urging the reader to buy a product or service. Bold-line cartooning is quite effective in answering this need. After having drawn the figure in pencil (see section on female construction), take a No. 2 round, red sable brush and point it well on a scrap by rolling it between the fingers. Do the heavy back lines first by applying more pressure than usual. Notice how the contour lines merge at the ankles (1, 2 & 3). See how the skirt hems are done in a lighter wisp line. Fig. 5 is abstractly treated with no hands or feet and an 'X' crossing at the waist.

Fig. 6 is accomplished by: (1) working out initial sketch on thin layout tissue, (2) scotch-taping a strip of medical gauze under tissue and then (3) taping black carbon paper under gauze with carbon side out. Tape prevents gauze and carbon from slipping. Hinge this with two spots of tape on a smooth bristol surface. Go over sketch with a hard, smooth, blunt-pointed instrument or big, rounded stylus. Lift up occasionally to check impression.

For fig. 10: make three flat strokes with litho crayon for background. →

Use brush and white for figure except for face & backside of hair.

Fig. 7 is litho pencil on white mat board. Figs. 8 & 9 are done with pencil for fine lines and edge of square litho crayon for wide lines and background. Press stroke along figure's contour while feathering fade-out area.

NOTES ON CARTOONING LITTLE PEOPLE

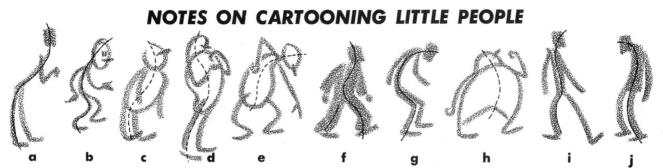

a b c d e f g h i j

One of the chief difficulties the cartoon student has is ridding his work of a straight-up-and-down stiffness. At times rigidity is all right and can even serve a purpose — maybe transmitting sternness or austerity. But life-lines bend and pulsate. This feeling of movement begins in the head and neck and travels through the body. Above 'a' is so stiff he bends backwards; this is better than mere vertical stick stiffness. Fig. 'b' is rubbery with bends. Observe the 'axis' or action lines running through the simple figures above. Remember the perspective trick of shortening the second leg and drawing that foot higher (see b, d, g & j). Pencil-practicing little people like these fortifies one with confidence, for it is not hard to develop details on an agile frame. Below are some little people styles and techniques.

PRE-SET ALPHABETS

The following were done with top-sheet type alphabets. This kind of thing has very limited use (mainly for some stylized spot), and is not recommended as a help in cartooning. Fig. 41: body is numeral 8, legs capital K, arms lower case j upside-down without the dot, head upside-down c with added segment for hair. Fig. 42: top of g head, body inverted b, legs a 4, feet comas, hand a period.

Figs. 44 to 48 parts of a script alphabet; a few parts drawn.

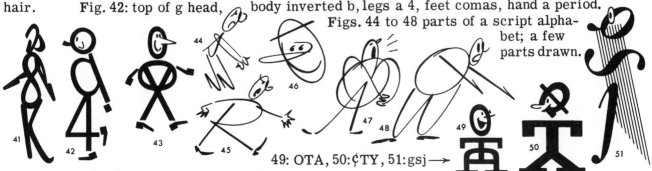

49: OTA, 50: ¢TY, 51: gsj→

THE CARTOON DESIGN

There are many places and ways where cartoon in design may be utilized. The characters may be much more abstract than pictured here, but such treatment leaves the field of cartoon and invades the related arts. Geometrical forms can be the agent for the cartoon touch, especially in advertising. Figs. 1 & 2 are made by cutting a few thin triangles of top sheet screen and laying them down as little men. The circles can be drawn or 'o's' from an alphabet on similar transparent sheeting. Faces conveying mood can be done in retouch white on (3) grease pencil on coarse paper or (4) black paper with a rectangle of reverse screen overlaid. In 3 spray the grease with workable fixative or swirl brush full of white on soap to make it adhere.

In fig. 5 use a black pebble paper or ink a block of coquille board, then touch bandage gauze (3 or 4 layers) gathered around finger tip into small puddle of white; tamp heavily at center and lightly around center to get faded effect. Rule triangle, then paint face with lamp or ivory black water-color.

Fig. 6 is two feathered strokes of stick litho crayon on a grained surface with grease or 935 pencil for face; white paint eye. Fig. 7 is made of two rectangles of graduated dot screen with cartoon painted on. See 5 for fig. 8's background; grease pencil used on tips of white strokes. Nos. 9 to 15 have an emphasized brush stroke running around or through the figures.

The repetition in 16 gives it the feeling of design.

UNUSUAL EFFECTS WITH A DESIGN SLANT

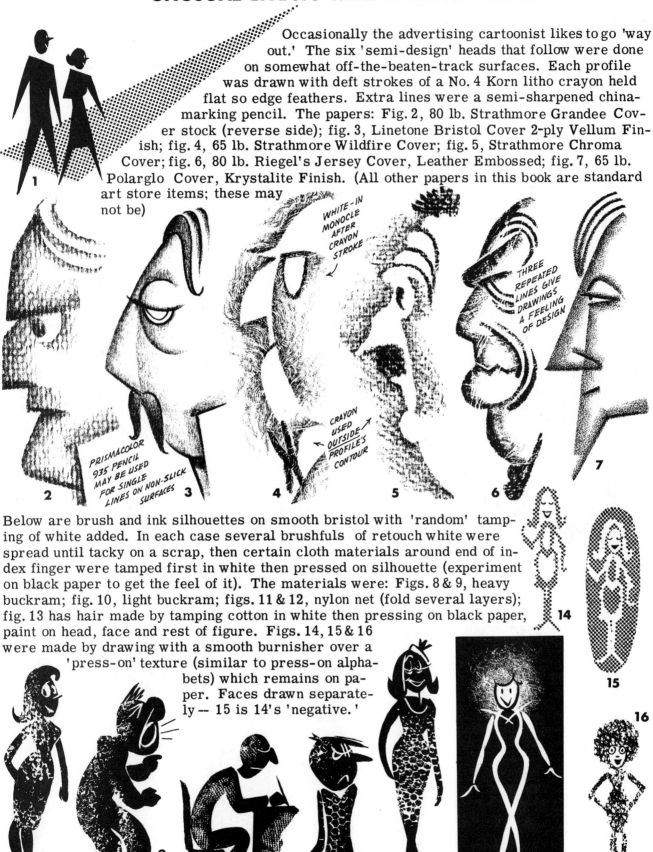

Occasionally the advertising cartoonist likes to go 'way out.' The six 'semi-design' heads that follow were done on somewhat off-the-beaten-track surfaces. Each profile was drawn with deft strokes of a No. 4 Korn litho crayon held flat so edge feathers. Extra lines were a semi-sharpened china-marking pencil. The papers: Fig. 2, 80 lb. Strathmore Grandee Cover stock (reverse side); fig. 3, Linetone Bristol Cover 2-ply Vellum Finish; fig. 4, 65 lb. Strathmore Wildfire Cover; fig. 5, Strathmore Chroma Cover; fig. 6, 80 lb. Riegel's Jersey Cover, Leather Embossed; fig. 7, 65 lb. Polarglo Cover, Krystalite Finish. (All other papers in this book are standard art store items; these may not be)

WHITE-IN MONOCLE AFTER CRAYON STROKE

THREE REPEATED LINES GIVE DRAWINGS A FEELING OF DESIGN

CRAYON USED OUTSIDE PROFILE'S CONTOUR

PRISMACOLOR 935 PENCIL MAY BE USED FOR SINGLE LINES ON NON-SLICK SURFACES

Below are brush and ink silhouettes on smooth bristol with 'random' tamping of white added. In each case several brushfuls of retouch white were spread until tacky on a scrap, then certain cloth materials around end of index finger were tamped first in white then pressed on silhouette (experiment on black paper to get the feel of it). The materials were: Figs. 8 & 9, heavy buckram; fig. 10, light buckram; figs. 11 & 12, nylon net (fold several layers); fig. 13 has hair made by tamping cotton in white then pressing on black paper, paint on head, face and rest of figure. Figs. 14, 15 & 16 were made by drawing with a smooth burnisher over a 'press-on' texture (similar to press-on alphabets) which remains on paper. Faces drawn separately -- 15 is 14's 'negative.'

MAKING ORDINARY OBJECTS 'COME ALIVE'

The need may arise to animate a cartoon that would ordinarily seem 'inhuman.' At times just arms and legs might do it (fig. 7) or only a face (fig. 3). The object may be doing something, like 'Mr. Corn' combing his silk (fig. 1), a bale of cotton smoldering (fig. 4), or a clock or umbrella speaking (9 & 11).

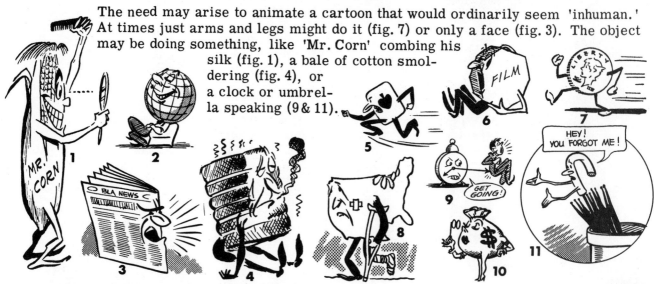

THE SILHOUETTE IN CARTOON

Sometimes in a comic strip the figures in one panel are silhouetted for the sake of variety. This may occur in broad daylight and not necessarily at night. The silhouette may be partial with some parts of the interior showing as in fig. 1 (notice eyes, teeth, collar & cuffs). Sometimes the more 'do-dads' sticking out the better (examine fig. 2). The silhouette may be grey (fig. 3). In advertising before and after shots are good (figs. 5 & 6) or 'the shadow of things to come' (fig. 7).

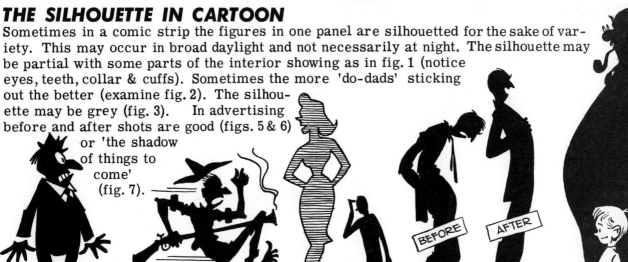

THE 'OLD-FASHIONED' LOOK IN CARTOON

Should the cartoonist have an order for an 'old time' character, he will do well to put a certain austerity in his work. Helps toward achieving the by-gone years can be: round, long-lashed eyes with pupil in center, figs. 2 & 3; parallel line edging, figs. 2 & 3; a semi-wood engraved effect, fig. 4; curly-cues and cross-hatch edging, fig. 5; and a 'sampler' treatment done with lettering pen, fig. 6:

COSTUMES OF MANY LANDS IN CARTOON

1 Mexico	2 Russia	3 Scotland	4 China	5 Holland	6 'Indian'
7 Arabia	8 'Aladdin'	9 Japan	10 Greece	11 Alaska	12 Turkey
13 Germany	14 Norway	15 Spain	16 Hawaii	17 India	18 Egypt

Few cartoonists escape for long the need for drawing a figure representing some particular country. It is a good idea to keep a file on costumes of far-flung places. This is not a page concerned with line technique as such. The delineation here is much the same throughout; mostly No. 2 round, red sable brush is used. The finer folds of fig. 12 are pen, likewise the dress shading of 16 and the hem of 14's outer garment. The cartoonist may combine pen and brush as he feels the need of it. Actually, some of these costumes are simplified considerably. In some cases in real-life they are much more elaborate. Fancy costumes of many lands are quite ornate. As a rule the cartoonist seeks to simplify them. Also, many lands have variations in dress depending on economic classes or rank. However, we recognize some attire as 'typical.' (Attention should be called to the different head sizes, the larger ones being toward the top — an arbitrary matter with the cartoonist.) — also see p. 115.

91

ANIMATION IN CARTOON

The major requirements for successful animation are:
1. Simplicity -- the character needs to be simply put together so that it may be repeated often in a graduated sequence. Too many details make the process cumbersome. 2. Adaptability -- the figure needs to be pliable; that is, easily bent into the required cycles. 3. Appeal -- the character needs to have a delightful piquancy about it. Abundant life needs to spring from what it does.

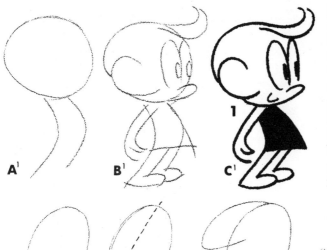

Or, if the character is listless and sluggish, it should drag as though it were full of lazy lead. In connection with this phase of cartooning, study the principles of the walking, running, sitting, sleeping (etc.) sections of this volume. Refer to the action shots in the sports section. Examine the various moods and emotions thoroughly. They will become lifelong servants to the animator. Other cartoon departments which will help are those on babies, children, old people, etc. There is a related tie in all of cartooning. It is most profitable to acquaint oneself with the many sides of the subject.

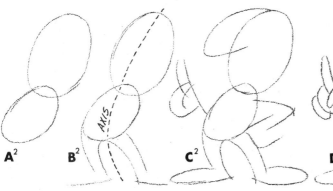

Underdrawings for animation are usually circular shapes on a stance or action axis (see B2). Develop these roughs after the manner suggested above. Animated cartoons may be watched several times during the day on the TV screen. Take note of the standard or pose positions of the little people. Watch the parts which start to move; see how they hinge on the less mobile masses. Observe the extremes of the action. These were developed first by the animator, then he drew the stages which tied the extremes together. To practice the rudiments of animation, work up roughs of a character on tracing paper. Decide on the several movements which, when seen one after the other, will give the figure 'life.' Some animators move only the legs in a walk or run, letting the arms dangle straight down from a still or jerking shoulder. On the screen watch for eye blinks, squashes, stretches, twitches recoils and other pulsating movements which must be done in stages. Rearbacks and twangs may have straight and stiff lines, but general animation is by pliant, elastic curves.

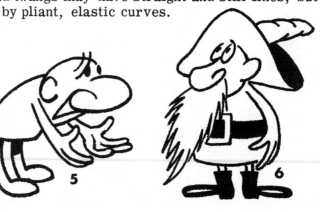

BABIES IN CARTOON

1

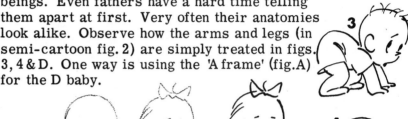

2

3

4

The stork bomber can give the cartoonist little trouble if certain factors are taken into account. Actually, babies are the simplest of all human beings. Even fathers have a hard time telling them apart at first. Very often their anatomies look alike. Observe how the arms and legs (in semi-cartoon fig. 2) are simply treated in figs. 3, 4 & D. One way is using the 'A frame' (fig. A) for the D baby.

Don't make the baby head too old. Fig. 'a' below illustrates the difference between the 'crawler' and his older brothers. Take a look at the comparative distances between the dotted lines by a, b & c. After all, just dots and dashes make a pretty good kid face.

A B C D

a b c
MORE HAIR
↑ INCREASED
↓ SEPARATION
MORE CHIN

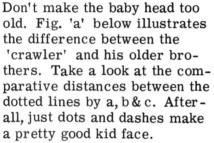

5 **6** **7** **8**

9

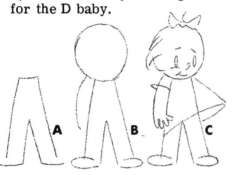

10

More complicated is Mr. Dirty Face on the right. Smudges don't blot out happiness. Notice the receding chin — most all babies have them. The nose size is always played down. The eyes (pupil and iris) at birth approach adult proportions and in their small setting look large — so we hear, 'he has eyes like saucers.' Often the lower eyelid is pushed up by fat cheeks and cuts off from view the bottom of the eyeball (see fig. 13 and eyes of D baby girl above). Fathers 6 and 9 have hit the jack-pot. Father 11 is having his problems, and Junior has just belted his daddy in 14.

13

GOO!

11

12

BOP

HOLD THE LITTLE DEAR GENTLY, HORACE

14

TIPS ON CARTOONING BABIES

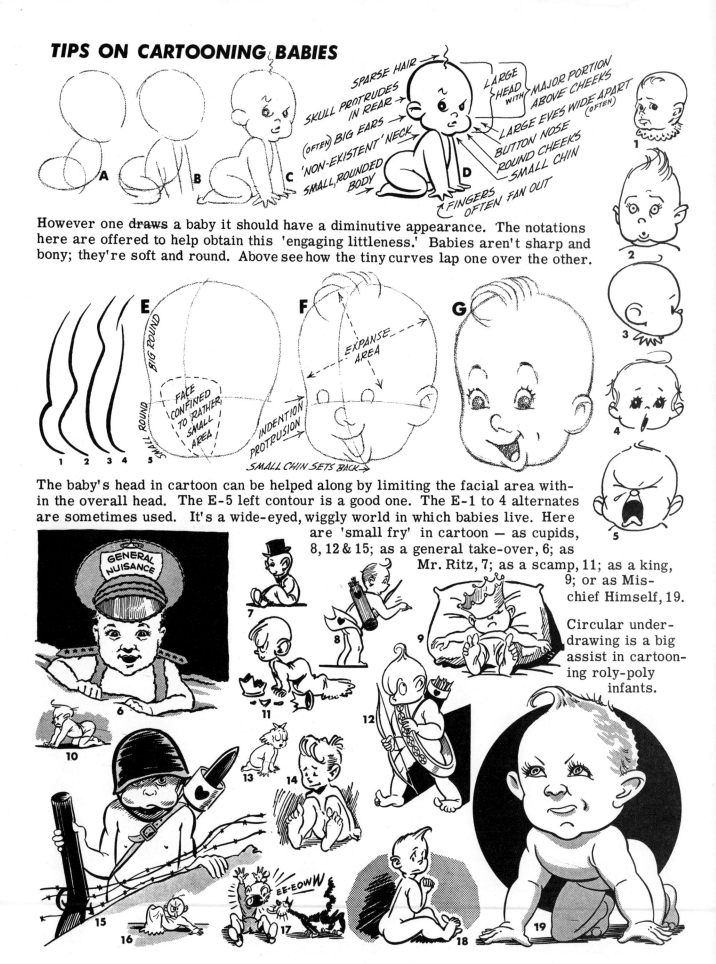

However one draws a baby it should have a diminutive appearance. The notations here are offered to help obtain this 'engaging littleness.' Babies aren't sharp and bony; they're soft and round. Above see how the tiny curves lap one over the other.

The baby's head in cartoon can be helped along by limiting the facial area within the overall head. The E-5 left contour is a good one. The E-1 to 4 alternates are sometimes used. It's a wide-eyed, wiggly world in which babies live. Here are 'small fry' in cartoon — as cupids, 8, 12 & 15; as a general take-over, 6; as Mr. Ritz, 7; as a scamp, 11; as a king, 9; or as Mischief Himself, 19.

Circular underdrawing is a big assist in cartooning roly-poly infants.

VERY YOUNG CHILDREN

THICK TUMMY → TAPERED LEGS → 1

SMALL CHEST → WIDE PANTS → 2

WIDE BODY → THIN LEGS → 3

NECK-LESS SHOULDERS → THIN NECK → THIN ARMS → PARALLEL PANT LEGS → 4

ROUNDED WAIST → MUSCULAR ARMS AND LEGS → 5

The next step from the crawling toddler is the preschool child or one in the lower grades. There are many ways of cartooning him. At left are five little guys with bodies which are altogether different. Compare the necks and chests, then the waists and legs. One reason each is a little kid is that each has a big kiddie head. Since the bodies are so small (1 to 5) it is hardly necessary to begin with complicated underdrawing. Let a couple of simple outside lines encase the body from neck to foot. Next, split the body with waist and leg lines. Add arms and details.

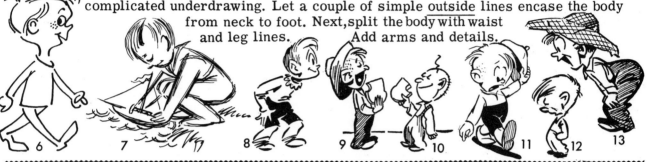

6 7 8 9 10 11 12 13

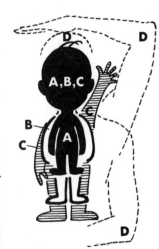

The chart at left illustrates several potential helps for the student who wishes to cartoon little children. The head 'A, B, C' has been set down to go with the three bodies A, B and C. Granted, in cartoon a smaller body than A has been used, but it is difficult to run a still smaller body through any succession of activities. The white B and the shaded C bodies are still those of children. In relation to the head, if a larger than C body is used, then it will not be as 'cute' and begins to invade the much older child category. These points should be noted: 1, as a rule the cartoon child has practically no shoulders; 2, these little shoulders either come from his head or his neck is quite slender; 3, his entire chest area is seldom larger than his head; 4, his elbow may reach no farther down than the nipple of his chest (this is true of real babies and very tiny tots), yet an adult elbow hits the hip bone and when raised comes level with the top of the head — see dotted lines D (of course, cartoon license may permit violation of this real adult proportion). Notice the raised shaded arm of the C body. His hand comes a little above the ear. Actually in real life even a new-born baby can reach the top of his head, but we are dealing with cartoon. Here there is no law, but a beginner can be helped by the above considerations. If one thinks shorter legs and longer arms or whatever look right, go ahead — you're the boss!

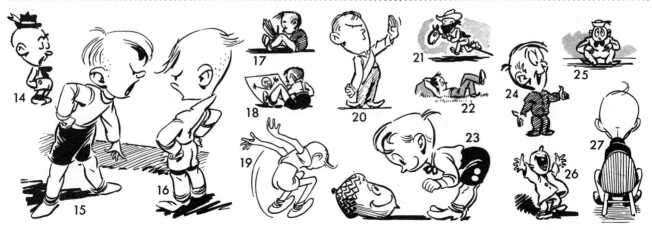

14 15 16 17 18 19 20 21 22 23 24 25 26 27

CARTOONING LITTLE GIRLS

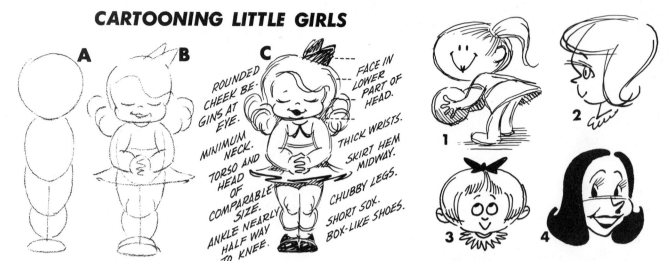

Should a 'kewpie-doll' type little girl be wanted, the suggestions around fig. C above may prove helpful. The drawings 1 through 12 offer several other types. A cartoonist soon learns that a hairdo change and a dress, in many cases, will transform a boy to a girl or (in slapstick) a man to a woman. The little girl may be daintier perhaps, but as a rule cute children are interchangeable.

CARTOONING PARENTS AND CHILDREN

Below are some miniatures of children with their parents. Before much cartooning has gotten underway, a call will come through for a family or at least one parent with a child. It is not necessary to draw this small to be sure, unless a mere spot is wanted, but to conserve space these situations are shown on a small scale.

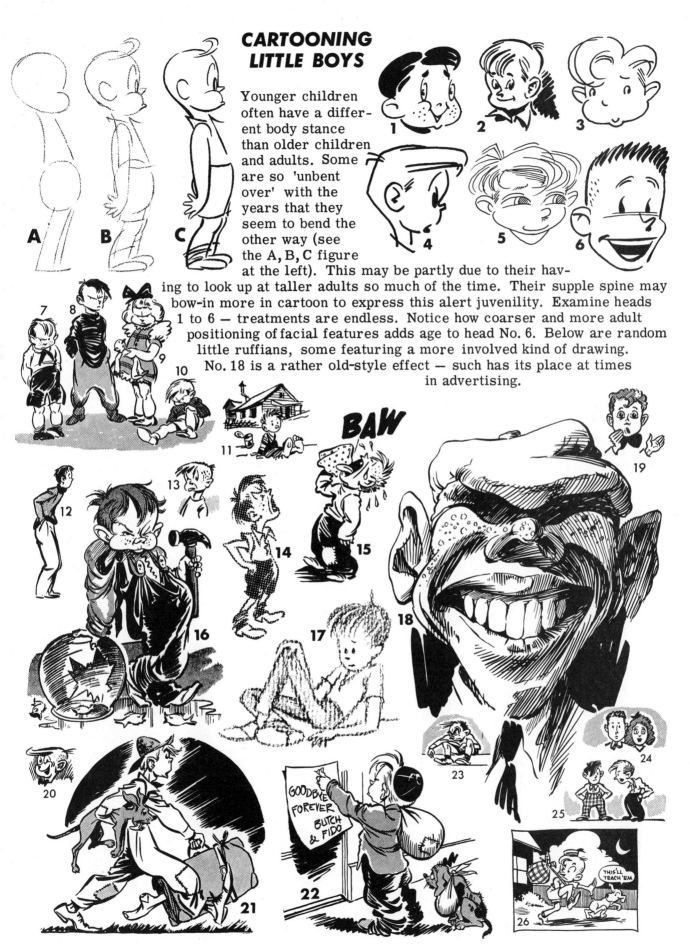

CARTOONING LITTLE BOYS

Younger children often have a different body stance than older children and adults. Some are so 'unbent over' with the years that they seem to bend the other way (see the A, B, C figure at the left). This may be partly due to their having to look up at taller adults so much of the time. Their supple spine may bow-in more in cartoon to express this alert juvenility. Examine heads 1 to 6 — treatments are endless. Notice how coarser and more adult positioning of facial features adds age to head No. 6. Below are random little ruffians, some featuring a more involved kind of drawing. No. 18 is a rather old-style effect — such has its place at times in advertising.

BAW

GOODBYE FOREVER BUTCH & FIDO

THIS'LL TEACH 'EM

THE SPORTS CARTOON—ITS IMPORTANCE

Any sports section of a newspaper is enhanced by a good sports cartoon. Photographs are in abundance, and they have their place; but they lack in showmanship. The reader usually goes to the sports cartoon first if it is well done. A spectator sport entirely lacking in excitement and 'razzle-dazzle' fares poorly at the box office. The sports cartoonist can capture this wonderful aspect of the contest and actually increase spectator interest. However, let the student begin with a few still shots before he gets into the action.

SIMPLE ANATOMY:

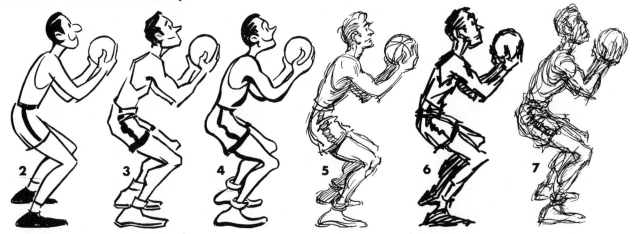

There is no question but that a well-founded knowledge of anatomy helps the sports cartoonist immensely. Sports participants are usually lightly clad to afford unhindered bodily movement. Even in vigorous contact sports where thickened protection is built into the suits, muscle and bone power needs to be in evidence somewhere in the drawing. As a starter, the above diagrams are broken down and simplified with the various portions presented apart from each other for the sake of clarity.

Throughout this book the cartoon student has been urged to study and consider many styles and approaches. Out of it all individuality in drawing will be born. If one has in front of him a lone mode of cartooning, he is more likely to become a copyist. Above are a few divergent handlings: 2. A plain, non-Herculean concept. 3. A raw-boned, angular figure. 4. A rounded, rubbery type — thick and thin line. (2, 3 & 4 are done with a round, red sable No. 2 brush.) 5. A looser pen sketch. 6. A 'tangle' sketch done with a felt wick pen 7. A 'tangle' sketch with a steel pen. The purpose of tangle sketching — especially in example No. 7 — is to intentionally overwork the pen with deliberate (not wild) repeat lines in a somewhat roving manner. This can be a curative for a 'calcifying cartoonist' — one whose style is getting stiff and stone-like from tight tension drawing.

PUTTING MUSCLES ON THE 'STICK' FIGURE

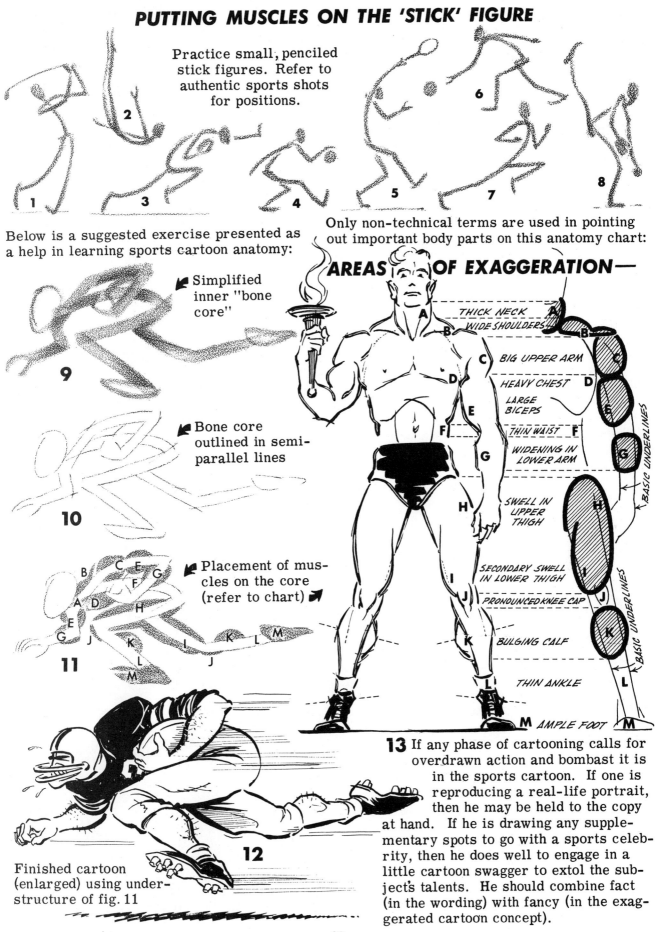

Practice small, penciled stick figures. Refer to authentic sports shots for positions.

1 2 3 4 5 6 7 8

Below is a suggested exercise presented as a help in learning sports cartoon anatomy:

◄ Simplified inner "bone core"

9

◄ Bone core outlined in semi-parallel lines

10

◄ Placement of muscles on the core (refer to chart) ➤

11

Only non-technical terms are used in pointing out important body parts on this anatomy chart:

AREAS OF EXAGGERATION—

A — THICK NECK

B — WIDE SHOULDERS

C — BIG UPPER ARM

D — HEAVY CHEST

E — LARGE BICEPS

F — THIN WAIST

G — WIDENING IN LOWER ARM

BASIC UNDERLINES

H — SWELL IN UPPER THIGH

I — SECONDARY SWELL IN LOWER THIGH

J — PRONOUNCED KNEE CAP

K — BULGING CALF

L — THIN ANKLE

BASIC UNDERLINES

M — AMPLE FOOT

Finished cartoon (enlarged) using under-structure of fig. 11

12

13 If any phase of cartooning calls for overdrawn action and bombast it is in the sports cartoon. If one is reproducing a real-life portrait, then he may be held to the copy at hand. If he is drawing any supplementary spots to go with a sports celebrity, then he does well to engage in a little cartoon swagger to extol the subject's talents. He should combine fact (in the wording) with fancy (in the exaggerated cartoon concept).

EXAGGERATING SPORTS ACTION

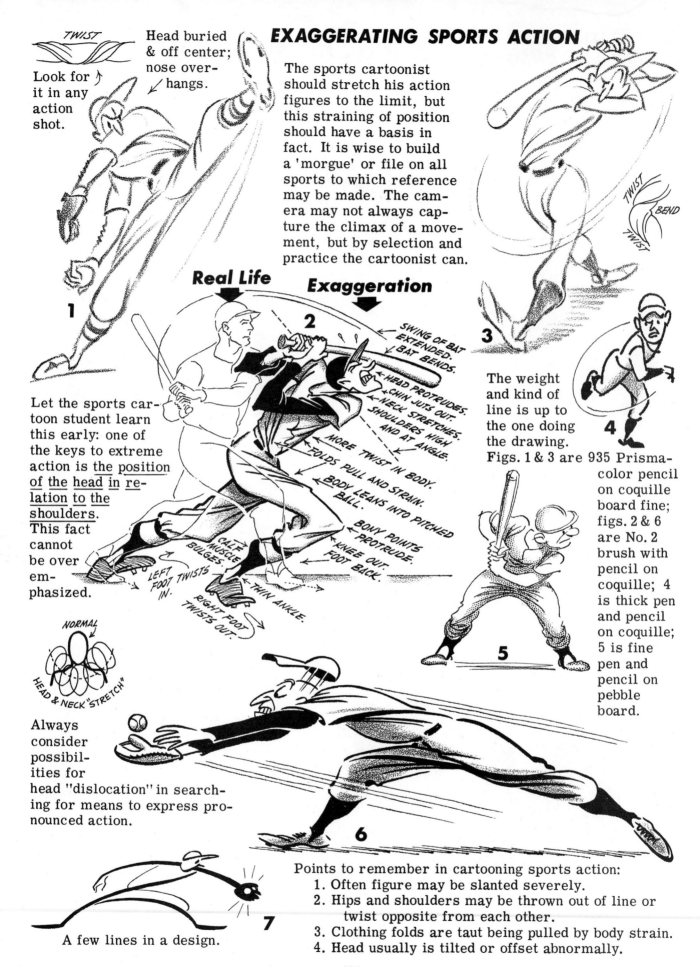

TWIST

Look for it in any action shot.

Head buried & off center; nose overhangs.

The sports cartoonist should stretch his action figures to the limit, but this straining of position should have a basis in fact. It is wise to build a 'morgue' or file on all sports to which reference may be made. The camera may not always capture the climax of a movement, but by selection and practice the cartoonist can.

Real Life

Exaggeration

TWIST
BEND
TWIST

1

2

3

The weight and kind of line is up to the one doing the drawing.

Figs. 1 & 3 are 935 Prismacolor pencil on coquille board fine; figs. 2 & 6 are No. 2 brush with pencil on coquille; 4 is thick pen and pencil on coquille; 5 is fine pen and pencil on pebble board.

Let the sports cartoon student learn this early: one of the keys to extreme action is the position of the head in relation to the shoulders. This fact cannot be over emphasized.

SWING OF BAT EXTENDED.
BAT BENDS.
HEAD PROTRUDES.
CHIN JUTS OUT.
NECK STRETCHES.
SHOULDERS HIGH AND AT ANGLE.
MORE TWIST IN BODY.
FOLDS PULL AND STRAIN.
BODY LEANS INTO PITCHED BALL.
BONY POINTS PROTRUDE.
KNEE OUT. FOOT BACK.
CALF MUSCLE BULGES.
LEFT FOOT TWISTS IN.
THIN ANKLE.
RIGHT FOOT TWISTS OUT.

4

5

NORMAL

HEAD & NECK "STRETCH"

Always consider possibilities for head "dislocation" in searching for means to express pronounced action.

6

7

A few lines in a design.

Points to remember in cartooning sports action:
1. Often figure may be slanted severely.
2. Hips and shoulders may be thrown out of line or twist opposite from each other.
3. Clothing folds are taut being pulled by body strain.
4. Head usually is tilted or offset abnormally.

PUTTING 'THUNDER' IN THE SPORTS CARTOON

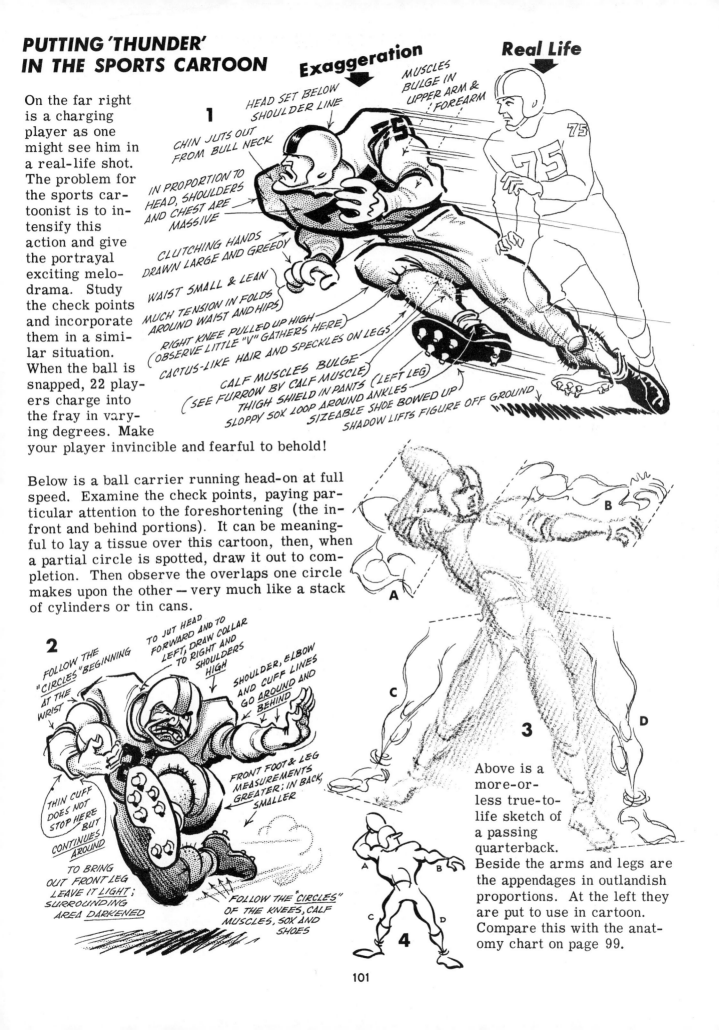

Exaggeration

Real Life

On the far right is a charging player as one might see him in a real-life shot. The problem for the sports cartoonist is to intensify this action and give the portrayal exciting melodrama. Study the check points and incorporate them in a similar situation. When the ball is snapped, 22 players charge into the fray in varying degrees. Make your player invincible and fearful to behold!

1

HEAD SET BELOW SHOULDER LINE

CHIN JUTS OUT FROM BULL NECK

MUSCLES BULGE IN UPPER ARM & FOREARM

IN PROPORTION TO HEAD, SHOULDERS AND CHEST ARE MASSIVE

CLUTCHING HANDS DRAWN LARGE AND GREEDY

WAIST SMALL & LEAN

MUCH TENSION IN FOLDS AROUND WAIST AND HIPS

RIGHT KNEE PULLED UP HIGH (OBSERVE LITTLE "V" GATHERS HERE)

CACTUS-LIKE HAIR AND SPECKLES ON LEGS

CALF MUSCLES BULGE (SEE FURROW BY CALF MUSCLE)

THIGH SHIELD IN PANTS (LEFT LEG)

SLOPPY SOX LOOP AROUND ANKLES

SIZEABLE SHOE BOWED UP

SHADOW LIFTS FIGURE OFF GROUND

Below is a ball carrier running head-on at full speed. Examine the check points, paying particular attention to the foreshortening (the in-front and behind portions). It can be meaningful to lay a tissue over this cartoon, then, when a partial circle is spotted, draw it out to completion. Then observe the overlaps one circle makes upon the other — very much like a stack of cylinders or tin cans.

A **B**

2

FOLLOW THE "CIRCLES" BEGINNING AT THE WRIST

TO JUT HEAD FORWARD AND TO LEFT, DRAW COLLAR TO RIGHT AND SHOULDERS HIGH

SHOULDER, ELBOW AND CUFF LINES GO AROUND AND BEHIND

FRONT FOOT & LEG MEASUREMENTS GREATER; IN BACK, SMALLER

THIN CUFF DOES NOT STOP HERE BUT CONTINUES AROUND

TO BRING OUT FRONT LEG LEAVE IT LIGHT; SURROUNDING AREA DARKENED

FOLLOW THE "CIRCLES" OF THE KNEES, CALF MUSCLES, SOX AND SHOES

C **D**

3

Above is a more-or-less true-to-life sketch of a passing quarterback. Beside the arms and legs are the appendages in outlandish proportions. At the left they are put to use in cartoon. Compare this with the anatomy chart on page 99.

A **B**

C **D**

4

DRAWING SPORTS PERSONALITIES

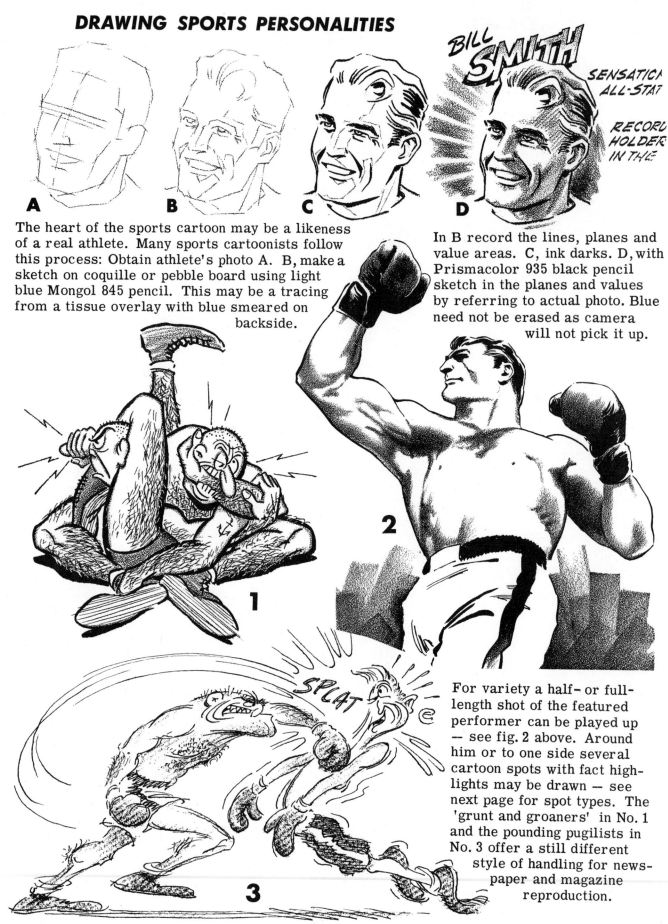

BILL SMITH

SENSATICA ALL-STAT

RECORL HOLDER IN THE

A **B** **C** **D**

The heart of the sports cartoon may be a likeness of a real athlete. Many sports cartoonists follow this process: Obtain athlete's photo A. B, make a sketch on coquille or pebble board using light blue Mongol 845 pencil. This may be a tracing from a tissue overlay with blue smeared on backside.

In B record the lines, planes and value areas. C, ink darks. D, with Prismacolor 935 black pencil sketch in the planes and values by referring to actual photo. Blue need not be erased as camera will not pick it up.

1

2

SPLAT

3

For variety a half- or full-length shot of the featured performer can be played up -- see fig. 2 above. Around him or to one side several cartoon spots with fact highlights may be drawn — see next page for spot types. The 'grunt and groaners' in No. 1 and the pounding pugilists in No. 3 offer a still different style of handling for newspaper and magazine reproduction.

SPORTS SPOTS

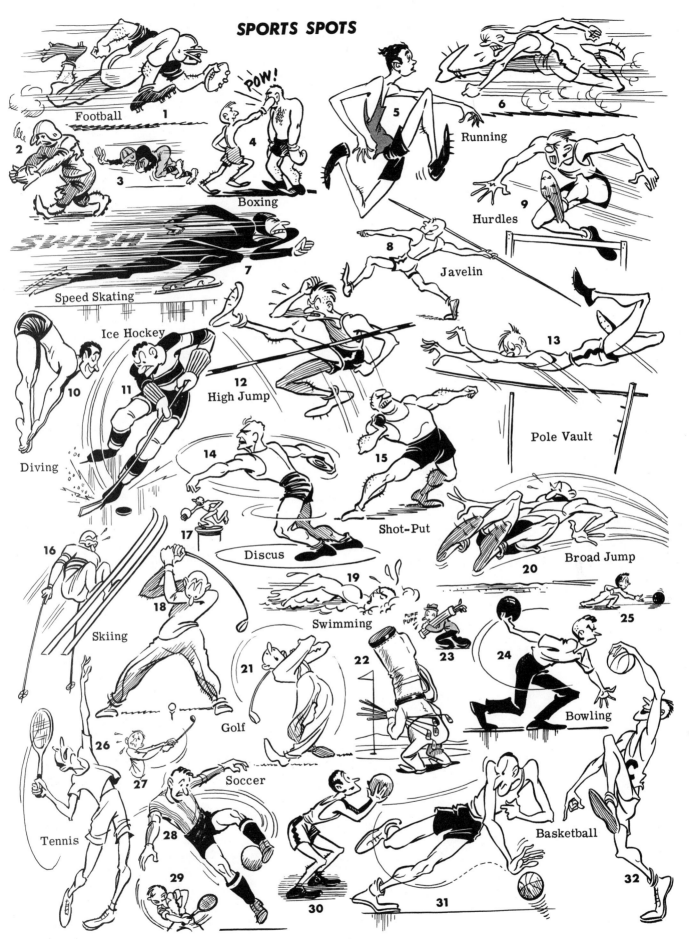

Football 1

2

3

Boxing 4

Running 5

6

Hurdles 9

Javelin 8

SWISH

Speed Skating 7

Ice Hockey 11

High Jump 12

13

Pole Vault

Diving 10

14

Shot-Put 15

Discus 17

Broad Jump 20

16

18

Skiing

19 Swimming

23

24

25

Bowling

Golf 21

22

Tennis 26

27

Soccer

28

29

30

31

Basketball 32

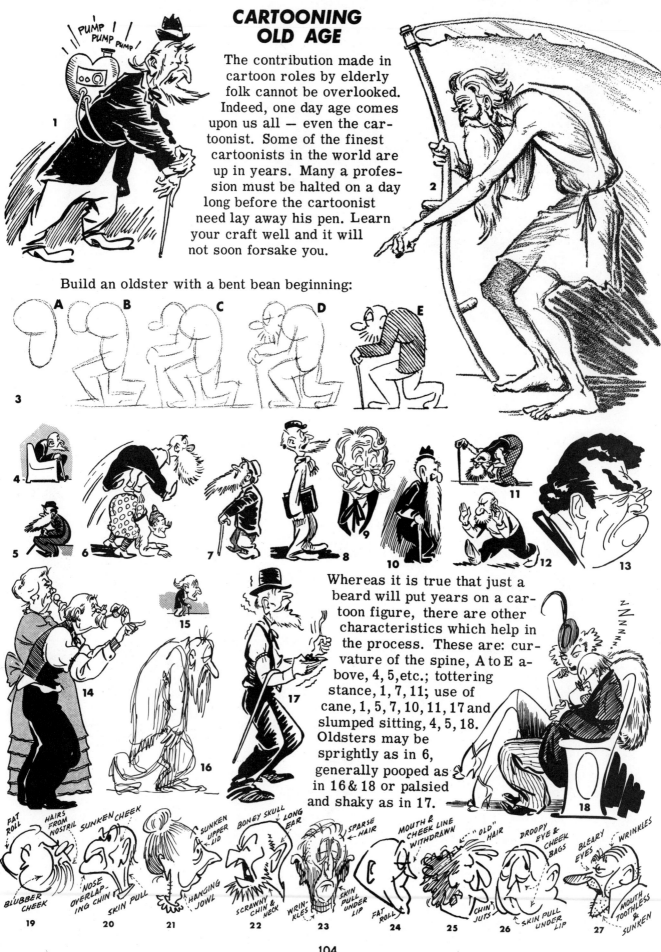

CARTOONING OLD AGE

The contribution made in cartoon roles by elderly folk cannot be overlooked. Indeed, one day age comes upon us all — even the cartoonist. Some of the finest cartoonists in the world are up in years. Many a profession must be halted on a day long before the cartoonist need lay away his pen. Learn your craft well and it will not soon forsake you.

Build an oldster with a bent bean beginning:

A B C D E

Whereas it is true that just a beard will put years on a cartoon figure, there are other characteristics which help in the process. These are: curvature of the spine, A to E above, 4, 5, etc.; tottering stance, 1, 7, 11; use of cane, 1, 5, 7, 10, 11, 17 and slumped sitting, 4, 5, 18. Oldsters may be sprightly as in 6, generally pooped as in 16 & 18 or palsied and shaky as in 17.

FAT ROLL
HAIRS FROM NOSTRIL
BLUBBER CHEEK
SUNKEN CHEEK
NOSE OVERLAPPING CHIN
SKIN PULL
SUNKEN UPPER LID
HANGING JOWL
BONEY SKULL
LONG EAR
SCRAWNY CHIN & NECK
WRINKLES
SPARSE HAIR
SKIN PULL UNDER LIP
MOUTH & CHEEK LINE WITHDRAWN
FAT ROLL
CHIN JUTS
"OLD" HAIR
DROOPY EYE & CHEEK BAGS
SKIN PULL UNDER LIP
BLEARY EYES
WRINKLES
MOUTH TOOTHLESS & SUNKEN

19 20 21 22 23 24 25 26 27

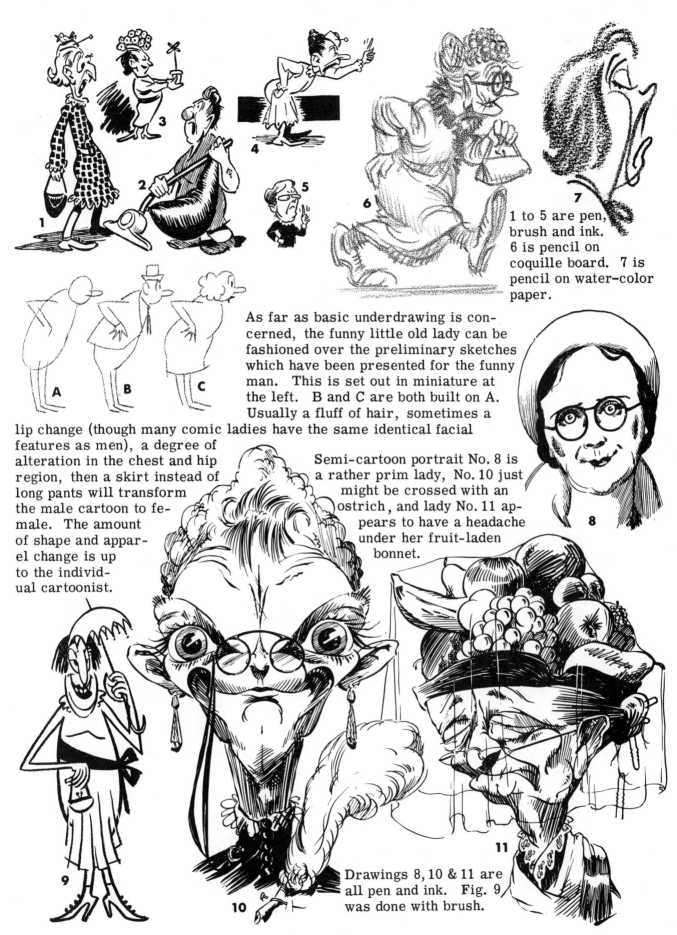

1 to 5 are pen, brush and ink. 6 is pencil on coquille board. 7 is pencil on water-color paper.

As far as basic underdrawing is concerned, the funny little old lady can be fashioned over the preliminary sketches which have been presented for the funny man. This is set out in miniature at the left. B and C are both built on A. Usually a fluff of hair, sometimes a lip change (though many comic ladies have the same identical facial features as men), a degree of alteration in the chest and hip region, then a skirt instead of long pants will transform the male cartoon to female. The amount of shape and apparel change is up to the individual cartoonist.

Semi-cartoon portrait No. 8 is a rather prim lady, No. 10 just might be crossed with an ostrich, and lady No. 11 appears to have a headache under her fruit-laden bonnet.

Drawings 8, 10 & 11 are all pen and ink. Fig. 9 was done with brush.

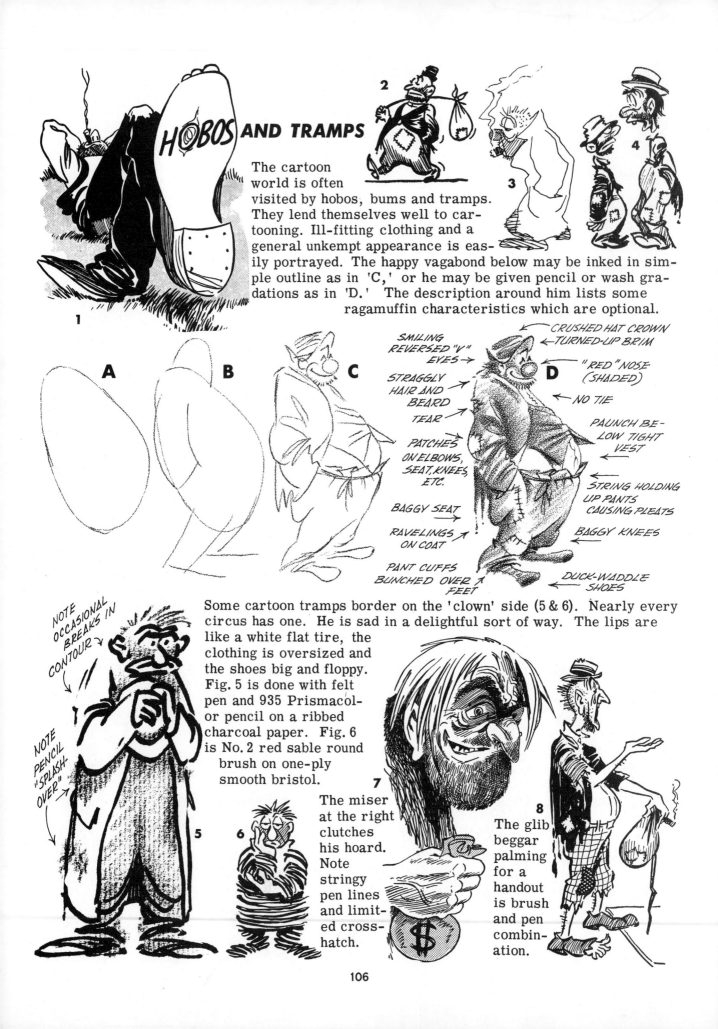

HOBOS AND TRAMPS

The cartoon world is often visited by hobos, bums and tramps. They lend themselves well to cartooning. Ill-fitting clothing and a general unkempt appearance is easily portrayed. The happy vagabond below may be inked in simple outline as in 'C,' or he may be given pencil or wash gradations as in 'D.' The description around him lists some ragamuffin characteristics which are optional.

1

2

3

4

A

B

C

SMILING REVERSED "V" EYES →

STRAGGLY HAIR AND BEARD

TEAR →

PATCHES ON ELBOWS, SEAT, KNEES, ETC.

BAGGY SEAT

RAVELINGS ON COAT

PANT CUFFS BUNCHED OVER FEET

D

← CRUSHED HAT CROWN
← TURNED-UP BRIM

"RED" NOSE (SHADED)

← NO TIE

PAUNCH BELOW TIGHT VEST

STRING HOLDING UP PANTS CAUSING PLEATS

BAGGY KNEES

← DUCK-WADDLE SHOES

Some cartoon tramps border on the 'clown' side (5 & 6). Nearly every circus has one. He is sad in a delightful sort of way. The lips are like a white flat tire, the clothing is oversized and the shoes big and floppy. Fig. 5 is done with felt pen and 935 Prismacolor pencil on a ribbed charcoal paper. Fig. 6 is No. 2 red sable round brush on one-ply smooth bristol.

NOTE OCCASIONAL BREAKS IN CONTOUR

NOTE PENCIL "SPLASH-OVER" →

5

6

The miser at the right clutches his hoard. Note stringy pen lines and limited cross-hatch.

7

8

The glib beggar palming for a handout is brush and pen combination.

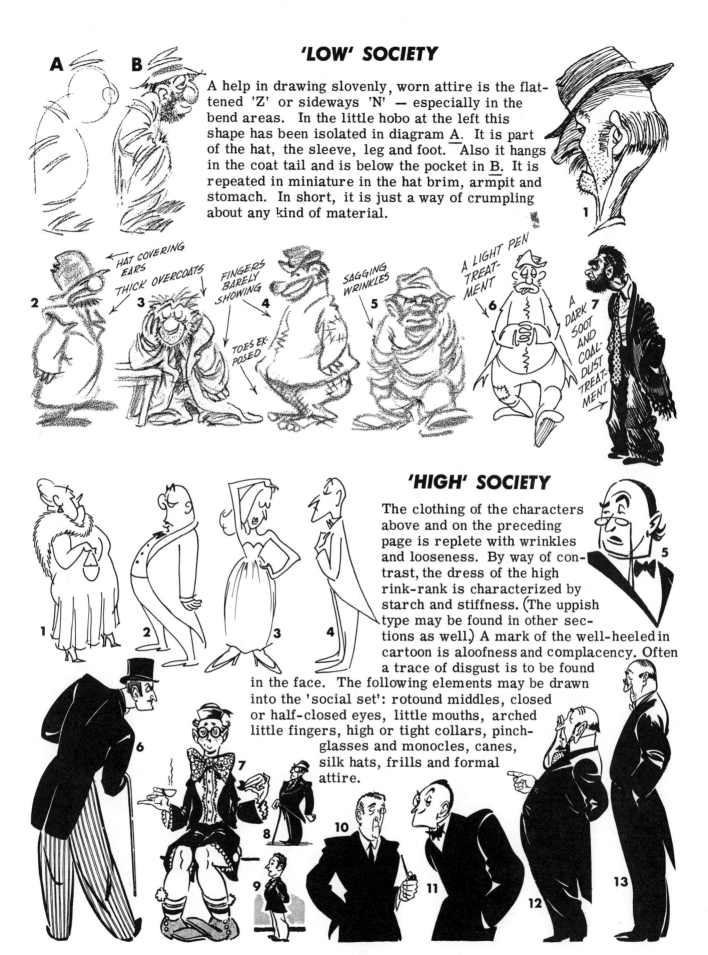

'LOW' SOCIETY

A help in drawing slovenly, worn attire is the flattened 'Z' or sideways 'N' — especially in the bend areas. In the little hobo at the left this shape has been isolated in diagram A. It is part of the hat, the sleeve, leg and foot. Also it hangs in the coat tail and is below the pocket in B. It is repeated in miniature in the hat brim, armpit and stomach. In short, it is just a way of crumpling about any kind of material.

HAT COVERING EARS

THICK OVERCOATS

FINGERS BARELY SHOWING

TOES EXPOSED

SAGGING WRINKLES

A LIGHT PEN TREATMENT

A DARK SOOT AND COAL-DUST TREATMENT

'HIGH' SOCIETY

The clothing of the characters above and on the preceding page is replete with wrinkles and looseness. By way of contrast, the dress of the high rink-rank is characterized by starch and stiffness. (The uppish type may be found in other sections as well.) A mark of the well-heeled in cartoon is aloofness and complacency. Often a trace of disgust is to be found in the face. The following elements may be drawn into the 'social set': rotound middles, closed or half-closed eyes, little mouths, arched little fingers, high or tight collars, pinch-glasses and monocles, canes, silk hats, frills and formal attire.

CARTOONING THE HEAVY FIGURE

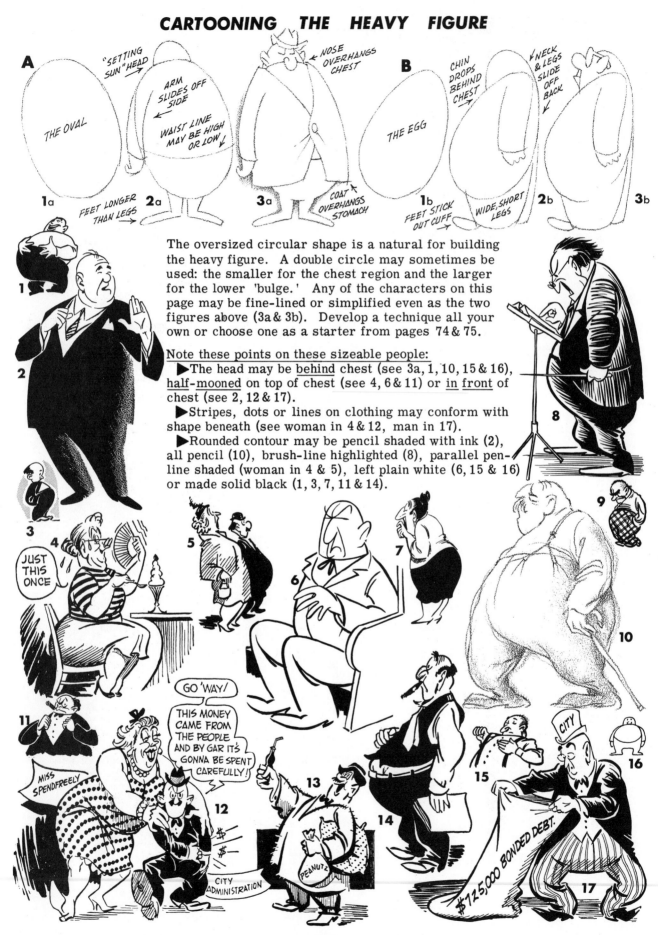

A — THE OVAL — "SETTING SUN" HEAD — ARM SLIDES OFF SIDE — WAIST LINE MAY BE HIGH OR LOW — NOSE OVERHANGS CHEST — FEET LONGER THAN LEGS — COAT OVERHANGS STOMACH

1a **2a** **3a**

B — THE EGG — CHIN DROPS BEHIND CHEST — NECK & LEGS SLIDE OFF BACK — FEET STICK OUT CUFF — WIDE, SHORT LEGS

1b **2b** **3b**

The oversized circular shape is a natural for building the heavy figure. A double circle may sometimes be used: the smaller for the chest region and the larger for the lower 'bulge.' Any of the characters on this page may be fine-lined or simplified even as the two figures above (3a & 3b). Develop a technique all your own or choose one as a starter from pages 74 & 75.

Note these points on these sizeable people:
▶The head may be <u>behind</u> chest (see 3a, 1, 10, 15 & 16), half-<u>mooned</u> on top of chest (see 4, 6 & 11) or <u>in front</u> of chest (see 2, 12 & 17).
▶Stripes, dots or lines on clothing may conform with shape beneath (see woman in 4 & 12, man in 17).
▶Rounded contour may be pencil shaded with ink (2), all pencil (10), brush-line highlighted (8), parallel pen-line shaded (woman in 4 & 5), left plain white (6, 15 & 16) or made solid black (1, 3, 7, 11 & 14).

JUST THIS ONCE

GO 'WAY! THIS MONEY CAME FROM THE PEOPLE AND BY GAR IT'S GONNA BE SPENT CAREFULLY!

MISS SPENDFREELY

CITY ADMINISTRATION

PEANUTZ

CITY

$125,000 BONDED DEBT.

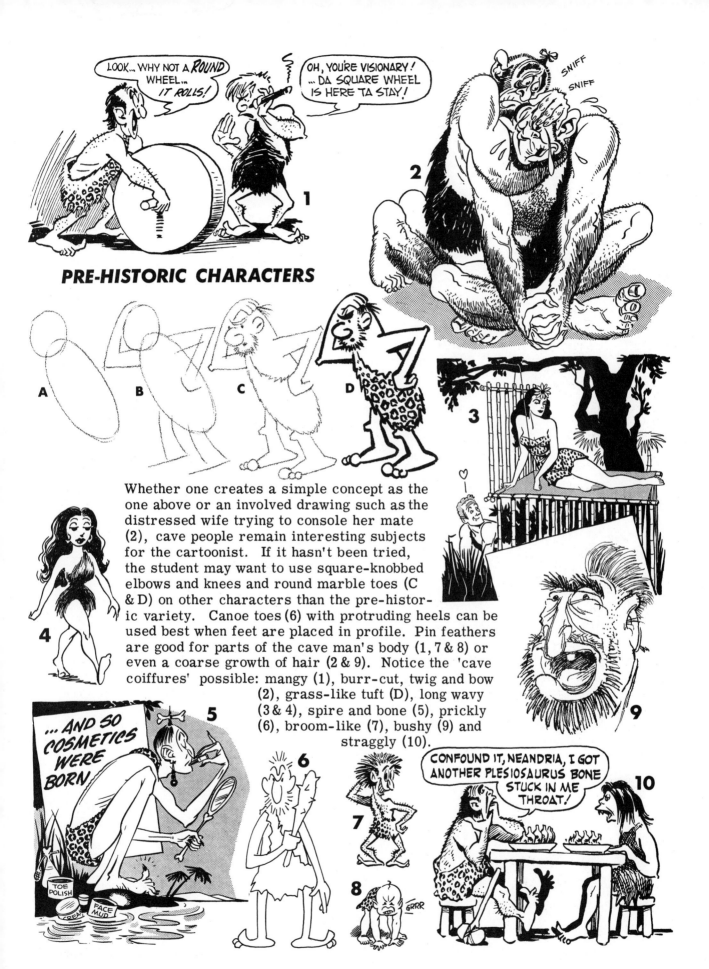

PRE-HISTORIC CHARACTERS

Whether one creates a simple concept as the one above or an involved drawing such as the distressed wife trying to console her mate (2), cave people remain interesting subjects for the cartoonist. If it hasn't been tried, the student may want to use square-knobbed elbows and knees and round marble toes (C & D) on other characters than the pre-historic variety. Canoe toes (6) with protruding heels can be used best when feet are placed in profile. Pin feathers are good for parts of the cave man's body (1, 7 & 8) or even a coarse growth of hair (2 & 9). Notice the 'cave coiffures' possible: mangy (1), burr-cut, twig and bow (2), grass-like tuft (D), long wavy (3 & 4), spire and bone (5), prickly (6), broom-like (7), bushy (9) and straggly (10).

THE MILITARY IN CARTOON

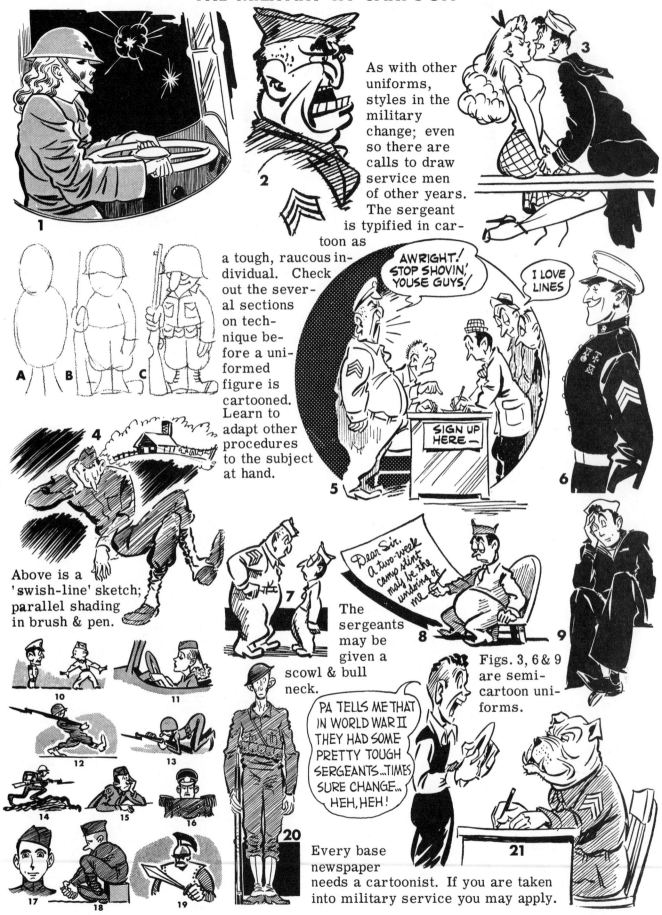

As with other uniforms, styles in the military change; even so there are calls to draw service men of other years. The sergeant is typified in cartoon as a tough, raucous individual. Check out the several sections on technique before a uniformed figure is cartooned. Learn to adapt other procedures to the subject at hand.

AWRIGHT! STOP SHOVIN', YOUSE GUYS!

I LOVE LINES

SIGN UP HERE —

Above is a 'swish-line' sketch; parallel shading in brush & pen.

The sergeants may be given a scowl & bull neck.

Dear Sir, A two-week camp stint may be the undoing of me

Figs. 3, 6 & 9 are semi-cartoon uniforms.

PA TELLS ME THAT IN WORLD WAR II THEY HAD SOME PRETTY TOUGH SERGEANTS...TIMES SURE CHANGE... HEH, HEH!

Every base newspaper needs a cartoonist. If you are taken into military service you may apply.

110

CARTOONING 'TOTAL EXHAUSTION'

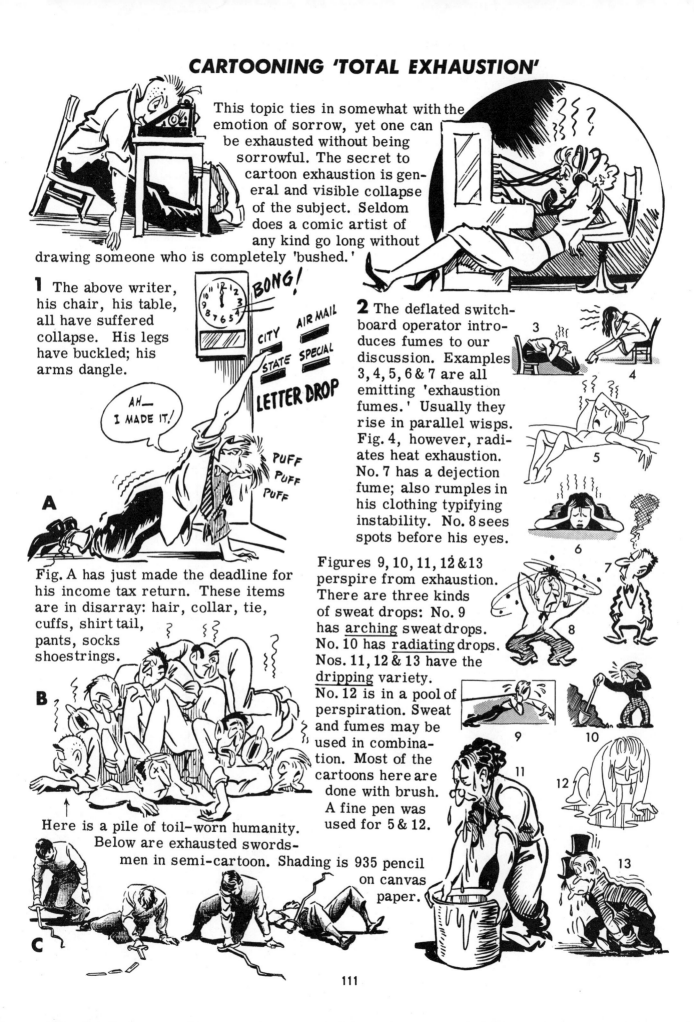

This topic ties in somewhat with the emotion of sorrow, yet one can be exhausted without being sorrowful. The secret to cartoon exhaustion is general and visible collapse of the subject. Seldom does a comic artist of any kind go long without drawing someone who is completely 'bushed.'

1 The above writer, his chair, his table, all have suffered collapse. His legs have buckled; his arms dangle.

AH— I MADE IT!

BONG!

CITY AIR MAIL
STATE SPECIAL
LETTER DROP

PUFF
PUFF
PUFF

A

Fig. A has just made the deadline for his income tax return. These items are in disarray: hair, collar, tie, cuffs, shirt tail, pants, socks shoestrings.

B

Here is a pile of toil-worn humanity. Below are exhausted swordsmen in semi-cartoon. Shading is 935 pencil on canvas paper.

C

2 The deflated switchboard operator introduces fumes to our discussion. Examples 3, 4, 5, 6 & 7 are all emitting 'exhaustion fumes.' Usually they rise in parallel wisps. Fig. 4, however, radiates heat exhaustion. No. 7 has a dejection fume; also rumples in his clothing typifying instability. No. 8 sees spots before his eyes.

Figures 9, 10, 11, 12 & 13 perspire from exhaustion. There are three kinds of sweat drops: No. 9 has <u>arching</u> sweat drops. No. 10 has <u>radiating</u> drops. Nos. 11, 12 & 13 have the <u>dripping</u> variety. No. 12 is in a pool of perspiration. Sweat and fumes may be used in combination. Most of the cartoons here are done with brush. A fine pen was used for 5 & 12.

3

4

5

6

7

8

9

10

11

12

13

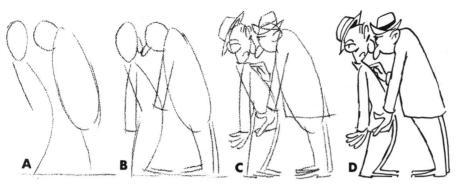

A B C D

CHARACTERS IN CONVERSATION

More cartoons exist with two people talking one to the other than any other situation -- and that quite naturally. What the person is saying has much to do with his appearance. Gestures are important as are the figures' postures.

Feel out the body stance with simple lines of direction. Become a participant in your imagination. Experiment in lightly-drawn pencil lines until the conversationalists strike the right mood. Don't be afraid to use the eraser -- at times it can be the student's best friend. Light lines disappear quickly and easily. Press toward the concept in your mind.

SSSPPP

1

2

3

4

5

It is best to work on both characters as one goes along. This helps in developing the feeling of a back-and-forth play in the spontaneous dialogue.

6

7

8

9

10

11

12

13

6'2" SO NICE!
BROWN EYES
CLASSIC PROFILE LIGHT SUIT

14

15

Refer to the section on techniques to study still other methods in handling the figures, both in contour and interior darks, greys and lights.

16

17

CARTOONED PEOPLE
IN THE ACT OF WRITING

This page is primarily concerned with the bodily stance of a cartooned person in the act of writing. The holding of the pen or pencil will be taken up in the section on hands. Most of the characters here are right-handed, but not all. One may be called upon to draw a writer who is not at a desk. The disturbed lady paying bills in fig. 1 is biting her nails. Notice her black pen has a line of retouch white alongside as it crosses the black arm of her dress.

2. The young lady standing is writing a check for her fare. Often the body leans to accommodate the standing writer at a table. The pen as drawn could be held by either hand.

3. The irate baker is trying to balance his books. Many of the lines here are straight, even to a partial squaring off of the hands and fingers.

In 4 and 5 delete the pencil from either hand. No. 8 is writing on the wall.

In 9 the paper is held with the elbow, and in 10 the happy writer is satisfied with a door stoop for a desk.

6. The census taker may not believe the lady's age, but he's writing it down anyway. His head and right arm are on the other side of his back.

7. This newspaper reporter supports his pad with his stomach -- a good stance for lackadaisical male note takers.

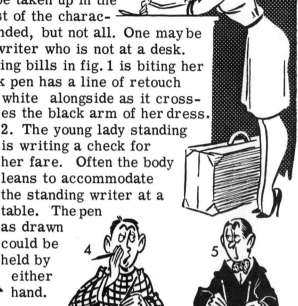

As in 6 and 7, the diminutive writers above from 1 through 4 are supporting their pad or paper with the other hand. The rest of the little figures are using a desk or table top. Since you, the cartoonist, are in a writing position when at work, take a look at your own hands and arms. Sketch lightly in pencil, then ink.

CARTOONING SPEAKERS AND ORATORS

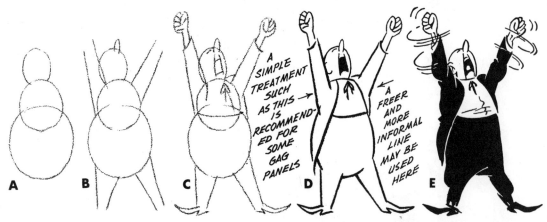

The degree of complexity of the cartoon is always up to the one wielding the pen. From the circular beginning in fig. A, the loud-voiced orator of fig. D or E may be evolved. D's suit may be treated as a grey or black. E's clothes are drawn with elbow and knee lumps.

All the speakers on this page have one or both arms overhead. No. 1 has his hands opened rather than clinched. Notice the little finger on each hand, one apart, the other overlapping.

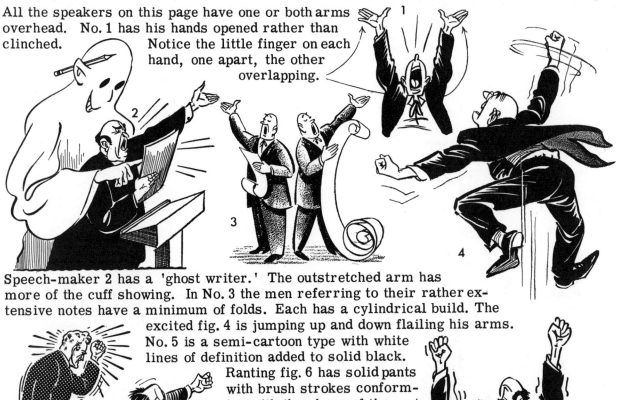

Speech-maker 2 has a 'ghost writer.' The outstretched arm has more of the cuff showing. In No. 3 the men referring to their rather extensive notes have a minimum of folds. Each has a cylindrical build. The excited fig. 4 is jumping up and down flailing his arms. No. 5 is a semi-cartoon type with white lines of definition added to solid black. Ranting fig. 6 has solid pants with brush strokes conforming with the shape of the coat. No. 7 grasps a microphone--shading is pen line. In cartoon 8 there seems to be a disagreement between the debaters. One dissenter grabs the other's face, thumb in mouth.

A's suit has highlights; B's has none (optional)

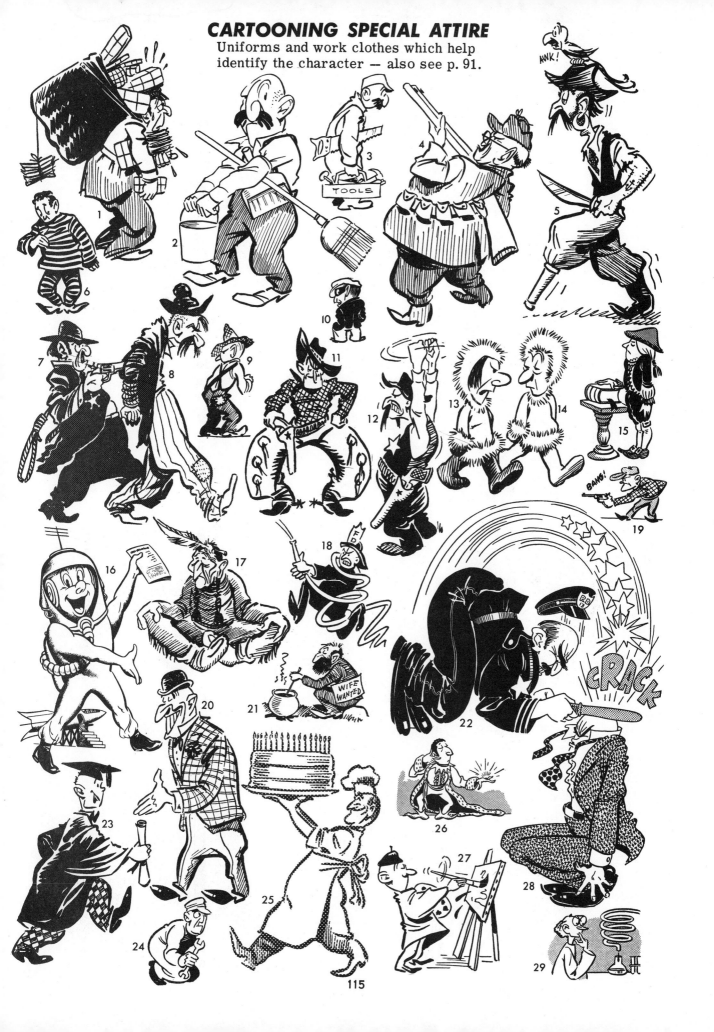

CARTOONING SPECIAL ATTIRE

Uniforms and work clothes which help
identify the character — also see p. 91.

115

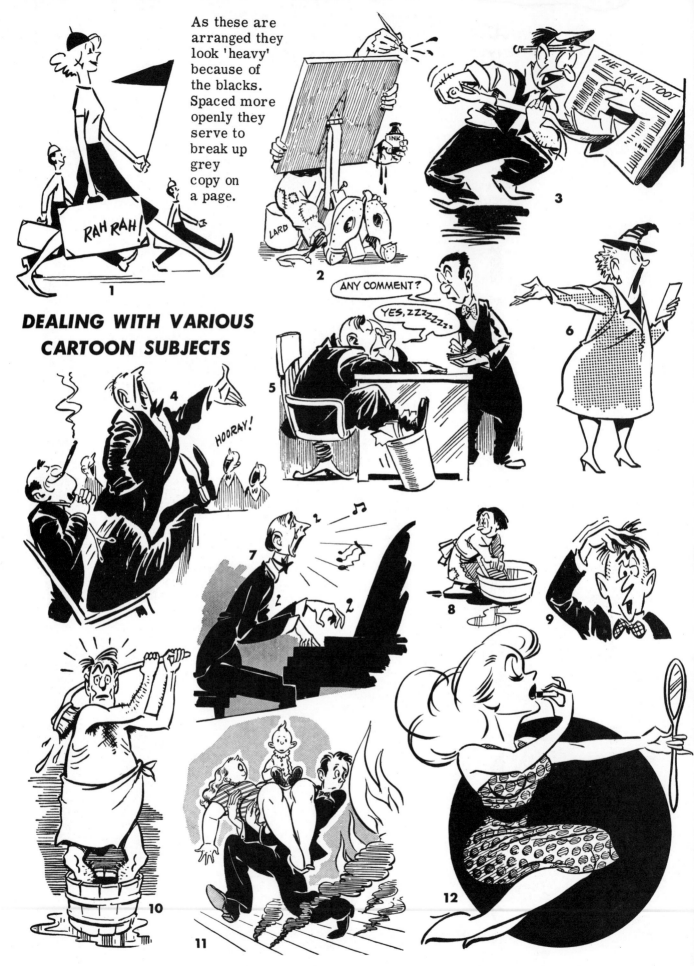

As these are arranged they look 'heavy' because of the blacks. Spaced more openly they serve to break up grey copy on a page.

DEALING WITH VARIOUS CARTOON SUBJECTS

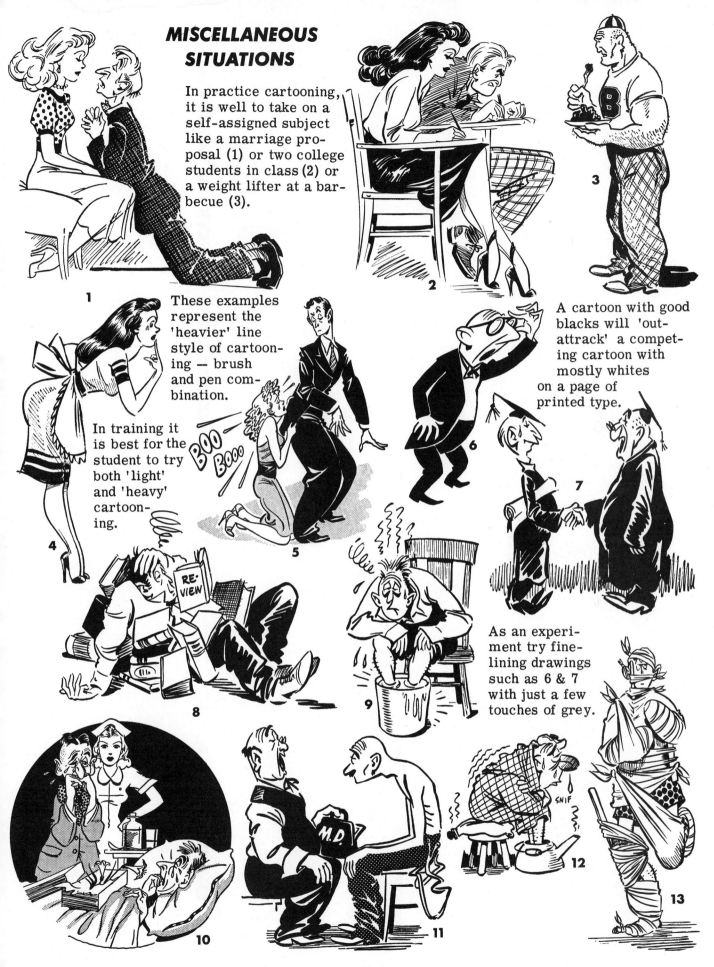

MISCELLANEOUS SITUATIONS

In practice cartooning, it is well to take on a self-assigned subject like a marriage proposal (1) or two college students in class (2) or a weight lifter at a barbecue (3).

These examples represent the 'heavier' line style of cartooning — brush and pen combination.

In training it is best for the student to try both 'light' and 'heavy' cartooning.

A cartoon with good blacks will 'out-attrack' a competing cartoon with mostly whites on a page of printed type.

As an experiment try fine-lining drawings such as 6 & 7 with just a few touches of grey.

BOO BOOO

RE-VIEW

SNIF

M.D.

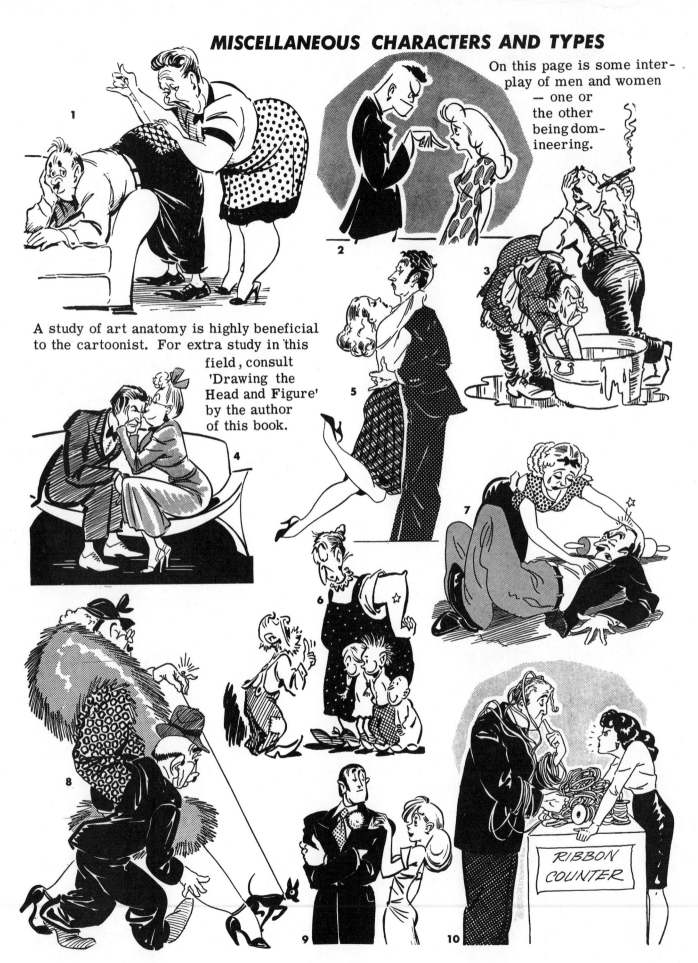

MISCELLANEOUS CHARACTERS AND TYPES

On this page is some inter-play of men and women — one or the other being domineering.

A study of art anatomy is highly beneficial to the cartoonist. For extra study in this field, consult 'Drawing the Head and Figure' by the author of this book.

RIBBON COUNTER

DRAWING CROWDS OF PEOPLE

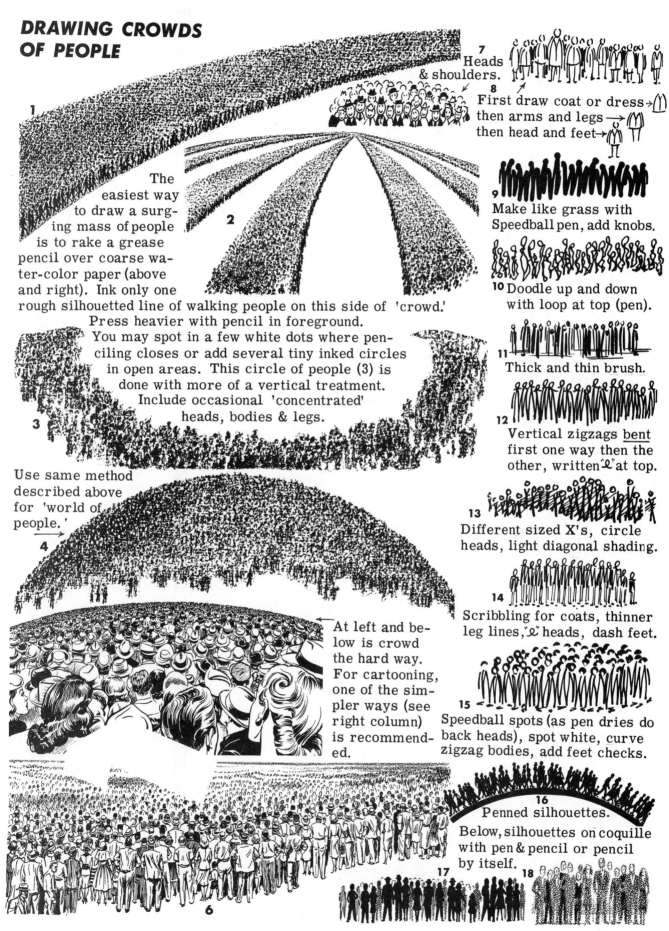

The easiest way to draw a surging mass of people is to rake a grease pencil over coarse water-color paper (above and right). Ink only one rough silhouetted line of walking people on this side of 'crowd.' Press heavier with pencil in foreground.

You may spot in a few white dots where penciling closes or add several tiny inked circles in open areas. This circle of people (3) is done with more of a vertical treatment. Include occasional 'concentrated' heads, bodies & legs.

Use same method described above for 'world of people.' →

At left and below is crowd the hard way. For cartooning, one of the simpler ways (see right column) is recommended.

7 Heads & shoulders.

8 First draw coat or dress → then arms and legs → then head and feet →

9 Make like grass with Speedball pen, add knobs.

10 Doodle up and down with loop at top (pen).

11 Thick and thin brush.

12 Vertical zigzags bent first one way then the other, written *ℓ* at top.

13 Different sized X's, circle heads, light diagonal shading.

14 Scribbling for coats, thinner leg lines, *ℓ* heads, dash feet.

15 Speedball spots (as pen dries do back heads), spot white, curve zigzag bodies, add feet checks.

16 Penned silhouettes.

Below, silhouettes on coquille with pen & pencil or pencil by itself.

A FINAL WORD...

Throughout this book we have concentrated on CARTOONING THE HEAD AND FIGURE. Before one seeks to apply his drawing abilities, it is wise to develop them. A student who begins by trying to submit gag panels, cartoon-sell a product or complete a comic strip, is getting the 'cart before the horse. When he feels at home with the tools, then he is better prepared to till in the soil of ideas.

If cartoonists, as people, differ from their fellow men in any respect at all, it is this: they are able to see the funny side in the midst of misfortune and even tragedy. This is not to say they do not have heart or cannot sympathize. Of course, in the face of a real-life disaster, levity should not be lowered on those suffering. But imagine real people enacting the roles we see taken by cartoon characters! In the lines from the cartoonist's pen there is born the funny side — when the most deplorable circumstances prevail. The world around chuckles and somehow is better equipped to face the day ahead. The cartoonist can say 'take heart; it's not all that bad.' From the time-honored Scriptures we read, 'A merry heart doeth good like a medicine; but a broken spirit drieth the bones' (Prov. 17:22). No other creature can laugh but man — the Creator made it so.

Sure, good cartooning takes practice, but if you have experienced some adversities, suffered some reverses, bumped your head on a low ceiling — and, if you still like to draw, you may be a cartoonist in the making. Rest up, eat and sleep, then try again. In continuing to heed the stimulating challenge, remember: there is great profit in being able to step aside for a moment of laughter over one's self!